THE BEST OF HEARTLANDS
SELECTIONS FROM 15 YEARS OF MIDWEST LIFE & ART

INTRODUCTION

Perhaps this volume should be subtitled: *"Some* of the Best of *The Heartlands Today* and *Heartlands Magazine,"* because it truly is only a selection of some of the thousand manuscripts and art works we have published in the last 15 years. But it is a fine and healthy sampling we wish to share with you, our audience and community.

Thanks to the work of The Firelands Writing Center, a co-operative of writers and artists from Northwest Ohio, *The Plough: North Coast Review* was born in 1985 as a tabloid of populist writing and art. In 1990 *The Heartlands Today: A Midwest Literary Journal* was begun with the clear intention "to support the art of good writing in the Midwest"; it ran for twelve years publishing short stories, poems, personal essays, reviews, art and photo chapbooks from around the Midwest. And this has led to the three recent volumes of *Heartlands: A Magazine of Midwest Life and Art* (2003-2005), taking us back to our populist roots and the Firelands region of Northwest Ohio as the center of a circle of subjects and audience expanding from Ohio into the Midwest as heart of the U.S.—twenty years in all, 12 as *The Heartlands Today* and 3 as *Heartlands*.

We have been supported in this endeavor of making writing and art real for people and supporting artists and writers by the generous support of the Ohio Arts Council, The Sandusky/Erie County Community Foundation, and by our home institution, Firelands College of Bowling Green State University. We haven't counted up the number of stories, essays, poems, photos and art that have seen the light of day through our publications, but we all feel it's a better place to live in because of them. As managing editor, I'd like to thank the hard working editors and the devoted writers and artists who have shared their work for so long.

The Firelands Writing Center is itself 27 years old (or young) and survives on the dedication of its community members. We sponsor author readings and talks, a coffeehouse reading series that includes an open-mic session for community writers, a monthly newsletter and writing workshop, and an Island Writers' Retreat—all open to the public. Loyalty runs deep for a group dedicated to such a basic thing as "promoting the art of good writing." Our heartlands area is a rich and deep source, and we invite you to share it here.

-Larry Smith, Managing Editor

Editorial Staff:

Larry　　　　Susanna　　　　Yvonne　　　　Becky

Managing Editor..**Larry Smith**
Associate Editor....................................**Susanna Sharp-Schwacke**
Layout/Design......................................**Susanna Sharp-Schwacke**
Assistant Manager...**Yvonne Stella**
Photography Editor...**Becky Dickerson**
Nonfiction Editor...**Nancy Dunham**
Fiction Editor...**Connie Willett Everett**
Poetry Editor....................**David Shevin & Lin Ryan-Thompson**
Review Editor..**Larry Smith**
Copy Editors..................................**Staff & Members of**
　　　　　　　　　　　　　　The Firelands Writing Center

Nancy　　　　Connie　　　　David　　　　Lin

All works reproduced herein have been done so by permission of the artists/writers.

Published By:

The Firelands Writing Center
of BGSU Firelands

One University Dr., Huron, Ohio 44839

With Special Thanks To The:

Ohio Arts Council

For Its Continued Support.

ISBN: 1-933964-00-6

2　Best of Heartlands 1991-2005

Table of Contents:

Nonfiction:
- Introduction, Nancy Dunham..................14
- Growing Up Polish in Pittsburgh, Carolyn Banks..................15
- Wilding the House, Richard Hague..................19
- Veneer, Susan Neville..................21
- Laugh Solitude to the Bone, Maj Ragain..................26
- Carhopping at the Charcoal, Helen Ruggieri..................27
- Jackie and the Tracker, Bonnie Jo Campbell..................29
- Carlos, Pat Temple..................32
- Many Strong Rivers, Jeff Gundy..................35

Fiction:
- Introduction, Connie Willett Everett..................43
- Heating and Cooling People, Wendell Mayo..................44
- Sightings, Stephen Wolter..................48
- Georgie O'Keeffe's Summer Visit Home, Terri Brown-Davidson..................55
- Birds, Ron Nesler..................57
- The Dune House, Kevin Breen..................62

Features:
- Working Class Sisters: Making an Authentic Art, Larry Smith..................86

Photographs:
- Introduction, Becky Dickerson..................4
- Brian Smith..................5
- Roger Pfingston..................6
- Sam Osterling..................13
- Eileen Wolford..................31
- Adam Osterling..................61
- Algimantas Kezys..................66
- Eileen Wolford..................70
- Becky Dickerson..................76
- Herbert Ascherman, Jr...................80
- Karen St. John-Vincent..................84
- Additional Photographs By: Charlee Brodsky, Becky Dickerson, Connie Smith Girard, Matt Kowal, Brian Smith, and Eileen Wolford.

Art:
- Molly Stewart..................37
- Additional Art By: Tom Kryss and Susanna Sharp-Schwacke

Poetry:
- Introduction, Lin Ryan-Thompson & David Shevin..................7
- The Year Dylan Went Electric, Robert DeMott..................8
- La Pavana de la Luna, Lin A. Ryan-Thompson..................8
- Something Like Pete Seeger, William Jolliff..................9
- To Sherwood Anderson in Heaven, John Noland..................10
- Sleepless with Mussolini, Maj Ragain..................11
- Letter to d.a. levy in Existential Heaven, Larry Smith..................12
- The First Swallows, John Noland..................39
- Stomping on Bees, MJ Abell..................39
- Ripe Plums, Joan Baranow..................40
- What Good Does a Woodchuck Do? Richard Hague..................40
- The People's Republic, John A. Vanek..................41
- Ohio Coyote, Diane Kendig..................41
- Planning for the Past, David Shevin..................68
- Architecture, Herbert Woodward Martin..................69
- Open House at the Cleveland Valve Plant: 1996, David Adams..................72
- Closed Mill, Maggie Anderson..................73
- The Trains, Lawrence Ferlinghetti..................74
- The Suicide Sisters' Dance Hall Visits the Romance Factory, Susan Firer..................78
- Farmer Brown Ascends the Gallows, Edwina Pendarvis..................78
- The Side Yard, Charlene Fix..................79
- Two Wooden Bowls, Milla Kette..................82
- Midwest, M.L. Liebler..................83
- Tarbox Cemetery Road, Deborah E. Stokes..................83

Reviews:
- 15 Years of Books Reviewed..................89

Miscellaneous:
- Magazine Introduction, Larry Smith..................1
- Editorial Information..................2
- Credits..................92
- Call For Submissions..................95
- Final Image by Eileen Wolford..................96

PHOTOGRAPHY

PHOTOGRAPHY INTRODUCTION
BECKY DICKERSON
PHOTOGRAPHY EDITOR

Photographs evoke memories. They can take us back and help us remember what was. We find a picture, any picture and we start to make connections to our life and the world around us. We wonder who those people were and what their story was. We like to pull out our own photographs from under the bed, the closet, or the shelf. They may be in albums, shoe boxes or bags. They might be faded, colors altered, and tattered, but they are old friends, and we remember when. We remember stories, people, places and life. Like the written word our photos tell stories.

Photographs bear witness. They prove our memories and stories as true. We didn't dream this life. Like a mirror, they make us look at ourselves: our birthdays, graduations, weddings, anniversaries, every important occasion in our life we caught in an image. But photography also goes beyond our own lives to show us this world, this Earth. The beauty and catastrophe of nature. Technological triumph and failure. The grace and evil of the human race. Photography in its purest form stands sentinel.

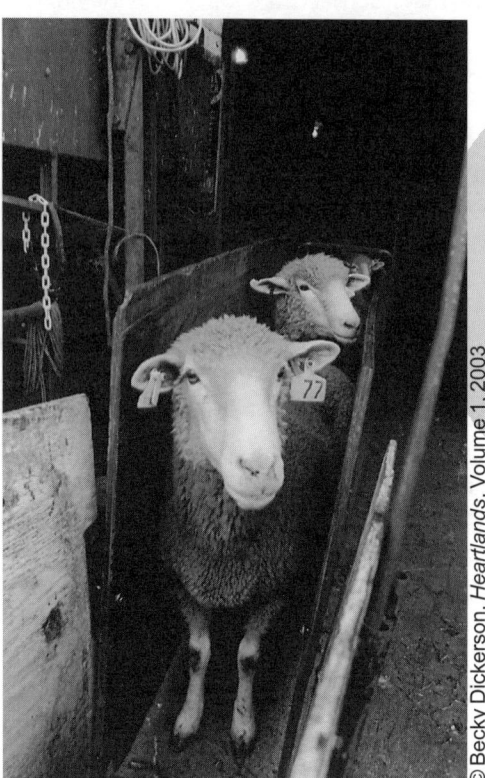

© Becky Dickerson, *Heartlands*, Volume 1, 2003

Photographs transcend time. They will outlive us. Long after the photographer, the people and the place are gone, the image remains. Photographers sometimes refer to photography as a "dark magic." We document the world in seconds, and we know that it is not a permanent, stable thing. We can't predict how long the things we photograph will exist, how long they will survive. We are brief moments on this planet but our photographs will remain. Photography, like words on a page, knows no time.

In my brief time with *Heartlands*, I have been both photographer and editor of photographs. My goal is to select images that provoke thought, memories and stories. Some photographs complement the poem or story. Others work best as essay. And some get to stand alone. But all the photographs tell the story of the photographer, bearing witness and transcending time.

Fifteen years. That seems like a long time. But for the photos and words found in *Heartlands* that's a brief second in its life. I hope to continue to present the best that the Midwest has to offer every year, and I look forward to 20, 25 and perhaps 50 years of *Heartlands*.

—Becky Dickerson

◆• PHOTOGRAPHY •◆

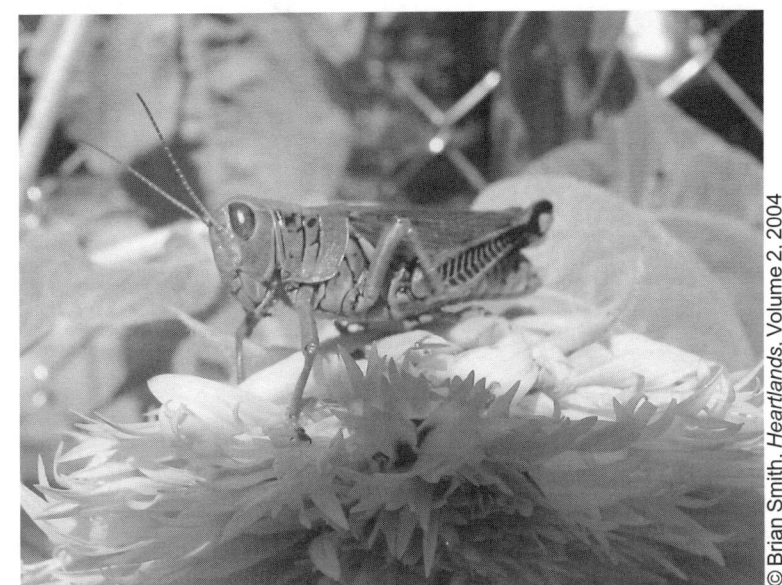

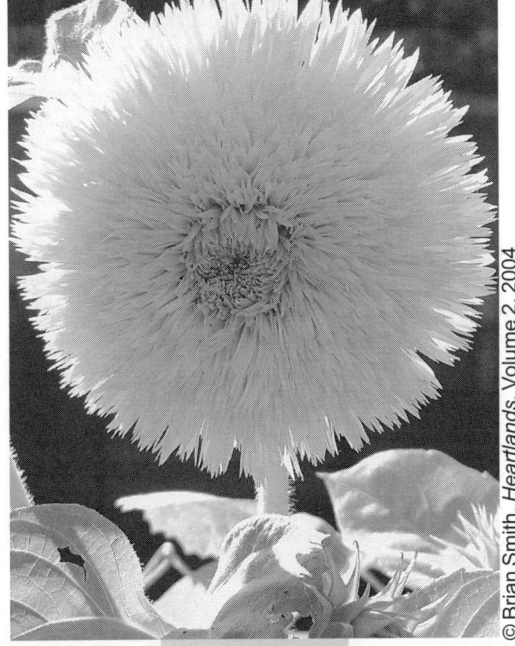

THE PHOTOGRAPHY OF BRIAN SMITH

◆◆ PHOTOGRAPHY ◆◆

"SNOW PILE, HOOPESTON, IL", *THE HEARTLANDS TODAY*, VOLUME 1, 1991©

THE PHOTOGRAPHY OF ROGER PFINGSTON

"BROKEN LINES, HOOPESTON, IL",
THE HEARTLANDS TODAY,
VOLUME 1, 1991©

"ABANDONED FARMHOUSE", *THE HEARTLANDS TODAY*, VOLUME 1, 1991©

POETRY INTRODUCTION
LIN RYAN-THOMPSON & DAVID SHEVIN
POETRY EDITORS

If you are like us, then turns of phrases, images, and the quintessential messages of the written word can resonate in your memory for years. We returned to the past issues of *The Heartlands Today* and *Heartlands* to gather up exemplars of such memorable verse to reprint in this *Best of the Heartlands* issue. To be sure, the toughest part of the task was limiting our selection to the space allocated for poetry—we wish we had more of it. Nevertheless, the poems in this special issue deserve to be here because they are among the best specimens of the craft.

Both the language and the images that mark these poems as extraordinary cover a variety of subjects. Some draw us into reflection on the way we understand ourselves and our world. Some are tributes to those who, in some powerful fashion, have shaped our sensibilities: writers, singers, and political figures; fathers, mothers, and grandparents. Some are vignettes of nature in which the writer stood for a moment and then beckoned us to see a strange beauty through his or her eyes. Some pay homage to ghosts of industry and ancestors, tethered to the life it brokered. Some recount events from the writer's past that model our common experiences, but they do so in remarkable terms and with uncommon insight.

You will find here poems long and divided into something like chapters; poems brief but brightly burning; poems strewn across the white of the page; and poems of not only discrete lines, but also of discrete paragraphs. In all cases, they demonstrate an economy of words, the absence of clichés, and the sculpting of language into surprising images that project sharply on the imagination of readers. They are beautiful, haunting, and above all, memorable.

—Lin Ryan-Thompson

"Fifteen Years", and "Best Of". It's all pretty hard to believe, especially the years part. We have a tight editing community, and there is always a project in progress. As an issue comes together, we are looking at the theme for the next time out. Then those years zip past like the telephone poles on the highway. It seems like maybe a quarter mile of road has passed by, and then it's time for a retrospective. It's almost equally challenging to think in terms of "Best Of". After all, *all* of the poems were selected because they were the best … and poetry is not, after all, a race after the rabbit at the dog track. (Poetry, being the gorgeous phantom that it is, is fine with the truth that it's not a real rabbit. But every poet here is a real racing dog.)

Lin speaks of how the verses here "model our common experience", and that is what we looked for from the beginning of this enterprise. *The Heartlands Today* was birthed in the enthusiasm of the Writing Center word-crafters at Firelands College as a collaboration of the vision we all had together. We culled lots of manuscripts at the college in Huron and looked for all that was honest, soulful, real and particular to the mix that was our diverging Midwest. We set out to be inclusive: meadow and mill, town and gown, celestial and domestic, shock and comfort.

It's no wonder that back then, we wanted to enter our Midwestern statement into a creative dialogue. It was a confusing world we saw when the enterprise began. The Berlin Wall had just fallen. Nelson Mandela was walking away from his 27 year imprisonment. The Communist Party in the Soviet Union had relinquished sole power. President George Bush was taking us into a costly war against Saddam Hussein, who had only recently been our ally. Another recent ally, Manuel Noriega, had just been taken into captivity. The Conservative Party's John Major succeeded the resigning Margaret Thatcher in Great Britain. My students today have no memory whatsoever of these confluences. "That was before there was TIME!" they would insist.

What the world did has only become more so. But just as when we began, we found an art that centered and identified the enterprise of remaining human in our corner of it all. I read the adventures in these lines. From first to last issue, these lines make wise sense. They advise or they jump and holler. Above all, they were and are real, honest, and damned entertaining. Enjoy. It's some of our best.

—David Shevin

POETRY

THE YEAR DYLAN WENT ELECTRIC
ROBERT DEMOTT
HEARTLANDS, VOLUME 2

An exaggerated scene, faded concert footage, you return to looking for clues: something like how who you are became who you might have been, something like memory and its discontents: the blue and the black, the hell to pay. Someday you'll figure out you are your own answer but then, after a night of special excess at Boynton Tavern, after way too many beers and shots to dull the pain of a woman you thought you loved moved out, after way too many pickled eggs, and belly full of loose fuck-talk with a gang of wet-dream buddies, you stumbled out alone, no one else in tow, dust swirling upward with each step down Worcester's wind-blown streets. Home, such as it was, then: suddenly, for no logical reason except that you thought you should make up for lost time (Lost how? Lost to whom?), you grabbed your landlord's battered upright from its place on the stairs, and began vacuuming your rooms, vacuuming it pitch dark. Just like that, spur of moment, without fanfare or premeditation, and no one to see, really, only a drunk-dumb audience of one. It seemed like the only thing to do: loud enough, too, to wake the dead, but you didn't care, impulsive bastard, because for a few minutes, in its whine and roar you were out there ahead of everyone else, at stage edge, without backup, going for broke; master of your fate, viceroy to a tiny universe of need. Admit it: in those clamorous moments you loved the reaper's single eye, more dazzling than the gaze of the all-knowing upon a desert wilderness. That, yes, plus the sexy, righteous way it took what it wanted, no questions asked, no apologies tendered: how it sucked up with impunity each foreign object, each piece of highlighted lint, speck of petrified food, tarnished earring, iridescent ant. Breadth and scope of the all-mighty: in the land of soot and dust Hoover ruled, queller of disorder, imperial collector of secrets, destroyer of alien detritus. Back and forth, up and down, through bedroom and hallway, each sculpted line on the frayed brown carpet a victory against that junk in your heart, snake coiled in your throat. Ride that beast, bucko: no more Mister Nice Guy for you, not then anyway, in full fret and frenzied throb of your bully machine, never again let sleeping dogs lie. Not you. Not ever.

LA PAVANA DE LA LUNA
(SLOW, SAD DANCE OF THE MOON)
LIN A. RYAN-THOMPSON
THE HEARTLANDS TODAY, VOLUME 12

Remembering Federico Garcia Lorca
(June 5, 1898 – August 19, 1936)
Spanish poet and playwright

Sometimes when Spain shudders
 when it shifts and groans
 I think it might be Lorca;
Lorca, who was not finished here,
 who breast-fed a country
 —a generation that would not die—
 he breathed for them.

Lorca cannot rest.
 He is too drunk with sorrow
 too heavy with the soul of Spain
 and her teak-eyed children;
he is their brown study
 the sad tale they tell each night;
he is their father and their mother
 they cry for him and cannot catch their breath.

The children of Spain sing cantos in their sleep
 they awaken in silence…

The children of Spain have liquid eyes
 glistening from beneath their lustrous
 veiled hair
 as veiled as the last moon Lorca loved
 before he was lain in deep-down sleep.

Sometimes, when it rains in Madrid,
 rains so hard it washes footsteps from the streets,
 I think a shadow passes by
 a shadow wandering in the weeping
 and weeping, too.

There is a wound in Andalucia
 small and deep, it will not heal it bleeds
 all Spain is throbbing;
only the olive trees know where Lorca sleeps
 softly, they sing his songs
 and watch the widowed moon dance for him.

SOMETHING LIKE PETE SEEGER
WILLIAM JOLLIFF
THE HEARTLANDS TODAY, VOLUME 9

I am waiting for a Seamus Heaney moment,
when all the earth-bound past and sky-bound future
roll together with lovely grey accents. And instead,

all I feel is this cassette in my pocket, right there
where my Bible should be. It's Pete Seeger,
"Darling Corey and Goofing-Off Suite,"

and if I could write with music on I'd play it now...
Nope. I still can't. Just like I couldn't be bald at thirteen,
though for Pete's sake, I wanted to be. Like God's grace

I'm told, and feel, occasionally, Pete is whole and constant,
enduring forever, noble and good, long-suffering,
and he sings in Russian, too, which the other kids

in my Sunday school class thought made him
a communist, or, worse yet, weird. What a bunch
of congressmen. But like grace, Peter keeps me in tune—

a star that glitters its one transcendent point to guide
my dumb ship by, like that Frost poem I can't forget.
But Pete knows how to tell a story or fable or joke,

how to play the five-string banjo, and how to wake up
the frayed edge of God Who shines and warms within me,
the part that says, "Do the right thing—oh yes, you can."

This morning the fog didn't leave Chehalem Ridge.
This morning I have to write an unkind letter.
This morning I want only to drink or listen to hearts break.

But the star cuts right through this dumb Willamette mist,
setting the holy mark, out of tune but just, and just right.
Peter sings, he sings, and, singing, the pole star burns.

TO SHERWOOD ANDERSON IN HEAVEN
JOHN NOLAND
HEARTLANDS, VOLUME 3

i.
Goddamn you, Sherwood,
you with your old man's
saint's voice,
for once be respectable.
Lie down and be dead and silent.
No more of this sleep-walking
at night. No more of this
frothing and prowling
the perimeters of heaven
muttering, "more, more."
Lie down, Sherwood,
and be famous and dead
and silent.

ii.
Goddamn you, Sherwood,
take your voice
out of my dreams, your old
cornhusker's voice
droning like locusts
in the long-dying dusk while you shuck off
a thousand twisted skins.
I've read your blind
and haunted poems. They're wordy.
They don't say much
that can't be said in vision.

And that's another thing,
keep those visions out of my life.
They keep opening up
like empty locust shells,
big-eyed and blind, whispering
"Grotesque, grotesque."
You don't have to tell me.
I know whose story I am.

iii.
Keep it to yourself, Sherwood.
I don't need it. I've seen
your heartland, vast and empty
as a dry well alive with lightning.
Locust trees, torn and twisted
as old poets, burning
in a spring of white fire
and flowers so bright
bees cartwheeled to the sun's
drunken slant. I've seen
your heartland cleaved in long wounds,
in furrow after furrow, cut
by a black tractor
through Midwestern soil so rich
ghosts still feed on it.
And I've seen people so hungry
their voice spun out and out
like barbed wire fences
when they sent their souls
seeking God,
running naked through wheatfields
at twilight. Quit smiling,
Sherwood. I know that grin.
It's the one the black snake wears
when he mesmerizes rabbits.

iv.
See, I *know* what you're talking about,
Sherwood. And I want to leave it alone.
I was there when they found Will Kearns,
our neighbor, pinned to the oak
by a chair leg after the tornado.
He always hoped to curse God
just before he died. "It spitted him neat
as a barbecued chicken," Eddy Pete said.
"He always did like barbecued chicken."
I was in the bluestem hills
when they found Bill Johnson
after lightning licked his mare's
steel hooves. I don't know
whether to laugh or cry, Sherwood.
Just a year before
Bill said heaven
was riding that sorrel mare
across his north forty
where we found him,
man and horse become one
and driven deep in limestone.
Some people wouldn't believe that,
Sherwood, but I know you will,
because you and I have both stood around
a lot of faces
when they discovered they had to live
and die alone
on the wild goose cries
of autumn. I've even tried to be a man,
Sherwood, and tear out that voice
calling, "More, more."

v.
Goddamn you, Sherwood, since you're here
let's sit down
and talk about the loneliness
of skin, and then
let's go down and feed the granddaddy
catfish and watch his blue eyes flame
while the prairie runs to the horizon
where a single black crow speaks of lightning and
limestone
and we burn lonely, vast
and mad as God
writing out His stories in flesh and fire,
crying, "More, more, more."

SLEEPLESS WITH MUSSOLINI
MAJ RAGAIN
THE HEARTLANDS TODAY, THE MYTHIC MIDWEST VOLUME 6

My plan was, that summer of 1955,
to steal time from death,
by sleeping only every other night.
I was fourteen.
I thought it worked that way.
We lived by a small lake in Illinois.
On the sleepless nights,
I'd be out on the water by three a.m.,
to drift and fish the false dawn.
I believed all kinds of things then.
The stars were gypsy campfires
on the lake floor; I could hear them singing.
Near the old brick tower was a cave
where a black catfish, head the size
of a car hood, ate the sins
of the fresh drowned.
In the deep beyond Boatman's Point,
a beautiful woman was weaving me
a deathless cloak of hair,
tears and willow skin.
Though I didn't know how
to love anybody,
what I wanted was to be loved obsessively,
the way Billy the Kid loved killing,
the kind of love that spawned the atomic bomb
and ruined Catherine the Great.
I floated over this kingdom,
in a small wooden boat,
sustained, my bones charmed.

The night the green fireball burned
across the Midwest, I never looked up.
The water was green flame.
I was to be a man who reads water,
not sky. Now when I walk,
I do not look up.
Not that I do not want to meet your eyes,
I am busy with water, with the rivers
that run under the sidewalks.
Remember, there are stars beneath us.

That summer I was after an old bass
named Mussolini. I'd seen him once,
under Maas' pier, as long as a man's arm,
thick as a football, hidden
in the shadow of a piling.
Fishermen dangled every bait:
a silver minnow, a painted nightcrawler,
a Luna moth, a priest's ear,
a child's promise, an abalone crucifix,
a live hummingbird, a bare hook.
Nothing worked.

I made it through July before
I broke the rosary of sleeplessness
and settled into my flesh.
I found out what the Italians
had done to their Mussolini:
the murder of El Duce and his mistress,
stripped and strung by the heels
in the town square
a lesson to the ruthless
that power, like love, wanes.
The old mossback Mussolini swims
in the spawning grounds one night a year
to spread his milt.
He lived deep.
He has never slept.
He hangs in shadow,
a moon in another sky.

LETTER TO D. A. LEVY IN EXISTENTIAL HEAVEN
LARRY SMITH
HEARTLANDS, VOLUME 2

d.a. levy, you were four months older,
yet I've outlived you by three decades,
and you know how hard that must have been.
You broke yourself for us, man, left us
to find our own songs for it.
Half your ashes at Whitehaven Cemetery,
the rest with family and friends,
your spirit spread over this cold city
that you loved more than I,
yet hated about the same.

West Side kid off Lorain Ave,
father a shoe salesman who
never measured your feet.
When you graduated from Rhodes High,
you wanted to kill yourself,
but found instead real books and art,
friends inside the darkness.
And you kept saving yourself with words
until you couldn't anymore.

Rebel artist, without a cause,
outliving James Dean by two long years.
You renounced everything, even yourself.
Your titles ring through my head at night:
"Egyptian" and "Tibetan Stroboscope,"
"Junkmail Oracle," "North American Book of the Dead."
Did you confuse Buddha's emptiness
with the existential nothingness, that night
you put a bullet through your head?
We need no martyrs, now, only friends.

Whitman lover of the streets and coffeehouses,
the bars and book shops, beloved Asphodel,
leaving your tired and lovely DagmaR
asleep in East Cleveland apartment
to walk down to Euclid and take the hungry bus
to University Circle. It was a scene you made
and watched, writing the long nights
covering the cold city with your lines,
pumping the days away on your letter press,
spinning the mimeo machine, breaking yourself
to get the words out to a city that turned its back.
Judges and lawyers and real estate men
cutting up the scene for themselves.
Police banging on doors and heads,
busting you all for contributing to
their own delinquent kids.

You were slight in the city wind,
blown in off Lake Erie. With Levi's,
motorcycle boots, and dark beard,
you found comfort nowhere in myths and lies.
Cleveland Milarepa yogi, you
stood in Trinity Cathedral at "The Gate,"
and opened the hearts and eyes.

You kept happening, broke yourself
a thousand times to keep us alive.
But then you couldn't. And you passed
quickly through a cloud like Hart Crane
or Sherwood Anderson, or Kenneth Patchen,
offshore somewhere in the Ohio night.
Your life was a book you wrote then erased
leaving us to survive without you.
The year after you died they closed the Palace
and Euclid Beach Amusement Park,
and then the Cuyahoga River caught fire.

© Art by Tom Kryss

◆― PHOTOGRAPHY ―◆

A Young Photographer: Sam Osterling

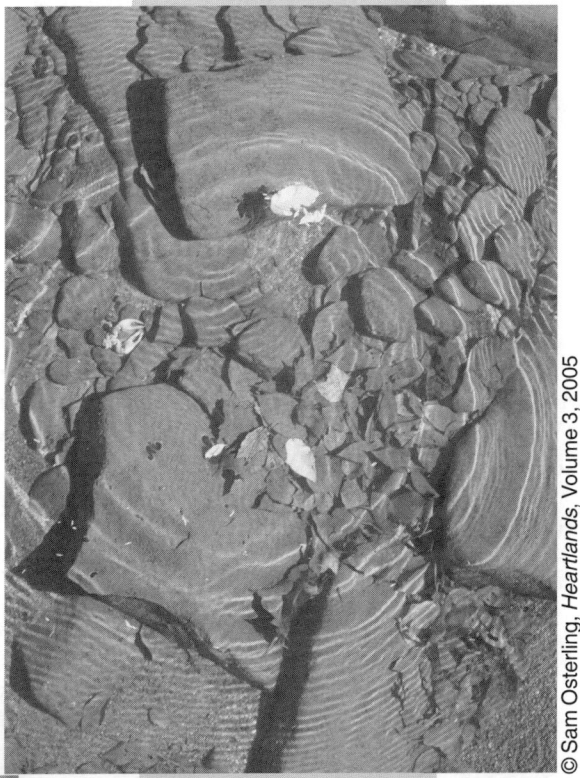
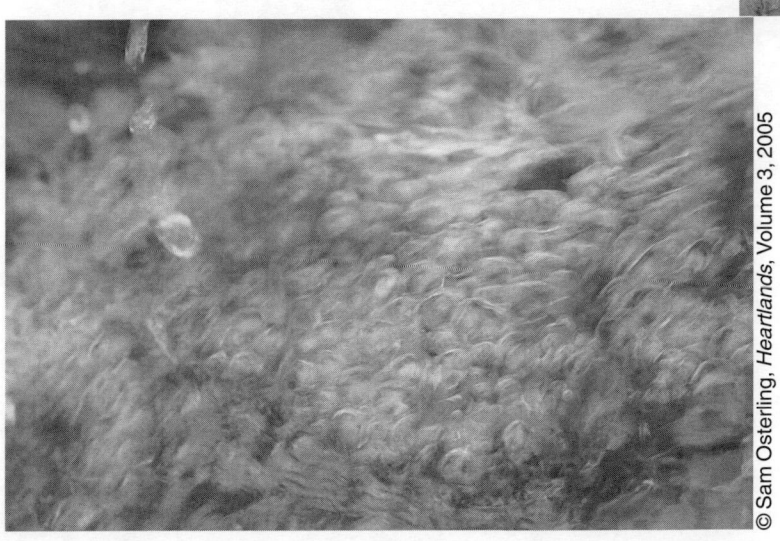

NONFICTION INTRODUCTION
NANCY DUNHAM
NONFICTION EDITOR

When several of us at the Firelands Writing Center first thought of putting together a Midwestern magazine, we had no particular goal other than to produce a publication of quality where writers of the region could send their work. We hoped, of course, that through submitted manuscripts, a Midwestern definition would emerge, a literature that revealed the core of Midwestern living. We called the publication *The Heartlands Today*, suggesting a space yet unexplored between the traditional past and an evolving present.

I didn't know when we started how much would follow, but manuscripts kept coming, and I continued reading, delighted by a growing connection between the magazine and others in the region for whom writing had importance. After Volume I, each book was given a theme. This helped set up parameters, providing a lens of sorts through which the faces of the Midwest could be explored. One year's theme often arose from what had come before: "Community," "Character and Voice," "The Urban Midwest," to name a few. Each volume made its own claim to definition. "The Real Work," (Volume 10) posed a particularly helpful query, asking what people in the Heartlands do with their time outside of jobs. It was a theme that lent itself well to naming values.

The personal essay, it seems to me, offers a particularly useful opportunity to probe the landscape, triggering glimpses of varied times and people. Helen Ruggieri ("Carhopping at the Charcoal") remembers "girls" in the 1970's. Maj Ragain, ("Laugh Solitude to the Bone") describes Spoony Paine, the last of the "river rats" of Olney, Illinois. Jeff Gundy rides on a highway between destinations ("Many Strong Rivers or Thoughts on the Way Home,") reconciling realities and dreams. Richard Hague, in Cincinnati, responds to an urban need to bring the outside in ("Wilding the House".) Bonnie Jo Campbell writes of a tough contender in a community Chevy competition ("Jackie and the Tracker",) and Carolyn Banks' reveals an ethnic neighborhood on Pittsburgh's Polish Hill ("Growing Up Polish in Pittsburgh".) Pat Temple is challenged by Carlos, a special student ("Carlos".) Susan Neville's veneer factory in Edinburgh, Indiana becomes a focal point for larger issues—family, future, the past, and global markets ("Veneer".) Together, the collection opens windows on the passing moment.

A definition of the Heartlands, it seems to me, remains tantalizing and elusive, partly the gradual outgrowth from secure traditions, partly an integral player in the rapid changes of the modern world. Who would have imagined the profound blow to the national psyche, the results of 9-11, registering shockwaves even on Midwestern seismographs and changing us in ways we are only beginning to think about.

This collection's title, *The Best of Heartlands* might well be called *Selections* for the essays were picked not only for their individual merit but also because they echo highlights from the manuscripts of other writers. Like the traditional Midwest, *The Heartlands Today* has continued on in spirit, but with adjustments. We've broadened the title to simply *Heartlands*. We're larger in size and more visually inviting. After 15 years, we're still going, still trusting of the strength of written words, still inviting readers in to share the work.

—Nancy Dunham

GROWING UP POLISH IN PITTSBURGH
CAROLYN BANKS
THE HEARTLANDS TODAY: A CULTURAL QUILT, VOLUME 2

The section of the city was called "Polish Hill." It consisted of narrow streets and row houses, brick pavements gradually being replaced by concrete sidewalks. A few slat fences were left, but these, too, were going, and in their stead, aluminum chain-link fences were being raised.

There was a hospital on the hill which loomed over the rest of the neighborhood. Its psychiatric ward, on the top floor, was commonly referred to as the "crazy house," and children used to line up at the fence, staring up at the top floor, waiting to see one of the patients. At the slightest sign of movement on any of the floors, they would run, screaming happily, home to safety and normalcy, the smell of *kishka* or *kielbasi* reaching from kitchen to hall and all through the house. On Mondays, bleach and ammonia in every staircase welled up from some hundred white-washed cellars.

Beyond the hospital, enemy lines. Names like Carrozza, Damiano Pizza houses, not ours, not our own.

Most of the people in our section spoke Polish, and all of the older children understood the language when they heard it but they didn't speak it. In the market on Saturday morning, over the smell of fruit and fresh-killed meat, a steady mumble of Polish rose. The market was a favorite gathering place. It was the only store in the three-block shopping district which covered its floors with sawdust. The older children would slide in it, and the little ones, hanging onto a coat sleeve or hem, would make tentative marks, with their shoes, circles, lines, little ditches. My own never realized dream, to be free of my mother, free of all grown-ups, free to storm and slide up the aisles, a whirl of chips flying, the dust clouds in my wake falling evenly on every bottle, every jar, every tissue-wrapped lemon and apple and orange.

But secular pleasures, even those only imagined, were few. The real center of the neighborhood was the church. Everyone, even the drunkards like Diane Rzemienuewska's father, went to church on Sunday mornings. The ones who went earliest were considered saintliest, while the ones who went to noon Mass were virtually atheists. My parents went, usually, to 6 a.m. Mass with my grandmother and Aunt Clara, while I went to "Children's Mass" at 8:30. All of my classmates were there, unwilling too, weary, but all of us kneeling starch-straight because of the nuns stationed every third row. Sometimes I pretended to be sick, so that I could sit, but during the sermon we all sat, and I would read almost all of the gospels in my Missal before the priest had finished reciting and preaching. Even though we went to church every week, few of us seemed to know when to sit, when to stand, when to kneel. We always had to look at each other or to look at the nun in the first row. Then rise, or sit, or whatever, so that it never happened all at once, in all the times I'd been to church. I always promised myself that I would learn the routine so thoroughly that the class would look at me before rising, before kneeling. And yet it was always the good girls, like Maryann Wrobleska, the girls who never talked in school and who never got their hands hit with the ruler by the nuns, who were never slow to decide when during the Mass to do whatever needed to be done. Despite my promises to myself I was always off in daydream or in the midst of some one of the gospels.

May was the cruelest month, the month of Mary. It began with a procession through the streets. The boys carried a large plaster statue of the Virgin and the girls followed, emptying baskets of rose petals along the way, all of us singing over and again a long, strangely sad Polish hymn, *Podgura Dolina,* I think it was called. I know that I hated the whole thing, and I think it was a safe guess that all of us did, the boys in crisp navy suits, the girls in starched dresses and knee length white socks. Old tapestry banners recalling miracles were held high, usually by the older men in the Sacred Heart Society: Lourdes, Fatima, Guadalupe. The smell of incense in the streets was fleeting except to those in procession. We grew dizzy as we walked, as we sang, as we cast petals of flowers in the warm spring streets. The neighborhood people would come down from their porches and stand at the curb. Some would lean out of upstairs windows. The old women would cry a little and try to sing with us, but always much too slowly.

Except for May, evenings in the church were given over to these old women, who would go in groups to say the Rosary. Since few of the *babkas* had even attempted English, it was said in Polish. In any language the words would have been indistinguishable. When the priest had hurried through his part of the prayer, the tired, soft chirping began, all at once, dwindling slowly, with each of the women praying at a different pace. Wrinkled and sad, most of them fat and dressed in dark colors, they huddled over their beads down at the small side altar. My grandmother was one of these.

The only occasion that I enjoyed (although I managed to look every bit as put upon as my friends) fell on the Saturday before Easter. The girls would come in *babushkas* and light jackets carrying baskets of food to be blessed for the Easter morning meal. We would kneel close to the center aisle with the baskets on the floor beside the pews. Filled with the sweet smell of Polish sausage and home-baked raisin bread, the church seemed

NONFICTION

less forbidding; perhaps, too, because the agonies of Lent had passed and we no longer had to spend each Friday afternoon making Stations of the Cross and because purple shrouds which covered all of the statuary had at last been taken up. Absent, too, was the regiment of nuns, so that we could sit or slouch as we chose. And then the priest would appear, heralded by two altar boys waving censers, filling the air with the familiar church incense, covering, temporarily, the warm and alien kitchen smells.

We would kneel, then, as straight as if the nuns were yet behind us, and up the aisle the priest would walk, muttering ecclesiastically, swinging a silver shaker of sorts, splashing the baskets and the company with tepid holy water. We would regain ourselves, shuffle out, complain together in the churchyard, and swagger home to beg the now sanctified raisin bread, eggs, or sausage. Each family kept a store of unblessed food, too, though nothing could equal the share in the baskets. But never once could we touch, let alone eat, the food which had been blessed before Easter morning.

The younger women, a group which included our mothers, did not go to Rosary, nor did they participate in our devotions. Instead, they played Bingo in the church basement. I went only twice, and, although I was bored by it, I was jealous of the girls who went regularly because they seemed so much more grown up than I. And so I always begged to go.

My mother never won anything except an Aunt Jemima cookie jar, but my Aunt Clara won almost every time she played: towels, doilies, and a salt and pepper set. Once, on one of the two nights I had been allowed to go, she won the $50 jackpot. She told me to place the see-through plastic chips on her card, but I was slow, too slow, and eventually she took over. I was almost asleep, my head pressed against the narrow table, when she called out, "Biiiiin-gooo!" We danced the polka in the streets that night on the way home and the next day my aunt bought a turkey, as big as our Thanksgiving turkeys were, and we had a huge family dinner at my grandmother's, to celebrate. Aunt Clara told all of my aunts and uncles and cousins that I had brought her luck and I got to pull the wishbone with her, although, as usual, she won. She always won. I had seen her pull the wishbone with my cousin Stash, and with my father. She always won, at everything. She even won a toaster, once, in the church raffle. Each child had to sell five books of tickets, which was pretty easy, since relatives usually bought a whole book. But Aunt Clara won the toaster and she was the only one in the whole family who bought just a single ticket. It was she to whom the Blessed Virgin once miraculously appeared. It was, in fact, the Virgin's only appearance in western Pennsylvania.

My Aunt Clara had never been my favorite. I remember her sitting on the front steps in the summertime drinking beer, setting the bottle on the steps beside her after each swig. I used to worry that my friends would see her, but if they did they never told me. She was a very loud woman and her teeth were laced with gold. She laughed a lot, throwing her head back so that all of the fillings would show. When she hugged me she squeezed too tight and her breath smelled of beer. I would squirm to get away from her but she always hugged me more than she hugged anyone else. At least I thought so.

Her rooms were next door to us, small and cluttered with her winnings and her handiwork. She crocheted for people in the neighborhood, pillowcases, hankies, things like that. All of our sheets had been bordered by Aunt Clara, and she made my mother's finest tablecloth, reserved for Christmas and Easter dinners. Most of my aunts and uncles bought doilies from her to give as wedding presents and to use in their homes. My parents did not use doilies except for one long one across the dining room buffet, and so, in our house, all of the doilies which Aunt Clara had given us were upstairs in the third drawer of my parents' chest of drawers, wrapped in white tissue and smelling faintly of lavender sachet. But Clara's rooms had lots of doilies and long crocheted strips with tasseled edges hanging from the window frames and on the door between her bedroom and sitting room. There were many religious statues—the Infant of Prague, the Virgin in her various guises, a small wooden statue of St. Joseph—with sanctuary candles burning red and blue before them, and on the wall at the entrance, a white enamel holy water font. Her rooms were hot and the holy water was always lukewarm. I loved to dab it on my forehead when I came in, and so I never really minded having to make the Sign of the Cross when we went there, even though we didn't do it at home, only at church or at my grandmother's and at Aunt Clara's.

On the day that the Virgin appeared my aunt had finished a blue tablecloth. Every year on that day, June 12, she used that cloth, and uses it today. "It was blue, and blue is her color," my aunt told everyone later. "I should have known, because I never made a blue one before, that she would come." When she called on my mother that night she did not behave as if she knew the Virgin was coming. Instead, my aunt came an hour before the Bingo was to start, as she always did, settled in the green armchair with a loud, deep sigh, as she always did, and, pulling off her shoes, began to rub her feet, which she did only when she had spent the day delivering her needlework.

"Please, can I go?" I asked my mother.

"Not tonight, Karolcza," she said, and before they left they each kissed my cheek for luck.

May devotions ended, I had nothing to do that night. My father worked a crossword and listened to the radio and I went to bed early.

In a fuzzy way I remember hearing my name, Karolcza, being called in my sleep. This had happened only

once before, on a New Year's Eve four years back. I heard my name, and then, over bells and whistles that sounded like the noon whistle at the mills, I heard my mother say, "It's 1946!" She told me that I said, "Oh," and rolled across the bed, never really waking. This time, though, she didn't allow me to fall asleep again. Instead, she stood me upright beside the bed and switched on the overhead light. I started to cry and she handed me a pile of clothes.

"No, no, don't cry." She sat on the bed and began unbuttoning my pajama top, "you must get dressed, Karolcza, your aunt has seen the Virgin." Then she shouted down the stairs, telling my father, in Polish, to hurry. My mother only spoke to my grandmother in Polish all of the time. To my father and to my aunt she spoke English, except when she said something to them which I was not to know. She turned to me and said something, still in her mother's tongue. "It's still night," I told her, but she went into the bathroom and began running the water. She came out with a washcloth and, as she passed it over my face, I realized that the Virgin had come to Polish Hill.

My father opened the front door and I was startled to see the street filled with people, all of them hurrying toward the hospital. I had never seen so many people, not even during the day. I could remember waking at night and looking out the window. It was so quiet at night and no one was ever out. Now, it looked as though church had just let out, no, more than that, as if the 6 o'clock, the 8:30, the 10 o'clock, the noon Masses had all let out at once. I saw many children I knew and called to them as they were hurried along. Loretta Mozdien waved to me and her mother smacked her. Maryann Wrobleska walked as though she were about to take communion, her hands folded in prayer, eyes front and solemn. I am reminded of that night now when I see movies involving the evacuation of villages, war movies, science fiction movies. We walked, now, up the hill, as quickly as we could without leaving my grandmother behind. She began to recite the rosary aloud, *Matka boska, swieta Maria,* those soft, chirping phrases, and my parents joined in, and soon the street was a moving, murmuring mass of people praying. Then someone began to sing the May Day hymn, and the May procession was reenacted there on the hill, but with no need now of the plaster statue, the torn banners.

"Aunt Clara saw her?" I asked my mother when we stopped to let my grandmother catch her breath.

"I would have seen her, too, but I left before Clara did. I won a cookie jar. I guess that was the Virgin's way of appearing to me."

"A cookie jar?" but we were on the move again and my question was lost in the singing, louder now as we neared the hospital.

There must have been a thousand people at the top of the hill. Some of the men wore sweaters over pajama tops and trousers. Women were there in housecoats and pin curls, and some of the children still wore their pajamas entire, with a shawl or coat thrown over them. Though it was June, it was cool and a wind had been lifting the dust in the streets all evening, as though it might storm. The wind had died now, or perhaps it had been trampled in the crowd, but it was a chill. We sang and stared up into the night sky. Now and then a voice would break through and shout, "I see her," in Polish, "there she is," and all of the people would clap their hands and sing louder and faster and then make the Sign of the Cross. Inside the hospital, people were silhouetted against the windows. We could see nurses in white standing with the crowd for a time, but usually they would go back inside, I guess so others could come out. The children who came to taunt the crazy people, they were here, but neither laughing nor afraid. I looked for our priests, expecting to see one of them in the crowd, his trouser legs peeping out from under a hastily donned cassock.

"Maybe," I said to my mother, "one of the crazy people got out up there." My grandmother grabbed my arm and shook me, but my mother spoke to her. My grandmother gave me an evil look, spat upon the ground, crossed herself with great indignation, and resumed the song.

"Well maybe one of them did," I said, and my mother led me away from my grandmother, who was now beating on her breast, her fist clenched, eyes shut, begging forgiveness for her errant grandchild.

I looked up beyond the building, trying to find my first star. I could find none to wish on. No, I must gaze upon the Virgin. I tried to focus on the building, but saw the building only, with people black against the light within, people on every floor, even the top. Perhaps I was possessed by the devil. The nuns had told us of such people and of some who turned to stone for eating meat on Friday and who swallowed their tongue for taking communion in a state of mortal sin. Perhaps I was in a state of mortal sin, perhaps the Virgin had come to all but me. I sang louder and louder, raised my voice until it grew thick in my throat, but still did not see her.

A fire engine appeared, quite suddenly. It came slowly, as fire trucks are driven in parades, but with its headlights on, the fire bell clanging. A man called through a megaphone, "Go home, go home. There is nothing here to see." And someone shouted, "Protestant!" The crowd laughed and cheered and applauded. But the singing had stopped. The firemen trained a huge light on the building and it ran up the side like a roach. The light hovered at the rooftop, then began to move, slowly, along the edge. The roof was indeed empty. "You see, there's nothing there," shouted the man with the megaphone, "there is nothing there!"

My Aunt Clara's voice came shrill through the crowd. I could not see her, but her voice was clear as she shouted, "It is a miracle. She would not let them

NONFICTION

shine those lights on her! It is a miracle!" Her opinion of the Virgin's departure was immediately accepted. The Virgin was Catholic. The Virgin of Guadalupe, of Lourdes, of Fatima, Polish. Of course the Protestants could not see her. So it was that my grandmother translated Clara's words to two of her friends who spoke no English. They nodded, grave with knowledge. Everyone took up the cry, "Miracle!"

"Okay, folks," the man, whose voice had taken on the huskiness which my own had when I'd tried to sing too loudly, tried again, "take your miracle home with you. Go on home." The light still shone on the empty roof.

Suddenly my mother's voice grew loud at my side. "I won a cookie jar!" she shouted, as if to say, "Explain that away if you can."

"That's right," my father hollered, shaking his fist, "that's right, she did!"

"Okay, people," the fireman had not heard, "you can see she's gone now, so go on back, go back home now." The huge truck began to move, turtle-slow, down the street, and everyone began to back from it, from the man with the megaphone, from the building. We backed, too, like all the rest, not turning our eyes from the hospital, but shuffling backward, staring at the spot where She had been, trying not to trip or lose balance, not to shove or be shoved, but trying, too, not to relinquish that which was especially ours, the Virgin of Polish Hill, my own Aunt Clara's Virgin.

I saw Raymond Bielski some twenty feet away and he made a foolish face at me. I kept, somehow, from laughing. Like my parents and my aunt, like my grandmother, I would be solemn. I hope his mother slapped him when he called to me, "Hey, hey Carol!" but I did not, I swear, hear him for the Virgin.

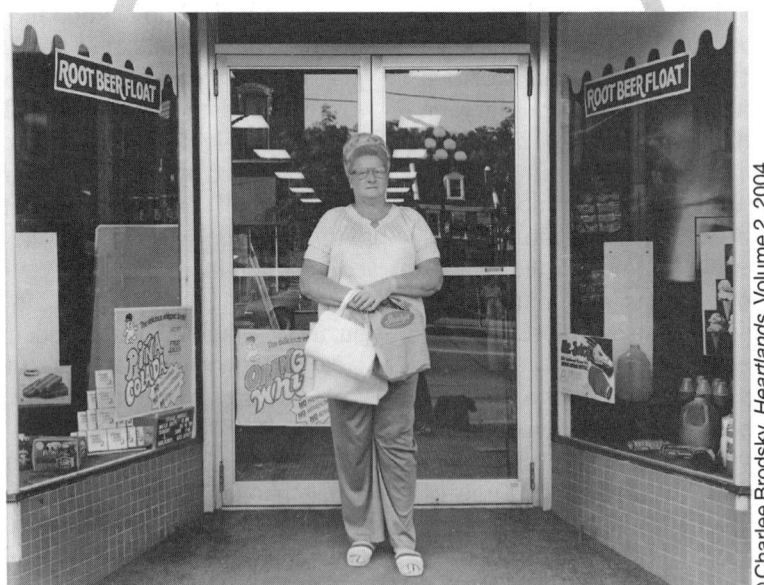

© Charlee Brodsky, *Heartlands*, Volume 2, 2004

WILDING THE HOUSE
RICHARD HAGUE
THE HEARTLANDS TODAY: A LIFE'S WORK, VOLUME 12

"When I found the beautiful white bones on the desert I picked them up and took them home."
—Georgia O'Keeffe

My wife and I, early in our marriage, took pleasure in late autumn drives into the country or walks along the railroad in our Cincinnati neighborhood to gather dried weeds and wildflowers. We'd spot a hillside of thistles, which tend to colonize unpromising spots like roadcuts and barren medians and played-out pastures, and we'd pull over and take out the heavy scissors or pruners that we'd brought along. Or we'd flush a scrawny city rabbit from a clump of Johnson grass between the eastbound and westbound tracks near Dana Avenue, and clip a few handfuls and carry them beside us like sheaves.

Once we got them home, we'd spend some time arranging them in great masses in vases Pam had made or had traded for from other potters. We'd set them around in the house in various places, liking how their earthy colors and loosely intricate natural lines played against the geometrical tile of the fireplace or the unstinting verticals of the dining room woodwork. There was something important those arrangements of wildness did for our household and for our psyches. Those thistle stems and dried blooms and tall brown mullein stalks and whatever else we grabbed up, once brought indoors, softened the unnaturalness of the house. They made us feel somehow a little less disconnected, by cityscape and architecture, from the land.

It is important, especially for urban people, to maintain a felt connection to the landscape around them. I cannot say that it is essential, because quite clearly we can survive in such prodigies of the unnatural as New York City or Singapore. But the issue is not simply survival. We are created not merely to survive, but to thrive, and the fact that we are creatures who once lived in trees, near water, and whose ancestors perhaps evolved in grassland environments with lots of sky and air, suggests to me that without those things, we are somehow cramped, slotted into a niche that is less than ideal in supporting our full development and our deepest connection with our environment.

The primary effect of such a troubled relationship is a kind of nomadry, not just among the poor who suffer displacement and eviction and homelessness, but equally among the well-off, whose migrations from sterile suburb to sterile suburb contribute to the decay of the inner cities, and to the mallification and uninspired housing development of valuable agricultural or forested ground. Can we really feel at home in center-less places like Oakland, California, over which Gertrude Stein exclaimed, "There is no there there"?

Just the other day I read in the local newspaper about a phenomenon of "cruising" that has seized suburban youth and caused a great deal of trouble for traffic officials and merchants. For a mile-long stretch of suburban strip outside Cincinnati that includes a video place, a restaurant, and some sort of entertainment arcade, high school students are driving their cars slowly back and forth, destinationless, breathing in heavy doses of polluted air, adding bits of rubber from their tires and the grease and oil from their cars to the poisons already trashing the landscape. They do it, they say, "Because there's nothing to do out here."

There is a bleak truth to what they say. All the houses are much newer than many in the city, so need little work. The land has been commercially landscaped to death, so there's little puttering to be had in that line. There are no interesting city centers on a human scale where you can leave your car at home and walk or bike safely to, and partake in that nice European habit of the afternoon or evening promenade, during which romance can thrive, neighborliness be practiced, a glass of wine taken at a little table on the sidewalk, and exercise obtained without the stupendous boredom of a treadmill or the shouting frenzy of an aerobics class. Lacking this sort of thing, no wonder the kids get in cars and just go— there's no center to their suburban neighborhoods and so they begin to suffer the same aimlessness of people with no center to their lives.

There is a cure, however. I would hereby invite them into my neighborhood, or any of the older city neighborhoods that resemble mine. There's a lot to do here: tons of litter need cleaning up, houses need fixing, gardens need planning and building and maintaining, children need tutoring, teams need coaching, public works need accomplishing. It would improve the world a great deal if we could simply count on all the juniors at Lakota West or Sycamore or Fairfield High Schools to come on into East Walnut Hills, or Over-The Rhine, or Lower Price Hill, and help repair and restore the inner city. Let's not waste our civic pride on football teams that extort huge palaces from us, levering their ways into our pocketbooks with the bogus prestige a professional team brings to a city, or with the dubious promise of income and jobs. Let's engender some real hands-on pride by getting our children's hands on real-life work, and real-life goodness, and real-life justice. By far the most laudable aspect of the Cincinnati Bengals football team over the last twenty years was former coach's Sam Wyche's visiting of the poor in Over-The-Rhine every Sunday morning before the game.

NONFICTION

In a recent "In Other Words" column about suburban sprawl in The Cincinnati Post, Sean Halloran wrote, "Has anyone noticed how much Mason [Ohio] looks like Florence [Kentucky]?" When our places, different from one another in culture, history, and geography, begin to appear as similar to one another as McDonald's restaurants, we are in some weird kind of trouble. Though well-housed and expensively landscaped (often with plants, by the way, no more native to our region than sequoias, or the cedars of Lebanon) we are nevertheless lost, homeless, and there is no place to go back to from which to reorient ourselves. The compass spins and the suburbs of Reading, Pennsylvania look exactly like the suburbs of Columbus, Ohio which look exactly like the suburbs of Denver or Indianapolis or Dubuque.

Though we lived in Evanston, in a well-integrated and stable urban neighborhood, it must have been some sense of threatening placelessness that drove my wife and me to try to seek out the native plants and landscapes, and to bring them indoors as tonics and reminders. That, and the innate beauty of many of their natural forms and textures. But of course, it's not enough. Though Georgia O'Keeffe brought the beautiful bones indoors, she did not merely lean them in some corner and let them gather dust. She looked at them, hard, every day, and then at last she painted them, which created a relationship more intense and intimate than mere idle gazes. John Moffett, in his poem "To Look At Anything," says that in order to really see something, "you must become that thing." And in order to become something other, we have to be willing, now and then, to give up what we are, to retire from ourselves for a time, to retreat into a quieter, slower place of the heart. Only by knowing who we are can we know where we are—or where we should be—and whether or not we just might be better off somewhere else.

I didn't say more comfortable—I said better off. As long as comfort is a major determiner of where we choose to live, lots of important business in this country that needs doing will not get done. Race issues will not be faced head-on if white flight and middle-class black flight continue from the inner cities in the quest for comfort. Every time an inner-city mother or father or aunt preaches to the children that the best thing they can do is "Get out of here, as fast as you can," my heart sinks. I understand the need to escape from an environment that is unhealthy, yet I also know that without native, educated, placed, savvy people staying in their neighborhoods, caring for their block as blocks need to be cared for, almost as certainly as children need to be cared for, our cities will continue to lose their souls.

The ancient Romans had their lares and penates—household gods, whose presence sanctified the household. We ought to have something equivalent in our households, so that we don't lose sight of the fact that everything we have is a gift, ultimately, and that we owe homage to the giver of those gifts, however we name the Provider and Creator. Wilding the house, reinhabiting it with the things of the field and the forest and shore, pays homage to, and resacralizes our domestic space. It mixes the merely human with the realms of air and light and season, and blends the wild world's spirit with ours, however momentarily. Every passing glance at the weeds in the vase reminds us of the larger world. Wilding the house strengthens and blesses us. It is one enactment of our spiritual obligation to what Gary Snyder has called "The Earth House Hold."

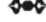

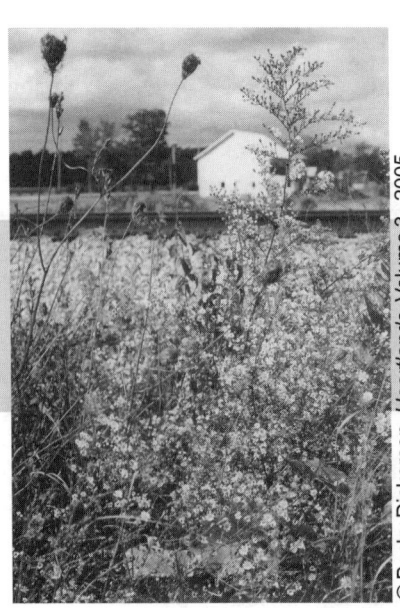

◆◆ NONFICTION ◆◆

VENEER
SUSAN NEVILLE
THE HEARTLANDS TODAY: MIDWEST CHARACTERS AND VOICES, VOLUME 9

Although specific rituals are necessary when the tree is cut down, carving the wood does not require special ceremonies.
—Diane Pelrine, Curator, Art of Africa, Oceana, and the Americas, Indiana University Art Museum.

I had come to the place that calls itself the veneer capital of the world. I was fishing for symbols. I expected to catch my limit quickly and head on someplace else. What else could you find in Edinburgh, Indiana, a place that sometimes forgets to include the silent *h* on even official documents, but irony.

I'd trained my eyes to look for certain things, and at first I saw them. The rusted cars, the complacent rural poverty, the way the road curves around the graphite-colored silos, the trashy railroad lines, the dust of dissolving brick on turn-of-the-century houses, the drooping shutters and cast-off kitchen appliances on porches and the interminable gray skies. It was cold and windy. The day before had been sunny and warm. You know there's only one other place on the face of the earth with weather as changeable as Indiana's, my son had told me. *Ohio?* I'd asked him. *Illinois?*

No, he'd said. *Siberia.* There are parts of Siberia, he said, where you'd swear you were home.

If there was a sister city for some gulag, I thought as I headed for the veneer factory, it would be Edinburgh. How could you live or work here? The ramshackle houses, the railroad tracks, the stacks of logs on trucks, in log yards, the aging factories on each side of town, each one larger than the town itself. And the sad little downtown with its attempt at beautification. Its one-way newly paved brick street with hardly any traffic, its two dollhouse-sized blocks with its hardware store and its bank and its boarded-up windows and its plastic flowers. Its veneer.

I was there a little early, so I stopped by the library to find what I could find of local history. The library was new, paid for by a grant from the factory I was here to see. There were no locks on the restroom doors. Hey Ruthie, Mabel just went in there, you'll have to wait a minute. No stranger is likely to just drop in here off the highway, and we're all family, so who needs locks? You have to make a point to drive to Edinburgh. It's not on anyone's route to anything.

There was the usual display of self-help books, an ancient woman picking them up one by one to inspect them, like vegetables. I ask the librarian to point me to the local history. She looks surprised. Genealogy? She asks. No, history, I say. Genealogy, she says, and points me to another room.

Where all the books have similar names: History of the Pruitt Family, History of the Stilabower Family, History of the Irwins. This is where you come on those days when you want a literal answer to who you are and how and why you ended up here. You try to find a narrative arc in the family story, one that leads inevitably to your own, that makes it more drama than denouement, that gives it meaning.

Hidden within the genealogies there are those old beautifully illustrated 19th century atlases and finally, what I'm looking for, a history of Edinburgh published by the sesquicentennial committee. Maybe I'll find an answer here. I want to know why, of all things, veneer? Why in this particular place? I think of veneer as a synonym for a kind of mask, for a falsification, a way to make something look expensive when it isn't. I think it must have been some industry that arose here by some accident or because of some entrepreneurial genius during the depression, like Depression glass and movies and cosmetics, something to make you look better than you were actually feeling. I think of small towns in rural Indiana as at the very least being what they are and have been and what you expect them to be. That's why I'm expecting irony. What else could you find when you're studying veneer.

I look through the history and discover that there wasn't just one veneer factory, there were three. And that of course it had something to do with the railroad line passing through from Indianapolis to Louisville. Many Midwestern towns were created, in fact, by railroads, as places to stop and pick up goods, usually grain or livestock or some natural resource. Like lumber.

When you drive down from Indianapolis to Edinburgh now, you see farmland and you see malls and subdivisions being built over farmland, but you don't see many trees. You grow up in the Midwest thinking that God put corn and soybeans outside of cities in some divine parquet pattern, that it's always been that way. You have to force yourself to re-imagine that this was once one of the world's finest hardwood forests and that it went from being that to what it is now in less than 100 years.

So that explains the sawmills, and I'm supposing that a veneer industry developed as the lumber became more scarce. That's my initial hypothesis. Other than the mills, and the usual fires and floods, the other interesting thing in the History of Edinburgh is the effect of World War II, which blew in and out of Edinburgh as though there'd been a battle here. Edinburgh, according to the history, saw all its young men go to war. Not a

single family was excepted. And of course Edinburgh rests on the northeastern edge of Camp Attebury, the Army base that was formed in less than ten days out of acres of farmland in June of 1942. Families were moved off of farms; churches and homes and schools were blown up, the entire neighboring town of Kansas was obliterated, and the refugees found new homes in Edinburgh. The girls worked in offices and women in the factories. The boys and men went off to Europe. 1800 new buildings were created in the Army camp, including what was at the time one of the three largest Army hospitals in the United States and housing for German and Italian prisoners-of-war. Where Kansas used to be, they built a false-front town nicknamed Tojoburg, so soldiers could practice taking over a city and blowing it up. All this building required lumber.

The population of Edinburgh almost doubled in that year. People trying to get their sugar rations formed crowds so thick in the general store that no one could move.

Two years later, almost to the day, in 1944 the army base was closed. It opened again in 1950, during the Korean War, then closed again. The families that had been displaced and moved to Edinburgh were supposed to be allowed to buy their land back, but they never did. The sons and daughters of six-generation farm families became factory workers, and their sons and daughters became service providers and corporate bureaucrats. Most of them moved on to the larger engine factories in Columbus, and eventually their children moved away. I'd forgotten that, in coming here, I was heading back into the history of that time.

According to the History, most people were heartbroken that the camp caused them to lose their homes. My husband's great-grandfather, who was from Kansas, committed suicide. Though others said that if the camp had not come, they would still be buried on a farm

I no longer expect to be amused. I just feel sadness when I walk outside the library and back into the town itself. All the things I'd noticed when I first drove in are what remain of sacrifice and a particular tragic history, of people who love a place long past reason.

It's a small, one-story office building, nothing much to look at from the outside, that universal aqua of small town office buildings. But inside, the wood is, of course, beautiful—the paneling, the office furniture. Beautiful but not ostentatious, nothing like a city lawyer's office, say, or the lobby of a bank. It's simple and functional with polished wood and soft lights, but the lobby is small, like an elevator.

Let me introduce you, the receptionist says, to John Grunewald. A small man, elegant, with an accent that I don't recognize. I ask him why sawmills, here of all places, and two of them. This used to be some of the best quality timber in the world, he says. The best white oak was just south of Edinburgh and the best walnut was a few miles north.

It was the quality, he said. It has to do with the soil, the moisture, the temperature. All those things affect the wood grain. You can't force it.

So it's aesthetics. When you cut a quality log into strips for veneer, it seems, you multiply the opportunity for beauty. Each thin strip from that log has the qualities of the log's design, its fingerprint. Why not cover as much surface as you can with that design?

Where do they go now for logs? Iowa for walnut, he says. Maple from Michigan, Illinois for white oak, red oak from Ohio and Michigan, cherry from Pennsylvania. Now and then some older local timber will come up for sale, but there's not much of it.

What about Attebury? I ask, thinking of all those untouched acres. It was mostly farmland, he says; it had already been deforested. And the timber that's left, he says, is full of bullet holes.

So logs are shipped here to be cut and then they're shipped out someplace else. One of our largest customers, he says, is a Korean piano manufacturer. They sell veneers in Korea, Malaysia, Singapore, China. China's business is doing particularly well.

They're relatively new to this economic meltdown, Mr. Grunewald tells me. Indonesia is badly effected, and Thailand. Japan is a basket case, he says.

That paneling behind your desk, I ask Mr. Grunewald, is what? Brazilian rosewood, it was one of our specialties years ago. It's a rich red patina with drips of polished yellow. An exotic species, in the language of log buyers. Guitar veneer. Rainforest wood, several decades old.

He tells me that the yellow strip is sap. Maple is all sap, he says, that's why it's so light. That color in light-colored furniture is bleach or sugar. The desk? I ask. Amboyna burl, from Burma. A burl? A cancerous growth, he says, the grain grows every which way, and it's extraordinarily beautiful.

The burl looks smoky and vaguely both star and amoeba-like, similar to those new photos you see of galaxies that look so much like swirling blood and amniotic fluid. A burl. The desk legs are black ebony and are from Indonesia. They're both valuable and rare, like jewels.

I look around the office. The mask? Senegal, he says. The room is filled with paintings and sculptures. That one by the door? Pre-Columbian, he says.

And the accent?

Hungarian, he says. He's Hungarian.

How did he end up here in Edinburgh? Where did this artwork come from?

Jerome will show you around the factory, he says. And then come back here. I'll tell you. Jerome is waiting in the outer office. He's wearing a leather coat. He smiles like John Travolta, that kind of smile. Poor thing, he has

to walk this woman who thinks of veneer as nothing but an interesting metaphor through his plant, this woman who can tell metonymy from synecdoche but can't tell white oak from red. What good is she? There are four interns from different parts of Europe living in a farmhouse outside of Edinburgh, just to learn to judge a piece of wood, like wine. What will he do with me? He'll be charming and gracious and make this a quick tour.

It doesn't matter. I think of these processes like some language that at some point in future history we will have forgotten how to speak. I'll never know the language, but perhaps I can gesture toward the rich and complicated culture that arose from it.

A gray day, and there are logs with gray bark lying stacked in the logyard, and they're stacked by species—walnut, cherry, white and red oak, maple. They're graded before they come here, and then there are men who walk around the yard and grade them a second time. The lower quality logs are marked with blue ink, for export. There are mounded burls, like mushrooms.

The logs go into a machine outside the mill that removes the bark so they're white and shivering when they disappear into the sawmill. The bark goes into a mulch truck, all of the byproducts are used for something else. I'm still thinking about World War II, and, watching the naked logs move along a chain into the mill, I remember that the Final Solution was an industrial one.

Maybe it's because there's so much violence in a mill.

You step inside and there is in fact the screeching and thunder, the horrific sound, and steps that are too far apart made out of iron filigree rising up into the air, to a catwalk, and you walk up the steps and can always see what's going on right under you, and it's terrifying. I never want to go in a sawmill again, not ever.

Two and a half million square feet a day, the pale logs are loaded on a machine that runs on rails, so when you're standing on the catwalk it's like looking down onto subway tracks, with that same rush of the train, only this time it's a log that rushes toward you on the tracks, with red laser beams pointing out where the log is to be cut and a sawyer sitting in a room above you, like playing a video game and pointing the laser and then the horrible sound of the blade squaring the log. It all happens so quickly, with so much sound and violence, and you're standing on the edge and right below you is this enormous blade and the wood and the tracks and you think of Anna Karenina and subway suicides and you just want out of there.

The log is cut into four pieces and then banded back together.

And outside the mill there's a polebarn filled with ovens, over here in this large warehouse, and it smells like vinegar and pitch. You look down into enormous stainless steel vats where the logs steam in their own juices, a blue-black tarry group, like dark swimming pools, twenty-six of them, kept at 190 degrees to heat the moisture that's there inside the log, to soften the wood, like warm butter, for slicing. Every kind of wood cooks for a specific length of time. And then someone planes the outside of the log to remove the dirt and grain.

And I'm thinking of hospitals, of the way you're wrapped in gowns, naked underneath, moving through the industrial hospital hallways into surgery, in the part of the hospital that's all function—no wood paneling, no pleasant rural prints, no statues of saints—the operating room and everything leading to it is a factory. It's mass production, a process broken down into its tiniest parts and performed by specialists. Thank God for window curtains and doilies and pictures of our children and last summer's vacation and your grandmother's hand-crocheted afghan, for everything that's not functional. The log is cleaned and heads into the knife blade. The log moves up and down and the blade remains stationary. It's sliced into sheets like a potato or an onion and each sheet is stacked in sequence then, like collating a book, because the thing about veneer is that you can match it, you can make a pattern, like with tile or wallpaper, or a clone.

There's a woman whose entire job is to flip each sheet individually onto a dryer that sucks it up against itself and then drops it down on the other side, where there are two more women who stack them once again in order. Everything is stacked into sheets and then checked, like tobacco leaves. They pull a sheet from the top, the middle, and the bottom and grade them once again. Again, like tobacco, the price will be different between one log and another. The buyers come here and they haggle, like a market. There's a part of this manufacturing that can't be controlled, the design that appeared over years of growth, and that means the price will vary.

The slices of veneer are soft and pliant, like a fish.

When the veneer is dry and flat, it's stacked in a warehouse in containers like giant flower presses. And then it's sold. And some is shipped to companies you'd recognize from the Price is Right—to Broyhill and Thomasville and Drexel. And some is exported. The ration is about 50-50, Jerome tells me. The other Edinburgh mill is primarily export now. And so it goes.

Come have lunch, Mr. Grunewald says, and I say that no, I really couldn't. You have to eat, he says, it will save you time on the way back. I have to pick my son up from school at 3:00, but there's probably enough time to eat lunch and see the factory, so I thank him and we head past office cubicles and down a hallway.

Edinburgh, Indiana, with its brooding church and graveyard on the highest point, a town so small there isn't even a fast food strip or Subway sandwich shop, and he takes me to a modest lunchroom, maybe eight small tables

without cloth, and we stand in a short line for food. There's no place to eat in Edinburgh, he says, so there are local women who cook and bring the lunch each day. He asks if I'd like a glass of wine with lunch, or beer. He asks other people in the line around him, and they decline, not today, but thank you.

I love that this is the outgoing president asking secretaries and salesmen and women and clerks if he can serve them. In most small businesses like this, there's much less of a bureaucratic hierarchy than there is in the university, which is in many ways like the army, where adjunct faculty, faculty and staff seldom socialize in the way that a colonel doesn't have lunch with an enlisted man. It's unstated in a university and so in many ways more troubling.

The food is rare prime rib with several kinds of sauce and vegetables and homemade rolls and tea and fresh-made lemonade.

We sit next to a Chinese woman who's in charge of sales to China. He offers us an espresso or a cappuccino. She takes cappuccino and he walks across the room to get it for her, and for himself a triple espresso as thick as Turkish coffee. How's it going now? he asks her. They're on holiday this month, she says, but sales are good. This is the year of the rabbit? he asks. Yes, she says, the rabbit.

What do they do with American veneer in China? I ask, thinking of Chinese children my daughter's age playing Chinese instruments coated in exotic American oak, some kind of instrumental Chinese postmodern fusion, like Thai/Mexican/French cuisine or the jazz/rock/Indian/Scottish highlands/country sounds of bands like Vast or Dave Matthews.

They put it on musical instruments and furniture, she says, and they send it back here.

Say what?

They send it back here, she says. The workforce is much cheaper, so the veneer is sent there to American companies hiring Chinese labor and then the furniture is sent back here and to Europe.

Wouldn't it be cheaper to save the costs of shipping? And what about robots and automation? Wouldn't that be cheaper if labor costs are so high?

A furniture company can hire twenty people in China for less than hiring one person here, she says. And it's cheaper to pay shipping and hire the human labor than it is to incur capital costs and buy expensive machinery.

They make the veneer here. They have the expertise. Whole logs can cost as much as $4000 to ship. You're paying for a lot of excess when you ship a log—for the bark and corners. The furniture factories in the United States buy the best veneer for top of the line furniture, but you're paying in some ways for the labor. The American companies in China buy the lower quality veneer, manufacture the furniture cheaply, and ship it out. It remains lower end furniture.

In one case the veneer is in fact more of a cosmetic. In another, it's an element of design, like paint. It depends on the skill of the manufacturer. It depends on what's hidden underneath the surface and how well the furniture's constructed.

There are mall export stores that sell relatively inexpensive cherry-veneered furniture. You know the stores, the ones that play on the language of British colonialism, a language of power and wealth, of imperialism. You're buying an historical allusion, to something exotic and foreign and expensive, filled with mosquito netting and butterflies. It's an allusion that is of course an illusion, one that hides another history, of violence and misunderstandings and, through an inability to see whole groups of other human beings as real, is the origin of much evil, most natural and moral. You're paying, in this case, for a mask. You're paying for veneer. In both the history alluded to, and the present one, the veneer is hiding similar truths.

It's a face mask made by the Dan people from the Cote D'Ivoire. It's made of wood and pigment, iron, copper, monkey fur and felt, of cotton thread. The monkey fur is used for a giant mustache and beard under a straight-edge nose and Modigliani eyes. The wearer of the mask sheds his human nature and speaks with a spirit voice, with that authority. "The Dan believe," according to Diane Pelrine, "that all masqueraders are the physical manifestations of spirits who live in the forest and were its original owners."

The craftsman who carved the mask saw the spirit first in a dream. Incarnate me, the spirit says, and the craftsman does as he is told. He builds the mask around the spirit. The wood and fur and felt and copper are formed around him, pressed like clay, the artist can feel the spirit in his hands in the same way, I imagine, a mime finds the wall or object in space as though it's something solid that he's come upon. The materials are pressed like stickers on a suitcase, like that, and it's an outward, visible sign of something holy, that work of art, and it's worshipped with offerings of blood and egg and kola nut and there's still that patina of offering on the wood.

Where did this artwork come from? He whirls a hidden compartment in a burled maple wardrobe and takes a book from underneath some other objects, and he gives it to me, a gift. It's a catalogue from a show at a museum. *African Art from the Rita and John Grunewald Collection.*

We were on the trade route, he says, quite by accident. Decades ago, sellers brought these works to motel rooms in Bloomington. He was attracted, he supposed to the use of the wood. In Europe, veneer was accepted earlier in the nineteenth century because there it was a craftsman's art. "It wasn't a question of cost," he said, "it was a question of design, of beauty. If there's a good match, a pattern, it's usually veneer."

NONFICTION

In the United States, veneer had more to do with practicality. It was mass produced, a way of conserving resources, not at first for conversation's sake, but for maximizing profits.

Grunewald is from Hungary, from a family of fine wood craftsmen. His uncle, I'll read later, was the finest veneer craftsman in Europe when World War II broke out.

Grunewald majored in philosophy and art history in college. Is the aesthetic experience of grading wood similar to that in collecting art? I'm trying to get at something but am not sure what it is quite.

Maybe it's some spirit, some dream I'm having here in the veneer capital. It's not the same, he says. And how is it different? One is an artistic idea, he says, and the other a question of discovering a pattern. Is it meaning? I ask, and he says no, that art doesn't always have meaning either. One is man-made and the other is nature-made, he says. Money doesn't influence the looks of the wood. What man can do is to open the log in a certain way to discover what is there. You can't tell before you open it, and you have to open it correctly. It's like cutting diamonds. You have to do it right. Some logs, no matter how you open them, there's nothing there.

Where were you when World War II started, I ask him, still thinking of the army camp outside of town, of the displaced farmers. I was a child, he said. I was sitting in a restaurant in France, having breakfast.

I looked up, he said, and I saw the waitress crying. And then my mother was crying. I asked my mother why are you crying? We were vacationing in Normandy. We went back to Hungary but couldn't return through Germany.

And what did you do then? Just tried to survive, he said. Just worked to survive.

His uncle was a lucky one, was able to come to the United States. Grunewald's family was Jewish.

John Grunewald was still a boy when the war was over. He was fourteen years old. My uncle, he said, sent a smuggler to Hungary to get me. It was very difficult to get out from behind the iron curtain, but here I am, he said. In Edinburgh, Indiana.

I don't ask him what happened to him during the war. I know the history of Hungary. Up until 1944, the Hungarian government protected the Jews. In that year Eichmann tried to barter Jews for money and goods from the Allies. At one point he offered 350,000 Jews for 2000 trucks. The Allies refused. So Eichmann deported all 350,000 of Hungary's Jews to Auschwitz. 250,000 of them were gassed within two months.

When his uncle brought him to the United States, he sent him to good schools. In college, he majored in philosophy and art. One decision leads to another. He ended up running a veneer mill in Edinburgh, far away from Hungary. He says everything with sincerity, as though each moment is filled with equal parts pain and sweetness.

Does he think about philosophy as he works? No, he says, I think about where I'm going to find logs, what I'm going to say to politicians the next time I travel to Washington.

Who were your favorite philosophers? I ask, realizing I can't stop, that I'm still looking for veneer, that I'm an academic and I want to hear a veneer salesman in southern Indiana say the words Kant or Hegel and he says Bertrand Russell and Bergson, and it makes me happy. This place is mysterious and beautiful and strange and civilized in a way that's much deeper than veneer, as mysterious and beautiful and strange as virgin forest, as human survival, as the ability, after everything, to love anything that man has made. Every place is so filled with human history that you could study it your entire life and never get to the bottom of its sadness.

© Eileen Wolford, *The Heartlands Today*, Volume 1, 1991

Nonfiction

Laugh Solitude to the Bone
-for Ben Gulyas
Maj Ragain
The Heartlands Today: Midwest Characters and Voices, Volume 9

Spoony Paine walked and talked the streets of Olney, Illinois, my hometown, in the mid '70's. He was one of the last river rats, those solitary men who lived down in the bottoms, half wild, uncurried. Word was Spoony took up lodging in an old school bus, down by the Little Wabash. In the good weather, he'd walk along the tracks, just appear out of the weeds and skulk around town, muttering and cursing to himself, kicking at things that weren't there. Folks knew him as a kind of crazy uncle, a lone survivor crawling out of a bomb crater, a post-Apocalypse cockroach man, everything the town tried to chase off, come back, Rumplestiltskin returned to marry your favorite sister and piss in your bird bath. Passersby taunted him with "Hey, Spoony." He'd shoot a fist in the air and never look up. High school yokels made a game of cursing him back in his own voice, a guttural "God damn... raw rum rumph." That made him furious. It's a wonder he didn't grab an ankle and tear himself in two.

The Town Talk Cafe, on Whittle Avenue, is a block from the county courthouse. Over the noon hour, it was jammed with lawyers, clerks, retired preachers, old ladies with hard hair, Olney's working hoity-toity. In came Spoony, one day, the hungry troll, who pushed his way to a corner table. Nobody wanted him there. Nobody wanted him anywhere. The waitresses ignored him, in his five pairs of socks and funky as old headcheese. Spoony finally grabbed an empty coffee cup and banged it on the table, a slow drum beat. And, in a gravely singsong, he demanded "Bring me some God damned chicken." Folks began to rustle and leave. He got his chicken, fast. He was unwelcome and didn't have a plug nickel, but he was a ripe man who cried out for what he wanted.

The lesson wasn't lost on me. Bang. Bang.

The bad winter of '76, Spoony got a job, house-sitting while the snowbird couple went to Florida. They thought they'd do him a good turn. Spoony was to look after things, fair trade. After Christmas, the pipes froze because Spoony opened the basement doors for the dogs that followed him around. The sewer backed up. He moved to the kitchen to keep warm, slept by the oven with the door open. By late winter, he never left the kitchen and, to simplify his life, he took to shitting in the pots and pans. When one filled, Spoony'd put on the lid and look for another. The first warm spring day, that river rat walked out the door into the sunshine. The owner hunted Spoony for months, said he'd kick Spoony's ass up between his shoulder blades, tie him and drag him behind a truck. Spoony had a way of going where you couldn't find him.

Last time I ever saw Spoony Paine was in the Red Door Tavern, Newton, Illinois. I was sitting at the back table with a beautiful redheaded woman, honeysuckle dream of my fading youth, her eyes playing on me, me drinking a bottle of cold beer, glad to the brink of fear. In came Spoony through the back door. He spied me, pulled up a chair and got in my face, I remembered how he got his chicken. I bought him a beer. It still wouldn't make him as happy as I was. He was looking at me with his Jack Elam walleye, then at the woman. Then, he leaned closer and growled, through his gumbo teeth, low, between the two of us. "If I was all boogered up like you, I'd walk in the river and drown." I hunched down my shoulders, squinted my left eye and, in my best Spoony voice, growled back, "Spoony, you're an old son of a bitch and I hope you live a hundred years." He grunted, eyed the woman again and asked, "You give me a ride back to Olney?" It was about twenty miles. I told him, "You better start walkin, Pilgrim." I turned to Mary, then back to him. He had vanished, no other word for it. There is not another word for it.

I never liked Spoony Paine. I wanted him to be alive in the world with me. That didn't mean I wanted his company. This time I was the guy with the girl and the beer. He told me the truth. Whatever happens to him, happens to me. Sometimes, I hear his song in my head.

*Spoony Paine was a son of a bitch,
whipped his kids with a hickory switch.*

NONFICTION

CARHOPPING AT THE CHARCOAL
Helen Ruggieri
The Heartlands Today: The Real Work Volume 11

My mother was so tight with a buck and I got so tired of trying to weasel money out of her for the necessities of life (sundaes, *Mad* magazines, Sandler of Boston shoes, white wool socks) that I got my working papers when I was fourteen. It was easier.

In May someone told me the guy who owned the pool hall up on the corner of Main was opening a drive-in restaurant up on the highway, so three of us went up and applied. We got hired. Carhops. The ultimate fifties job.

The Charcoal opened with great fanfare, the first local drive-in. The owners, the Picox Brothers, had a reputation. The pool hall, the one you crossed the street to avoid because all the hoods lounged out in front smoking and calling out rude comments about parts of your body, was off limits. It was forbidden entry. If someone saw you going in or coming out, it was all over town. However, The Charcoal was brand new, resting on a built up piece of fill that dove down toward the valley. The Charcoal featured burgers and hot dogs done over a charcoal pit. Wow—buttered hard roll, fresh chopped onions and chili sauce, root beer in frosted glasses from the Hires barrel, real potato fries. Burgers were a quarter, hotdogs twenty cents.

The Charcoal was a typical drive-in (or it came to be typical, but we'd only seen them on TV) with a slanted roof dropping to the rear and a glass front that looked out on traffic passing on Route 6-11, a dark three lane strip of asphalt heading south to Scranton and north to Carbondale.

We wore ridiculous pink and black outfits—black shorts, and a pink vest with black piping and a pink and black round hat like an organ grinder's monkey might wear. We walked over to the cars, took the orders and handed them in at the outside window. We picked up the orders and delivered them on special trays with a hinged arm that rested on the car door.

We'd sit outside on a bench and talk between customers, answering the blinking headlights that called us. At closing, about midnight, we'd go in and get to order whatever we wanted for free. We'd have hot dogs burned black with onions and chili sauce, chocolate milkshakes (made with real ice cream) and a piece of the cherry cream cake that the Charcoal was famous for. After we'd eaten, Joe Picox, the owner, would give us a ride home in his rust color Cadillac El Dorado with fins as tall as we were. We'd go home, count our change (we didn't ask him to change it into dollars because then he'd know how much we made and reduce our pay). That's the first rule a waitress learns—never tell your boss how much you make in tips.

I'd go upstairs and dump my change on the bed and pile up the quarters, dimes and nickels, and smile like Silas Marner at my hoard of gold. That was almost the best part, the piles of change adding up on the chenille coverlet. My father had gotten me wrappers from the bank and I'd pile roles of quarters, dimes and nickels on my dresser and then pass out.

The problem was school was still in session. I could manage to get up at 7 and do the morning classes, but after lunch it became harder and harder to stay awake. The sun came in the windows on that side of the building and it got warm and as hard as I tried to stay awake, no deal. I'd slump into sleep, a half doze you could start up out of quickly if called upon, but deep enough that you didn't have a clue about what was going on. I managed to wangle some time off to study for finals, but I'm ashamed to say I mostly slept. I really can't understand how my mother let me take that job. Well, she was glad I wasn't bugging her for money, but I have absolutely no recall of anything that happened during those last two months of school.

I remember standing on the blacktop parking lot in the dark waiting for the blink of headlights calling me to pick up the tray. I remember huge moths as large as birds that circled the lights over the parking lot, faces framed in windows, the smell of grease and burning charcoal.

I was in the chips, I was banking it. I was having a good time, eating well, meeting guys. There were many opportunities to meet guys, and guys with cars, at the most popular drive in midvalley.

Unfortunately, I had to put up with the Picox brothers. The elder, Joe, the brains of the business, fancied himself quite a lady's man. He was forever slicking back the sides of his D.A. and adjusting the curl that hung dead center over his forehead. He was always well dressed, or what passed for well dressed then—dark pegged pants riding low on the hips, suede shoes, a formal long-sleeved white shirt unbuttoned two or three buttons, a plaid sport jacket. Joe had two young children and a pleasant, pretty wife on whom he cheated with the worst bimbos—bleached and plucked girls, who were on the prowl around the pool hall.

Joe's younger brother, Stanley, was the cook. Stanley just wanted to assault the waitresses—that we were only fifteen didn't seem to make much difference to him. One week out of each month during the summer you had to work days. Days were slow and we shared them out. Everybody hated the day shift because you were up there alone for most of the afternoon with Stanley. Stanley

NONFICTION

was Joe's opposite. He was short and stocky. His hair was fine and thin, plastered back over his round head with Vitalis. He stuffed food into his mouth and seemed to swallow it whole, crumbs and bits dropping on the front of his shirt. He always wore kitchen whites and there was always a trail of meals down the front. He had small light colored eyes and was always watching you from under lowered lids that were creased as if he'd stolen them from some animal.

"C'mon in here," he'd say, "I got somin ta show ya." He'd have a big cooking fork stuck under his wrap around white apron so it looked as if he were hiding a ruler.

"Get lost, Stanley. Ugh!"

"You don wanna talkta me like dat or I'll fire ya."

"Go ahead, fire me. I'll tell Joe." Joe was the only one he was afraid of. He wasn't afraid of the waitresses. He'd grab you by the hair and try to pull you into the shed where they kept the garbage cans or drag you behind the counter. You always had to keep yourself positioned between him and the door.

We'd get together and complain to Joe and he'd go yell at Stanley, "Leave the girls alone!" Stanley would be cowed for a few days, and then he'd start again. You didn't dare go inside for fear of being trapped in the kitchen. You couldn't even reach in to pick up something from the outside serving window or he'd grab your arm and hang on.

Oh, Stanley, Joe. They taught us what we needed to know about men, about how to handle them, so they wouldn't handle us. Sexual harassment? No, it was the way things were. You put up with it or you left.

But the money was good and there was a certain glamour about it, about being an adult, a woman. Driving through the dark streets at two a.m. on a Sunday morning with the top down on Joe's El Dorado, the change jingled in my pockets, the humid night air caressed my hair. "That Old Black Magic," by Mr. B would be playing full blast; it was Joe's favorite tune that summer. Music filled the wind around us and we would all sing, "has us in its spell, that old black magic that we know so well." We were learning that girls who played up to Joe got the best sections and those girls who complained the most about Stanley eventually got fired. We learned how to do a job, and how to keep one; and the onions, so sharp they brought tears to your eyes.

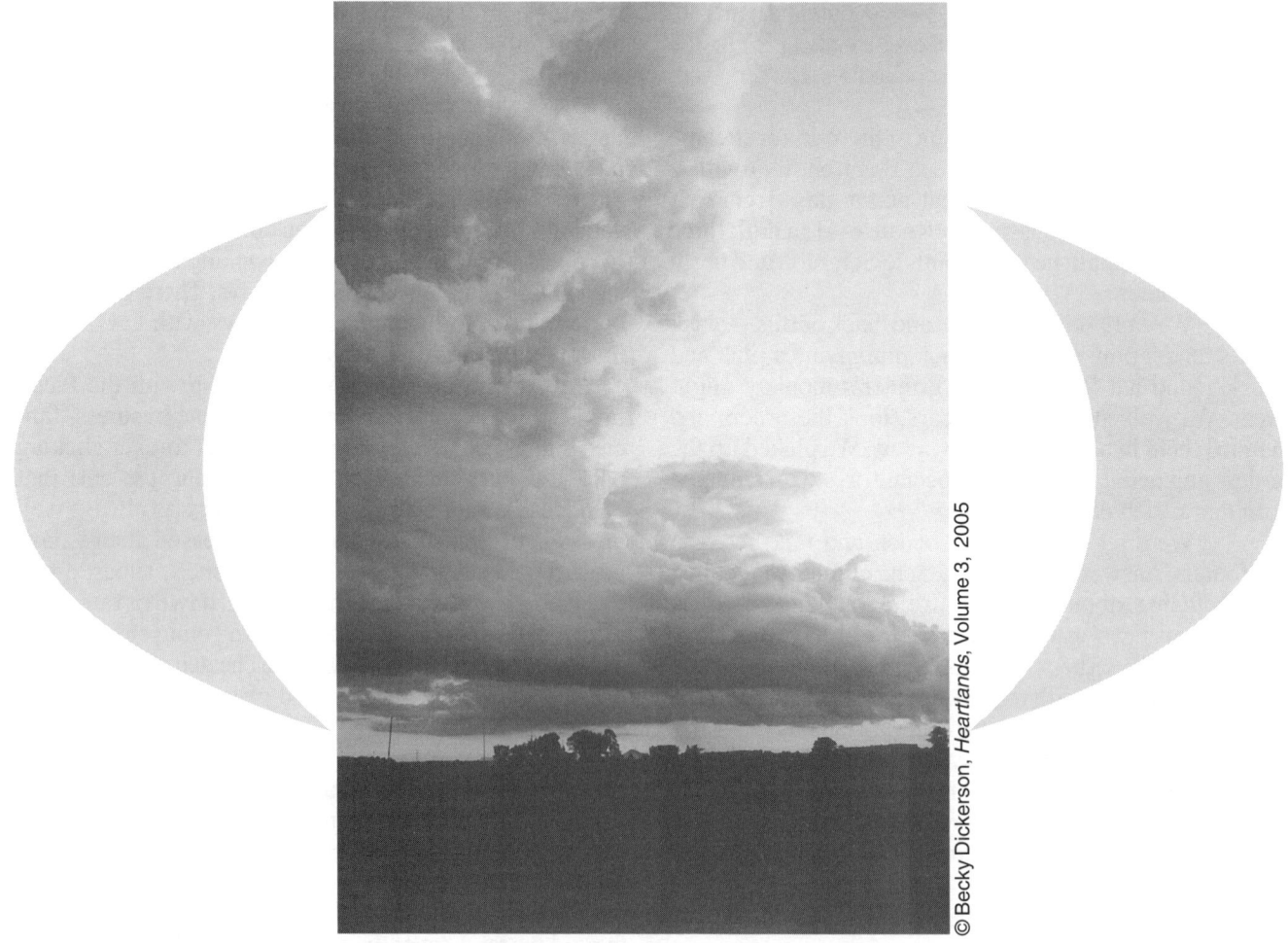

© Becky Dickerson, *Heartlands*, Volume 3, 2005

◆◆ NONFICTION ◆◆

JACKIE AND THE TRACKER
BONNIE JO CAMPBELL
THE HEARTLANDS TODAY: THE REAL WORK, VOLUME 11

She says she feels like an animal in a zoo. People honk their horns in greeting, but she rarely bothers to wave back. Jackie openly expresses her distaste for the bored housewives who come daily to rally in support of her. "Dumb bitches," she scoffs as they return to the parking lot to get into their Ford Tempos and Chevy Cavaliers. Food is free, but Jackie accepts only sandwich bags of ice cubes to supplement the crackers and carrot sticks brought by friends. She doesn't like the book she is reading, but she hesitates to ask for another one. Only rarely does she talk to the man sitting next to her, the man with whom she has spent every waking and sleeping moment of the last twelve days. All in all, Jackie Dillon is getting kind of cranky.

Jackie was a finalist in a drawing held by a local rock-and-roll radio station, WRKR, which made her eligible to win a Geo Tracker, a sort of small, Japanese jeep. With much fanfare, the four finalists were packed into the vehicle. The one who would remain in this "Geosphere" the longest would win the vehicle. The contestants get a ten-minute break every six hours, at which time they are allowed to get out and move around, go to the bathroom or wash up in buckets. The rest of the time, however, contestants remain in the Geo Tracker, sitting upright, seat-belted into position.

This particular vehicle is called the "Geosphere" to suggest an analogy with the Biosphere II, out in Arizona, where a handful of people sealed themselves and necessary supplies into an airtight bubble. The Geosphere is like the Biosphere in that everything that goes into the Geo with the contestants, stays in the Geo. If Jackie's boyfriend John brings her a packet of crackers, the plastic wrapper stays with her in the jeep; if he brings her a book, it stays, whether she enjoys it or not. Each contestant holds a bag of belongings—a change of clothing, pens, books, tapes, a radio, whatever—and a bag of accumulated garbage. Those who accept the free food from McDonalds, provided in generous quantity, must accept the bag complete with napkins, paper wrappers, etc. No one except the disc jockeys on duty may hand the contestants anything, either while they are in the car or during the breaks.

This promotional gag is being hosted by one of our local car dealers, who is giving away the prize vehicle. The Geosphere sits under a canopy in front of the Denooyer Chevrolet/Geo dealership, in full view of everybody cruising by—thus the honking. The list of rules which contestants must follow is fairly strict: no smoking, no standing, no vomiting, no lewd behavior, no diapers, and no driving. Participants must enter the vehicle in clean clothes. Contestants will not be allowed to verbally or physically harass other participants in the vehicle. Every six hours, after the ten-minute break, the passengers rotate positions in the Tracker, clockwise.

"It's hot," says Jackie, fanning herself with a copy of the *Weekly World News*. "Bo-ring," both syllables drawn out, is her most frequent refrain; her favorite gesture is an exaggerated roll of the eyes, usually in response to people yelling from their cars. By the eighth day, the number of competitors had dropped from four to two. The first guy, an unemployed burger flipper, had only lasted a day; the second loser was a young unemployed mother who Jackie had told us kept committing minor infractions—she stood up after spilling her coke; she was careless with her personal garbage. Jackie says she knew from the beginning this gal was doomed to fail, and on the eighth day she woke from a nap, nauseous from the ninety-five degree heat and late morning humidity, and she stumbled to the port-o-john to throw up, which is in clear violation of the rules. When those two left the competition, unfortunately, their garbage stayed in.

Jeff is Jackie's sole remaining competitor. Jeff weighs about 325 pounds and spends his time contented and zombie-like, staring straight ahead and listening through ear-phones to his Walkman. His ankles have swollen up to the size of muskmelons from inactivity. On break when he gets out of the car he can hardly move—he walks stiffly, as though his legs were made of wood. I was horrified to discover during one break, that after sipping iced tea for six hours, Jeff does not even go to the bathroom, but just takes a few strides around the vehicle and stretches. When I express sympathy for Jeff's huge, ugly fruit ankles, Jackie rolls her eyes, as if to say that Jeff has the wrong competitor if he expects to reap any advantage from such an obvious sympathy ploy.

For a while it seemed that Jeff was going to be a tragic figure. After six days in the car, Jeff's boss came to the Geo-site and informed Jeff that he was to return to work the next day, or else consider himself fired. Jeff informed his boss, on the WRKR airwaves, that he would, then, consider himself fired. At first I had thought it curious that the two unemployed contenders dropped out of the competition early, and that these people with jobs have stayed on. Jackie works at a gas supply house and stayed on; then it occurred to me that if one can endure sitting in a small car with strangers for a week and a half, one can probably endure all the indignities and inconveniences of holding a steady job. Regarding Jeff's job, however, Jackie told us that the "firing" itself was actually a staged event, calculated to build sympathy for the big fellow. Needless to say, if it was gauged to impress Jackie, it was for naught.

Jackie has told me that she thinks if she can just win this Tracker then she can sell it and get ahead money-wise for the first time in her life.

Jackie's ankles are looking slim and pretty. When she gets her ten minute break, she heads immediately to her personal chem-toilet (the one with her name on the door.) When she returns, she smokes two cigarettes in succession as she jumps up and down and kicks her legs around. Then she rinses her hands and face in a bucket and combs her hair. Despite the fact that she hasn't seen a bathtub, shower or sink for two weeks, she looks pretty darned good. Her boyfriend John tells me not to say this to her, however, because she'll think I'm being sarcastic; she might get mad, throw something at me from the Tracker, and thus be disqualified.

Being in the Geosphere is probably something like being in prison and something like living in a submarine or a bathysphere. Except that, when you are in prison, or under the ocean, you are not roused at 2:15 a.m. by drunk people who got kicked out of bars and who are looking for more entertainment. These voyeurs are kept at a distance by ropes encircling the Geosphere. The ropes, along with the tent canopy, the buckets of water, and the flattened grass, lend the spectacle the aura of a carnival exhibit—like the site of the world's smallest horse, largest pig, etc. The disc jockeys prevent the late night drunks from poking sticks at the Geospherians or throwing food at them. Jackie would probably really appreciate the beers they sometimes offer, but alcohol is against the rules.

On-lookers all ask the same questions. Jeff just stares ahead, disinterested, but Jackie still occasionally deigns to answer. How long have you been in there? How long are you going to stay in there? Do you get to go to the bathroom? Did Scotty "Bud" Melvin (a favorite morning disc jockey) really moon you guys on Friday? I try to find a silver lining to her cloud; I ask, "Don't you enjoy not having to do dishes?" She replies: "I don't do dishes anyway. John does them." "What do you miss?" I ask. Her house, she says, especially her shower.

On Wednesday, day twelve, southwestern Michigan is stricken with severe thunderstorm warnings and a tornado watch. The wind blows so hard that it pulls several tent stakes out of the ground. After reporting this, the radio station actually goes off the air due to a localized power failure, cutting us off from information about the fate of the Tracker Troupe. As branches crash around my house and the sky turns a tornado shade of gray-green, I become uncontrollably curious, and I brave the elements to drive out to the Chevrolet/Geo dealership to see what's going on. I find no tent, no Tracker, no Jackie. I wander around until someone directs me to a garage.

Apparently, the powers-that-be have decided to take the Geo and passengers inside the dealer's service garage, so Jackie and Jeff will spend the night indoors. It is kind of disappointing to find them safe and under cover. I had looked forward to seeing them seat-belted in position, withstanding the sixty M.P.H. winds and the branches flying all around them. Jeff would be staring straight ahead, while Jackie sneered at the storm. Perhaps, then, the wind would have blown hard enough to sweep the Tracker into the air and suck it into the center of the tornado, where it would be spun around and whipped like Dorothy and Toto into an alternate universe, to the land of Oz or wherever. I ask Jackie what she thought about the prospect of being in a tornado. "That would have been interesting," she says, almost cheerfully, "A tornado. That would have really been something."

Epilogue: On day fourteen, Jackie was disqualified for smoking in the Geo. Well, she wasn't actually smoking. ("They just wanted to get this damned contest over with," she says.) The on-duty disc jockey said, "Ten seconds 'til break's over," and Jackie jumped into the jeep as she was pinching off the burning end of her cigarette in order to store the butt with her other garbage. So Jeff won the Tracker. As you might imagine, Jackie, who has just used up this year's vacation from Amerigas Corp., is really pissed.

❖ PHOTOGRAPHY ❖

PHOTOGRAPHS BY EILEEN WOLFORD

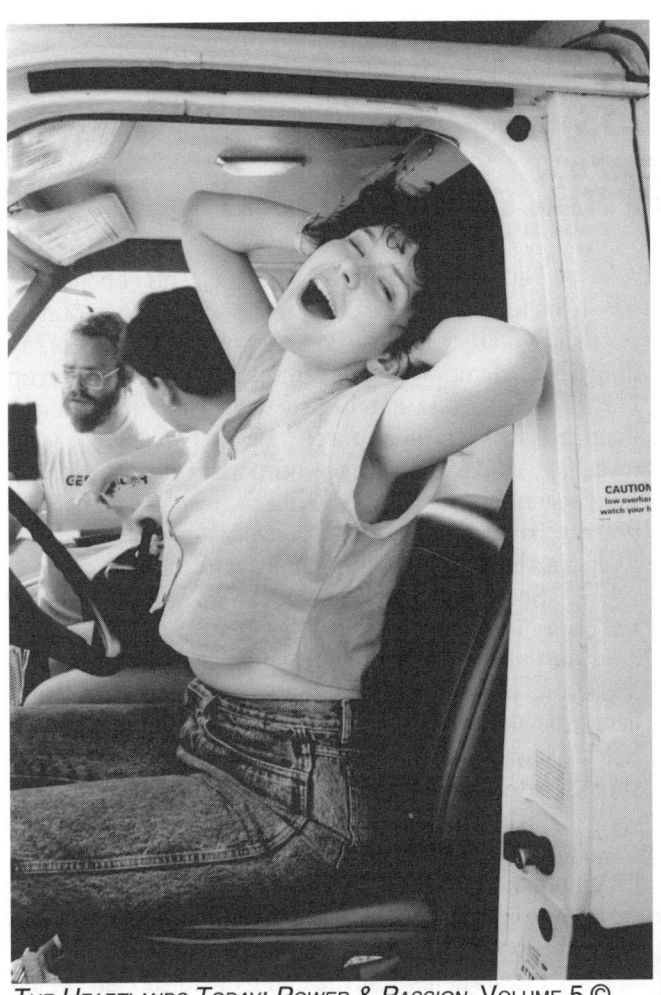

THE HEARTLANDS TODAY: POWER & PASSION, VOLUME 5 ©

THE HEARTLANDS TODAY: POWER & PASSION, VOLUME 5 ©

CARLOS
Pat Temple
THE HEARTLANDS TODAY: THE REAL WORK VOLUME 11

In one of Carlos's recurring fantasies, he blows up the building and kills the entire faculty of our grade school. "I like a couple of you," he tells me, "but you're gonna have t'die with the rest. It can't be helped."

We study each other's noncommittal faces for some sign of a reaction as we sit at the reading table to talk it over.

"Why? How are you planning to kill us? "

"I'll get dynamite, and after school when all the kids'r gone, I'll come back and blow the school to bits." His voice trembles, "The teachers'll still be here. You'll be here. You'll die too." He pauses, "Books and blood will be flyin' everywhere. . . Sometimes good people have t'die so you can get the bad ones." Again he pauses. "Nobody can do nothin' about it."

"Where will you get the dynamite?" It's always best to be a little cautious. "I can get it." His voice falters, "Where do you go t'buy dynamite?"

"I don't know either; I doubt if you could just go pick it up at the hardware store. Maybe you need to have a license or something."

He nods. A license makes sense to him. It's a serious thing buying dynamite. It dawns on me that I have never seen him smile. I am his third grade teacher, and for some dumb reason, it pleases me that of the people he's planning to kill, I'm among the ones he likes.

Our school social worker is from Chile, a complex cataclysmic land with frequent earthquakes and revolutions. In Chile magic fuzzes into real without a warning, and spirits have their own agendas. "Oh that Carlos," she says, "He is such a beautiful child. His thin frail mouth and his delicate cheek bones, his impassive impenetrable eyes, those are the eyes of a mystic."

To me though, his face has the innocence of a kitten's. A cat knows no guilt. If it knocks a figurine off a shelf or kills a nest of robins, it's nothing to the cat. It would claw the most doting owner if she tried to rescue it from a fight. The pain to the birds and the owner, the value of the figurine, lie completely outside anything a feline cares about or comprehends.

The social worker is my friend. I tell her the things Carlos says. We can't ignore his remarks altogether and still pass for responsible people.

She talks to him in her soft Chilean accent while the two of them play checkers, "Now Carlos, you know you aren't really going to blow up the school. You're just being silly, aren't you?"

"Yeah," Carlos agrees, and she sits a little taller until he adds, "But someday I might have to."

She tells me he's confused, so confused.

I listen to his whispery voice and worry about what lies in his future. Sometimes you can see disaster coming, but there's nothing you can do to stop it. I hear teachers say things like, "I knew way back in second grade he'd end up like this," or, "You can tell early who'll amount to something and who'll end up in prison." Before I became a teacher myself, I would wonder why someone didn't intervene. Now I understand. A teacher can't fight the whole avalanche of poverty, bad parenting, drugs, greed, history, all by herself. Even with help the outcome remains uncertain.

Sometimes Carlos comes to school early to help me pass out papers. "When I grow up I'm gonna be a cop," he tells me, "I'll fight bad guys and put 'em in jail, and if one of 'em messes with me, even if it's my dad," here he shakes his head and purses his lips, "it's too bad, but I'll have to shoot him." There is a weariness in his shoulders too old for a third-grader.

"I'll have money too. Cops make lots of money. I'll buy shoes, Nintendo, anything I want and tulips for my ma. I'll git hundreds of 'em, and one night while she's sleepin' me and my buddies'll come and plant them all over the yard, and in the spring they'll blossom, and she'll be so surprised."

He sits at his desk dreaming of violence and blood over and over, and tulips. He loves their pure reds and yellows, so uncomplicated, almost the color of crayons. He keeps a tag inside his desk that he got off a mesh bag of bulbs Frank's Nursery and Crafts sent over to our school. Frank's is one of our business partners. They initiated a project to beautify our school by planting their leftover bulbs in all the bare places around the outside of the building.

The principal came to our classroom to inform us of the project, "Now boys and girls, they will be your tulips. I want you to help with the planting and then to care for them in the spring." She speaks like a bored tour guide, one who has lost proper inflection from repeating the same spiel over and over to thousands of tourists. I wonder how many times she has said, "Now boys and girls." "If it's dry now, boys and girls, your class will have to take them water."

"I'll do it!" Carlos rises out of his chair. The job holds great possibilities. A tulip waterer would have to leave the classrooom to go in and out of the building carrying important buckets of water. It would take a long time to water the tulips.

"I don't know if I'll be a policeman here or if we'll be in Texas," he tells me. " My sister lives in Texas."

"I never knew you had a sister."

"Yeah. She went there t'have her baby. My grandma's there. My ma talks all the time about movin' t' Texas. If we do, I'll be a marshal or a ranger, same thing as a cop."

"I bet you miss her. Would you like to live in Texas?"

"Yeah, I got a horse there. My grandma's keepin' him for me." His eyes lose their focus, and I know he sees something I can't see, perhaps himself galloping on his horse through some dusty Texas town.

"She had a baby boy. I'm the one who has to teach'im stuff. I'm the only man in the family, well except for my dad; anyway he's not allowed to see the rest of us."

I watch his face while he imagines himself as the baby's idol. He will have to be a hero and do brave things for him.

One morning he came to school with a welt on his cheek.

"What happened to your face? Does it hurt? On the side, it's all bruised."

"The little girl who lives with us hits me on the head while I'm sleepin'."

"What does she hit you with?"

"Anything. Toys, shoes."

"How old is she?"

"I dunno."

"Well, does she go to school?"

"Nah, she's too little for that."

"Is she some relative? A Cousin?"

"Nah. My ma met hers at Aldi's when we were buyin' groceries. The next day they just moved in." He shrugs. "They were livin' in their car. They got the bedroom so my ma sleeps on the couch now."

"I thought that's where you slept."

"Me? I sleep anyplace, on the rug, under the window." His shoulders carry the hint of a swagger.

"Does your mother know she hits you?"

"Yeah, but we need the money."

On the morning when our town was abuzz over the tragic deaths of three girls whose car was hit by a drunk driver, bloody car accidents were taking place inside his desk. "Oof! Bam! Man that one's over the cliff! Blood and bodies are fallin' out everywhere! People are screamin', Aagh! Help! The cop cars come. Whee, whee! It's the worst accident in history! Aagh!" All in his fragile voice.

His fascination with violence and death is also his unconquerable fear. He is haunted by the derangement and gore he can't leave alone. I worry over his infinite hunger for peace and security and tulips.

"I'm goin' t'have t' beat up on a few kids t'day to remind my enemies they'd better not mess with me," Carlos is heading outside for after-lunch recess.

One of the mothers who minds the children on the playground overhears him. "Oh no you're not, Young Man! There won't be no fightin' on my playground." She wears lots of blue eye shadow and red-black lipstick. She reaches for his arm.

Carlos pulls away. "Don't touch me. I'll poison the water. I'll blow you up with dynamite." He delivers his threats in asthmatic whispers while he holds up his hands to halt her.

"Git to the office!" She herds him inside.

The thing is he never beats up on anyone. It's all just part of the gibber that goes on inside his head, like blowing up the school or the traffic accidents inside his desk.

Our principal talks to him.

"Now Carlos, how would you feel if the other boys said they were going to beat you up?"

"Let 'em try, I'll smash their faces into the ground."

"Carlos, I'm not saying anyone is going to beat you up."

"If they're smart they'll leave me alone."

The principal rolls her eyes. "Carlos, no one here wants to fight with you."

"That's cuz they know I'd beat'em up."

The principal surrenders. They share no common reference point. "Carlos! Go to your classroom and behave yourself."

Sometimes I try to imagine what could account for his behavior. I know his life isn't easy, but children are resilient. Lots of them have difficult lives, and they manage to cope. I'm not pretending to be a psychologist or anything, it's just that I wonder.

Young children accept their parents' word for what is right and wrong. We've all heard funny stories based on the literalness of kid-logic, like my sister's little girl who went home with her mother's friend, even ate cookies in her kitchen, but refused to speak. When my sister asked her afterwards why not, she said, "You told me not to talk to strangers." Only later and gradually do children understand the reasoning behind their parents' rules.

But what if one time when you were naughty, say you snuck a cookie, they laughed and thought it was cute. Then the next time, they scolded you, or maybe burned you with a cigarette. Is it too far-fetched to think that a child raised like that might grow up never understanding right from wrong?

One morning before school started, the principal looked up to see a young policeman standing in her doorway. His alert gray eyes and military bearing projected the seriousness of his mission. "You need to clear the playground," he said, "The father of one of your students, Carlos Portillo, has been spotted circling the school in a yellow compact. We think he might be looking for his son. He has a gun."

The principal rang the bell for the students to come in, then walked down the steps to meet them. "Line up now boys and girls. We're going to let you wait inside today," —her tour guide voice.

"But we don't want. . ."

NONFICTION

"Just keep them away from the windows," she said to the teachers on duty.

Now the children understood. Now they crowded into each other, eager to get inside. A first-grade girl, like a tiny Pied Piper led them single file up the stairs and deep inside their school house mountain.

Carlos was the most attentive student as he manned a shovel for the planting of the tulip bulbs. The assistant manager at Frank's, a man in his forties with unkempt hair and wrinkled pants, made a joke of offering him a job.

That night, carrying a large slotted spoon, Carlos came back to the school yard to dig up some bulbs. He waited until dusk when the parking lot was empty except for the fireflies and the windows in the neighborhood's houses were beginning to light up. Then he made the rounds of the places where the bulbs had been planted, collecting a few from the various sites.

It might have gone unnoticed in the quiet of the hour if Alma and Leticia Rizo, who lived upstairs in a house across from the school, had not been caught speaking English by their father. "Not in my house!" he shouted, "No one speaks English in my house!"

Language rage, road rage, rage in the supermarket check out line, so many kinds of rages. He banished them to the bedroom where they sat on their parents' bed, saying mean things about him in English and looking out the window, and so they saw Carlos. Their little bodies trembled as they dreamed of morning and reporting their important information.

The principal called Carlos in to see her even before the bell rang.

"Did you dig up our tulip bulbs last night? Did you Carlos? I want them back."

"Too late, they're buried in our yard now."

"Then dig them up again!"

After school he returned most of them, whereupon she made him go out and replant them in the places where he'd found them.

The next day dead bodies were everywhere inside his desk. "Over here! Oh no, a little girl! Who could've done this? Dig here! My baby! My baby! Maggots have eaten this ones eyes!"

"What color tulips would you like, Carlos? I'll go buy you some after school." I tried to divert his attention.

"It don't matter. We're gettin' out o'here. We'll be in Texas by spring."

"But what if you don't go? You could plant them just in case."

"Oh, we're goin'. You can ask my ma."

"If it's what you want, I hope it works out." I felt such a longing to comfort him, "We'd miss you a lot."

"Too bad," the hint of a wrinkle was on his forehead, "Nobody can do nothin' about it."

"I know."

"It can't be helped." He shrugged his shoulders.

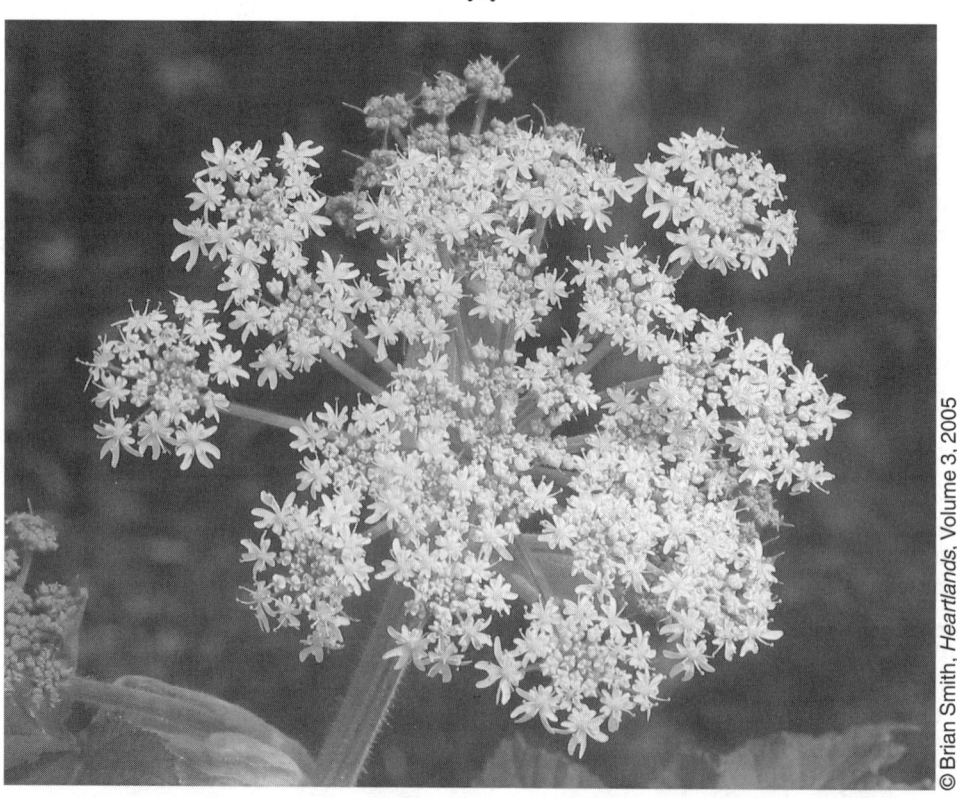

© Brian Smith, *Heartlands*, Volume 3, 2005

Many Strong Rivers, Or Thoughts on the Way Home
Jeff Gundy
The Heartlands Today: The Mythic Midwest, Volume 6

(1).

I've got the Streets of Gold Gospel Hour on the radio, I'm cruising along through northeast Arkansas, a little mist above the rivers but not enough to slow me down. I've seen an armadillo on the road, dead, I've seen a beautiful wildflower garden and in the same moment had a bird curl out and into my headlight, so that I heard the thunk and saw it on the road behind me. It's a beautiful morning.

I've crossed the White River, running fast and clear, twice in this first hour of my way home from the workshop. I crossed four of what must be irrigation canals, one right next to the other, running perfectly straight from northeast to southwest like someone took a big four-toothed comb to the earth. They must go to the Mississippi. They struck me as beautiful, too, in a very odd and formal sort of way.

I've been thinking about paths to the sacred, ways of approaching it. I've just heard Linda Gregg talk in her startlingly resonant and clear-headed way about seeking the sacred through romantic love, through sexual love, her conscious, passionate pursuit of the kind of relationship to another human being that could somehow remain in a state of permanent ecstacy, although she knows well the odds against that quest. Being a practical guy myself, and boringly monogamous for too many years to count, I have my own doubts. But that vision of some ultimate affair, of a relationship that would not slide into gentle, enduring love but stay at the first, white heat of initial passion forever . . . who can think of that and not yearn, some way? Who can hear a poem like this one and not yearn?

> Taken as an animal, she yields
> to that desire which devours.
> Happy in yielding her body
> to the other who wants this altering,
> the darkness he pushes her through.
> The two of them lost but alive
> in the land of death on fire.
> But another passion continues in her
> like a great wind, like birds curving
> and lapsing in the bright sky
> and returning to the dreaming trees.
> She tries to think in the sexual
> darkness they have become, and the dark
> inside that dark smelling of him.

("We Do This with Our Bodies," *The Sacraments of Desire*)

Hearing Gregg read poems like this one, and talk a little about her life, I had the thought that people like her are in the world either so that people like me don't have to live that way, or because people like me don't get to live that way. I wasn't sure which. I'm not yet.

On the other hand, I'm thinking of Jack Gilbert's poem "The Abnormal Is Not Courage," which turns away from the idea of brilliant gestures, toward the celebration of various sorts of sustained accomplishment, things that build over a long time:

> Not the marvelous act, but the evident conclusion of being.
> Not strangeness, but a leap forward of the same quality.
> Accomplishment. The even loyalty. But fresh.
> Not the Prodigal Son, nor Faustus. But Penelope.
> The thing steady and clear. Then the crescendo.
> The real form. The culmination. And the exceeding.
> Not the surprise. The amazed understanding. The marriage,
> not the month's rapture. Not the exception. The beauty
> that is of many days. Steady and clear.
> It is the normal excellence, of long accomplishment.

(*Monolithos: Poems, 1962 and 1982*)

(2).

What I think at first is road kill, and something big, a deer maybe, is just some hay fallen from a truck, what looks like a whole bale. As I go by I scatter it a little more, and everyone that goes by scatters it a little more. And right afterwards I come up behind a semi piled high with great big round bales, wisps of hay pulling loose and streaming off into the wind, scattering back like some stringy greenish rain, all the way down the road.

And that's just before I come to the Mississippi— "I do not know much about gods, but I think the river is a strong brown god." That was Eliot, of course, who never trusted the body or romantic love either one, but grew up in St. Louis, hard by the strong brown god. There are many rivers in this part of the world, many strong rivers. They run fast and deep.

Here's an idea, a hope: that living an everyday, frazzled, even frantic life like mine can also be a kind of spiritual discipline, a way of searching for the sacred and recognizing or seizing upon or opening yourself to it when it finds you in the midst of it all. And that in fact the sacred will find you in the midst of that life, if you can somehow manage the right stance toward it.

Well. I'm brooding on desire, on what chance there is of living in both the spirit and the flesh, and also brooding about whether I should rotate my tires.

Is it possible to recognize that your desire will never be satisfied, and come to terms with that, without becoming merely bitter or merely resigned?

(3).

Trying to learn the gods. Trying to learn what it means to worship. What else is worth doing?

Why did the troubadours write about women that they barely touched, or never touched? Maybe that was the only safe way. Maybe they knew that to touch, to take, to give yourself to the beloved is always to start down a road, and that all roads lead somewhere. Maybe they knew that not to touch meant never to take the road, only to look down it, and that looking down the road it does not seem to end.

What gets put into your shadow when you don't act on your desires? What gets put into your shadow when you do?

(4).

Here it is, here it is, Linda. Heaven, that's where romantic love will be unending, immortal. In heaven the lovers never part. In heaven the lovers never tire. They never go off to the bathroom . . . In heaven the lovers truly learn God through bodies, in bodies, and they remember everything they learn, so there is always another thing to learn. On earth we learn God too, but forget every time, we cannot make ourselves remember, and so we must learn the same thing over again and again, having forgotten, and it is only the first thing.

And then I remember a verse from Jeremiah. I heard a beautiful sermon preached on it long ago, by a man who resigned his position a few years later, admitting that his passions had taken him beyond what the church could allow in its servants. "Seek the peace of the city where I have sent you into exile, and pray to the Lord on its behalf, for in its peace you will find your peace."

(5).

And so I spend the morning cruising across America, feeling like the designated mind of God, desire and beauty and hope churning in my head until I'm dazed by more than the driving. I stop at a McDonalds somewhere and order the special of the month, what they call a hero burger, and sit down and watch the family across from me. There's a half-bald guy, quick-eyed guy in his thirties—he looks alert, not smart but alert. And a dark-haired, slightly heavy woman with him, a baby on her shoulder. She holds the child until it's time for her to eat and then gives him to the other woman who is with them, a grandmother I suppose. What kinds of desire go around in their heads? What would they say if I asked them?

Two young women sit down behind me and one says to the other one, "Do you think they'll ever get back together?" I can't hear the answer, but I hear her starting to explain, and I know it will take all through lunch. What are we doing in this world?

I'm sucking coffee from my cup until my lip is sore. Trying not to say things into the tape recorder. This is getting too long.

(6).

What do desire and the will have to do with each other? In five minutes I go from sunshine to a downpour, not because of anything I wanted, except to go along this road.

My people have always thought, always hoped, that if you wanted to bad enough, and had Jesus to help, it would be possible to be good, possible to make your desire flow within the banks if not to dam it up forever. And there's no denying that for some of them it's worked, or almost worked. And there's no saying what's been lost, or how much. Where do we get the idea that we are in control of anything? This may be the year, Thoreau says, that the water will rise within us, and drown all our muskrats.

The rain has stopped almost as fast as it began. Linda, your poems and the work you've set for yourself seem to me beautiful and true and dangerous, as everything that's beautiful and true is dangerous. What I really want to do is thank you. And to know more. And to see God as plain as the hills of Kentucky and as permanent as the hazy sky. And more. And more.

And an old white van crouches by the offramp with its engine irrevocably blown, surrounded in gray, oily smoke, like a huge, dirty cotton ball with a rock at the center. How quickly disaster finds us.

(7).

These are the Kentucky hills, so beautiful. How little I see of them even when I remember to look, how fast they go by, how much I miss. This is the body of the world. This is the trace, the dwelling of God, of the gods. Desire is the woven body of the world, there in every tree, every blade of grass, every wildflower and crushed armadillo. Here is the world, and here we are in it like pebbles so small we blow in the wind, like shards of cooking pots broken centuries ago. And here we are going around, going around, thinking, dreaming, calling out, demanding to know about desire.

It's yearning that's eternal. Consummation is mortal.

I'm tired enough, I crave the bitterness enough, that this coffee tastes good even when it's almost cold, almost gone.

Original Art Of Molly Stewart (1957-1997)

Heartlands: Midwest Writing & Art, Volume 2, 2004

Art

© Molly Stewart

© Molly Stewart

© Molly Stewart

© Molly Stewart

38 Best of Heartlands 1991-2005

THE FIRST SWALLOWS
JOHN NOLAND
HEARTLANDS, VOLUME 3

back, turn
dart,
and twist,
emerald and white bodies
stitching patterns in spring air.

If I could touch
their flashing
flight, I think
my fingertips
would feel
how green
flares into a leaf,

or how a stone
fits its place
exactly,

how the river
runs all night
through its own fingers
without counting
any losses.

Here in the tapestry
that swallows' flight
makes of the world,

I would know
how each of us fits
the pattern,
how each of us feels

the needle—
beauty—
sewing closed
questions
haunting 3 a.m. air

and how
in a once and future time
invisible scissors
will slip us
loose
from any past

to rise
like insects
over water

into the swallow-
hawked
and shining air.

STOMPING ON BEES
MJ ABELL
THE HEARTLANDS TODAY: COMMUNITY, VOLUME 5

For Steve
Thinking patience and unswerving guts. A quick foot.

In May, bees threaded the spirea blossoms
along the porch, then dropped to clover.
Steve taught me to pick my moment, slam down
on bee and blossom, then grind the ball of my foot.
Second thoughts, and I could be stung. I was 9,
my brother was 10. This was the only way
I ever proved myself to him. This was daring and thrill
in the flesh, not in the books I read long hours inside.
What was one less bee?

What was a bee at all? Something that could sting us,
small with a measure of power.
We smashed its body, stinger and all, stealing
what we most needed.

When Ann Kagy next door wanted to try,
I didn't know if she had the quick kill
in her. I stomped one for example; she raised her foot
then backed into a nervous dance. How to summon that stern eye?
Again I killed her, cold-blooded.
She found another bee, gold and black bands gleaming, innocent
yet like us hiding a stinger. She stomped, twisted to the earth
then hopped guiltily. Murder is a point of no return.
Ann killed only once. Now she's an evangelist, blond hair afire
under the lights of small churches, sure that reckless murder
is wrong, even bees.

Me, I'm not sure. I miss that certainty, that unquestioning
thrust and follow through, the slow rising of the grass
in the aftermath, my brother.

RIPE PLUMS
JOAN BARANOW
THE HEARTLANDS TODAY: MIDWEST SIRENS & MUSES, VOLUME 8

They've come for the plums
that have fallen on the concrete
path behind the house. Mid-June,
the plums small and sweet,
so ripe they've split,
the deer cannot get enough.
I come to the door, step outside,
and even then they don't back away
but stare at me, their jaws working hard.
Once, a young one would have come close
to sniff my neck, but the doe
leapt between us,
struck the air with her hoof.
And that was all right. Later,
after they've climbed the hill, I find
the ground littered with the clean,
yellow pits of plums,
and that pleases me, the way, I guess
a good chef enjoys the leavings
on a china plate.
Here is where the deer sleep, where
we can look upon them from our bedroom.
I know they are full of fleas and ticks,
that few of the fawns survive.
Yet wasn't it the mere curve of a hind leg,
the swell of flank tapering to those
impossibly narrow legs
that first impressed us?
Someone in love with muscle and fur,
with the tentative energy of deer,
felt in his hands a correspondent art.
What does it matter if beauty
walks in the woods or dwells only
in the neural channels of the mind?
Think what you wish, the world
will still display its tameless
and endlessly describable stuff.
Open the door. The deer are sure to come back.

WHAT GOOD DOES A WOODCHUCK DO?
RICHARD HAGUE
THE HEARTLANDS TODAY: MIDWEST TURNINGS & CROSSINGS, VOLUME 10

For Stephanie C., who asked during a discussion of Maxine Kumin's "Woodchucks."

1
Where we cannot go, it goes,
travels the landscape's subway,
knows the buried meteor,
the cache of Indian bones,
the tight-packed native undershelves
of our laxer, greed-drunk world.
Brings to light what was lost
to time and avalanche and glacier:
paves its loose clay porch
with amethysts and relics.
Helps the earth to breathe and drink.
Harvests wild's abundance.
Feeds the fox and vulture.

2
Offers us another way of knowing:
imagining the groundhog,
its fat loping gallop
across the road from woods to field,
imagining ourselves in its flesh,
we smell the world intensely,
scent in every turn of wind
the instinctive essences of things:
clover, berry, beagle, rose.
Thus creation, for the groundhog
we become,
is ever birthbright, fresh, renewed.

3
Even never having seen one
is a hint, an education: we've failed
to know our neighbors and our place.
Having never seen one
is a goad to live differently, and better:
slower, more open and alert,
walking dirty roads in the country,
chewing a stalk of grass,
remembering our older and other selves,
our own low-to-the-ground beginnings.

4
"For the humble shall be exalted."
The woodchuck rises haloed,
made a minor saint and martyr
in a poem's hard-earned grace,
one vision of the treasure
we might build the wealth of mind on

OHIO COYOTE
DIANE KENDIG
HEARTLANDS, VOLUME 1

Not the coyote in the tales told by old natives
out of Chinle or Mesa. And not Prankster, Trickster,
Dancer—that myth man explicated to death
by Great West wannabes and young tellers burying
what he does under lots of ises and was.
This Ohio Coyote's just a coyote—though I do have to tell
one trapper's opinion: "He's so smart, with a license,
he could drive a car." This real coyote,

stands bigger, around fifty, not thirty pounds—
about like a collie crossed with a shepherd—
white muzzle, brindle nose, green-gold eyes
he focuses with the intent of a boy centering
a magnifier to start a fire with the sun.
Won't look at a human, though. He's shy

and omnivorous. In his belly they've found
grasshoppers, rope, chicken, berries, foil,
garden vegetables, carrion, fish, leaves, snakes,
and a Ralston Purina bag. There's a debate whether
he's indigenous or migrant, but everyone agrees
he's moving in on the cities—killed two ponies
on the edge of Cleveland, and in Columbus he and a friend
showed up at a brunch at the governor's mansion
the week the bill passed making him
the only game you can kill on Sunday.

THE PEOPLE'S REPUBLIC
JOHN A. VANEK
HEARTLANDS, VOLUME 1

A communist, half a world away
from his terra-cotta life in Xian,
Lai never actually said
he loved America;
he just savored her
like a concubine.

From my deck we watched
an arrowhead of geese
pierce a cloud,
as sunset melted over the marshland
and warm breezes launched Lake Erie ripples
like a comb through hair.

Total-body baptized in the Church
of Capitalism, Lai looked up
from his New Testament,
Consumer Reports,
to watch swallows
swirl like a waterspout across the bay—

then he returned to a gospel so foreign
it seemed written by a higher power.
He said he had faith that someday
his government would grant him a refrigerator...
but stumbled mid-sentence
as the distant crack of a rifle

emptied the marsh,
and saturated the sky
with birds proclaiming
their inalienable rights.
He recoiled, then sighed,
as a hundred sorrows floated

in his half-moon eyes.
He said that in his province
there were no birds.
His angular features wilted,
and from a place of silk and sadness, he added:
"We ate them all."

◆● PHOTOGRAPHY ●◆

© Eileen Wolford, *Heartlands*, Volume 1, 2003

Our Natural World: Man's Mark Upon It.

© Connie Smith Girard, *Heartlands*, Volume 1, 2003

FICTION INTRODUCTION
CONNIE WILLETT EVERETT
FICTION EDITOR

I've been fiction editor for the magazine for 14 years, and a lot of good stories have been printed between our covers. Recently, we've undergone a facelift including a new format and more visuals. Along with these changes, the time seemed right to look back; always consider the past even as you move forward. So, I pulled the old issues off the shelf. I opened to *Contents, Fiction*, scanned titles of stories not read in years, and it struck me how many of them I recalled in some detail. I've read more than a thousand manuscripts for *The Heartlands*; to be able years later to provoke my memory is, in part, the reason I select a story in the first place.

But, of course, I was looking for the *best* (the *best* being highly subjective, as all manuscript selections are.) A few stories presented themselves right away as "must includes." Certain criteria elevate one piece of literature above another. It must be memorable and original. Its telling must be interesting, confident and well executed.

Elements such as technique, tone, language, character, and pace should work in sync to benefit the story and never distract the reader. Stories that satisfy, engage our minds, touch our senses and evoke something, often unexplainable, within us. A good story resonates and makes us feel less alone. Our tastes in literature may vary, but first and foremost quality matters. This brief overview presents some factors that informed my choices for *The Best of the Heartlands*.

Wendell Mayo's *Heating and Cooling People* (Vol. 1) is a stylish story with mildly quirky characters we all recognize. The comfort level in the story masks deeper problems, and appearances are deceiving. Mayo has the authorial agility to reveal the profound in the ordinary.

Sightings, by Stephen Wolter (Vol. 4), moves a love story beyond the expected to explore the human need for place and belonging. Our desire for connection through community has a deep effect on all of our relationships. Wolter's alien theme works unusually well without becoming cliché.

I immediately reached for *Georgie O'Keefe's Summer Visit Home* by Terri Brown-Davidson (Vol. 8) because it has remained so vivid in my mind over the years. In a few strokes Brown-Davidson creates strong characters and examines the fine line between creativity and creating art and considers the elusive definition of a real artist. This story is delightfully imaginative.

Ron Nesler's *Birds* (Vol. 9) also had to be included. This story is very funny. The characters are rich and well-drawn, and to this day I laugh every time I see an ostrich. Comedy is hard to write; it's all about timing and tone, and Nesler got it just right.

Finally, *The Dune House* by Kevin Breen (Vol. 11) is one of the finest stories I have had the privilege to present in *The Heartlands*. Child abuse is an emotionally charged subject and Breen takes a hard look at it without lapsing into melodrama or sentimentality; the characters in this story are allowed room for self-discovery. This story is built to last.

These stories possess a lasting quality, and it seems right to introduce them to an audience of new readers. They are original, well-written and memorable. It has been a great pleasure working on *The Best of the Heartlands*, and a journey through many good works of fiction I am proud to have had a part in presenting to the reading public. I'm especially proud to present again these five short stories.

—Connie Willett Everett

Fiction

HEATING AND COOLING PEOPLE
WENDELL MAYO
THE HEARTLANDS TODAY, VOLUME 1

My in-laws are heating and cooling people in the Midwest. Summers, they are cooling people and care for all the cooling equipment breakdowns that occur in the flat, hot village we live in. Winters, they are heating people, with all the requisite equipment to respond to emergencies: a codaphone on a marble planter in the front room, two-part form receipts on a desk layered like baklava with carbon, the garage two rooms over and down, stocked with flexible conduit, pipe and pine boxes of fittings and Lennox supplies. The interior of their home is emerald. A cold white light beats through thick, green rubber-backed drapery. The house is warmed with a steady stream of air running in invisible sheets from the floor vents.

My father-in-law is reading the paper in the Lazy Boy chair in the front room. His feet are up. The TV is mumbling and the dishwasher is churning. My mother-in-law is in the kitchen, working through a stack of cold cuts with her fingers, sorting the slices of pale meat onto white bread, asking me when Sharon and I will ever get together again. I am telling her I think we're through for good this time; she tells me to give Sharon a little time; she reminds me how Sharon's not like me; Sharon lets things build up and then she explodes; people are always catching the fragments, and even if I am her husband, I'm going to get some of the fallout.

"I'll never understand what's eating her," I say, and carry the sandwich to the table. "She's your daughter."

My father-in-law has rolled up from the Lazy Boy now, and sits stiff-spined in it. He stretches and stacks the sections of the newspaper on the foot stool. He is a large, square man. He wears T-shirts, corduroys and white tube socks these days—says it's his *summer lingerie.* My father-in-law used to pitch for the Brooklyn Dodgers; he came up from the farm team for one whole season, and you can see it in his bones and his complexion. He got in one good season, a three point-seven ERA, won five out of nine games. I had to get all that from her, since he doesn't ever talk about the glory days, only heating and cooling, and how the hospital probably owes him ten thousand bucks by now with all the charity work he does over there. In the winter they can't go without heat for even a couple of hours, he explains.

My mother-in-law says: "You don't get summers *or* winters off, buster. Eddie—you know the Hostess delivery man lives over to the Mall?—he's been without heat for two days now and you gotta get out there."

"How about some lunch for *me?*" he calls into the kitchen.

She is sitting across from me, suspended in a squat above the chair, listening to his request.

"You got a call. Remember? Here," she walks over to him and hands him her sandwich, "eat this in the truck."

I hear him get up, his boots pound on the stairs leading to the basement. He works the side door open and goes into the garage. I hear the van start, then the groan of the engine dissipate in the distance down the street.

* * *

I keep in touch with Sharon through my in-laws. Sharon works at Suzie's Hallmark shop by the Krogers, and my mother-in-law is over there so much I give her messages from the homefront to take in to her. We haven't lived with our in-laws or anything like that. We rent an efficiency apartment, but her folks have this place, complete with whole house air and forced air gas heat. Three bedrooms. One-and-a-half baths. It's pretty nice over here. Comfortable. *Civilized, right?* my mother-in-law has a habit of saying.

There were some good summers for Sharon and me, two or three summers leading up to the last one, which was the last one before things got real bad. Sharon tells me our marriage is just a piece of paper. I tell her I'll get a job, maybe I could even help her dad out with the heating work—who knows? Would that make our marriage any better? Maybe I could have my own business, I tell her. But that just makes her madder. I think Sharon hates the idea that I could *make it,* like her old pop. Sometimes I think she is really serious about us separating for good; then I think how absurd it is, how friendly things are at my in-laws. So, I go over to the in-laws a lot when Sharon and I are fighting, since she has to work, and I don't keep regular hours at any job, when I have one.

Now I'm pondering the idea of asking her pop to be his apprentice, but I wonder if winter is the best time for it. Winters, my in-laws become heating people, and this is a very busy time for them. She takes the calls, which ring in torrents throughout the day. He makes the calls: big jobs, small jobs, a lot of odd jobs, I think. Heck, it's okay for him. It's pretty steady work, which is why I'm not so sure about it for myself.

"We've got fifty people with busted piping," she tells every caller today. She soothes one of them through the receiver: "You poor dear. . . a wheelchair? He can be by this afternoon."

He's out most of the day. Sometimes he comes in between calls. He wrings his arms and large hands with suds in the sink downstairs, like a surgeon in post-op. Now he's back from the last one.

"That house is full of gas," he hollers up the steps. "They want to stay there, though...I ran a temporary line for them—I think they're crazy if you ask me."

She doesn't hear him, or she ignores him. I want her to say *well nobody asked you* since it's the phrase I have imagined her saying to him. He goes back out. Sharon calls and my mother-in-law gets it.

"What does she want?" I ask her. My mother-in-law is talking to Sharon, but she is looking at me, wagging her head.

"What is it?" I say.

My mother-in-law hangs up the phone. "Nothing," she says. She butts the refrigerator door closed with her hip and brings over some cold sauerkraut balls in a bowl. She sets the bowl on the table, pauses to see if I'm interested, then she brushes the bowl my way with the side of her hand. She reaches in and hands me a ball.

"You gonna keep me company today?"

"Sure."

"Then make yourself useful and eat these before they go bad."

* * *

Winters, my mother-in-law brings out her gadgets, and sets out her decorations. This year she has an extraordinary inventory, since this is soon after Christmas, and she has added her new gifts to the old staples. She calls them her *pretties* and her *particulars*. This winter, her particulars include three pre-Korean Conflict AM radios, a Bearcat Police Ban Scanner, and a Radarange microwave oven. The kitchen is over-stuffed with these things to the point where she has decided to cook in the old white-enameled gas range in the basement. To make more room, her newer gas oven in the kitchen is packed with stale bread heels and crumpled, halfway-devoured bags of Fritos. So, winters she cooks, when she cooks, in the old white-enameled range in the basement.

I'm in the full bathroom upstairs, and I'm pissing as I look at another particular she has commissioned for use this winter, a Miami Carey Inc. intercom, now a common device throughout the house. Suddenly, I hear his voice come through the large oval shadow behind the wood-grained plastic slats.

"Coming up."

I'm baffled for a response, but then she comes in on the little speaker just behind him: "Them people two streets back got a bum furnace. You oughta get back out." There are many more pretties than particulars in the house now—mostly lamps and limited edition figurines. I suppose that's a hell of a generalization. But she has set out lamps and figurines throughout the house—Hummels, little German kids poised in Bavarian bliss, also Rockwells, barefoot kids, dimestore people and octogenarian dentists. She only puts out the tiny 3-D scenes, since, perhaps, the painter or designer can never quite duplicate a crease in the pants, the precise lay of a lock of hair. Just like the lamps. They are all brushed brass and frosted glass or lathed-and-stained maple or oak. The shades and bases of the lamps are hand-painted with log cabins, broad-leaved trees, Boonesborough types leaning on squirrel rifles. The brush strokes have been laid carefully. Only where the artist has raised the brush, just at the end of a stroke, unique wisps of paint trail up and away. She likes things that are unique.

I'm zipping-up, looking at one pretty now, this one perhaps different from the others, but I think not much. It's an oval plaster impression of a shepherd boy with two trumpets. It's supposed to be an exact replica of a 600-or-so A.D. piece. Roman, I think. She got it in September in Chicago at the sales counter at the Vatican Exhibit. Funny thing about her. She has never seen a day of church. She has never gotten much past lamp-art before. We were outside the Century Theater, and she says, hawkeyeing a bulletin board: "Touring just three cities in the United States..."

That day on, she would not be satisfied until we got tickets, got on the Amtrak, and got to see the pretties of the Papacy at the Art Institute. That's where we got the kid with two trumpets. Funny thing about him. The kid's not in the exhibition, at least he's not mentioned on the Walkman cassette tapes, the self-guided tour, or the commemorative volume of the exhibit. "This guy never made it out. Must be back at the Vatican in Rome," she giggled, and that supposition made her desire it all the more, I think.

* * *

My father-in-law is calling from the 7-Eleven. He comes in on the speaker phone: "Those people two houses back... set their furnace at 90 degrees for a month ... bought two of them Kerosun heaters and ran 'em all the time... Jesus, they never went downstairs to check the furnace... the storm door down there out through the back was whoppin' wide open. It froze up everything... so I shut it."

My mother-in-law says into the speaker: "You gotta see Mrs. Crowley, she's in that wheelchair, and she don't have no one."

"O-kay," his voice cuts in and out of the intercom sharply.

Sharon calls in; she and her mother talk a little while; usually they don't talk about anything, only I'm wondering if I should be doing something while they are talking, like asking for the phone.

"What did she want?" I ask my mother-in-law.

"Nothing for *you* to worry about, dear," she smiles wryly. "She just wanted to know if you were here."

* * *

Fiction

My mother-in-law and I are having microwaved popcorn, and I've just made a gross error. I told her I was writing a story about her Vatican Collection, with an angle on the Collection as it might be seen through the eyes of a child: *the innocent meet the inspired.* Anyway, she's calling every rectory and the like in town.

" . . . oh yes. . . my son-in-law needs to know where it says in the Bible 'When I was a child I done childish things, then when I was a man, and I put them away' . . . yes. . . okay." Then she whispers with her hand over the receiver: ("I couldn't get *him,* but I got his wife.") "... yes dear! ... One Corinthians ... Chapter Thirteen. . . Verse Eleven.. . uh-huh, thank you dear!"

I try to tell her the whole piece is dog shit anyway. She can't begin to know. *I don't do non-ficion,* I say. In any case, she's ruined it with her damned research.

"See . . . I told you. . . *New Testament,* not *Old,* she grins, leaning over to light a votive candle in one of her brushed-brass lamps.

I'm desperate trying to change the subject. I tell her I've rented an orange Nova for the holidays. The car is ten bucks a day from Rent-A-Duck. It's got a blue and yellow sticker on the back window: *THE UGLY DUCKLING.* She doesn't drive, and he takes the van to make calls. Since I have the car, she wants to go to the Hallmark to see Sharon. She says she and I should get out more together. She wants to go to *Suzie's* Hallmark *now. . .*

"It's awfully clean for a seventy-seven," she says, crimping her body over, inspecting the dash.

"I hate this duck," I tell her.

"Aw come on, there's no other duck like it."

The snow is coming down in fat flakes. The duck grunts through it. "Suzie's is by the Krogers," she points.

"Nobody's gonna be there now. It's their dead time."

"When we go in," I say, "tell Sharon I'm sorry."

"Sorry for what?"

"I don't know. . . just tell her I talked to you about how much I hate fighting with her—and make it sound like I didn't ask you to say anything, okay? Tell her we were just shooting the breeze and I happened to tell *you* that I was sorry—you know what I mean?"

Little bells jingle in the doorjamb as we go into Suzie's. I feel like pissing again. The half-off Christmas stuff is up front. My mother-in-law says she's after tree ornaments tonight. Suzie's are scattered on a tiered glass case. Not too badly picked over. Instantly, my mother-in-law takes up eight of them, and she has them hanging by limp threads through her fingers. She holds her hands up to her face with her fingers spread, like she's drip-drying them. The ornaments dangle from her hands, clacking against themselves.

"Sharon's not here," I say.

"Maybe she's on break," she says, still adoring the ornaments. "Go ask the woman at the counter." This is dead time and things are on sale. She seems to be in Heaven. "I always like to get just a little something each year just after Christmas—and it's all so cheap!"

"*You* ask the woman at the counter," I whisper, getting sick at the thought that Sharon may have lied to me about working tonight.

The baubles continue to clatter, hanging from her hands.

"These are precious!" she says warmly, looking lovingly through the menagerie of wooden elves, rocking horses, reindeer, camels-and-kings. Suddenly, she swipes up a plain, thumb-sized ceramic angel figure, who is singing a hymn from a tiny book.

"This is the most precious!"

"Where do you think she is—do you really think she's on break?" I ask her.

She takes up three of the precious angels, slips the other ornaments from her fingers, and unsnaps her pocketbook. She pays for the precious angels and we go out to the car.

"Don't know what these are, do ya?" she says to me several times on the way back to the house. "They're special," she concludes each time, without revealing the mystery.

* * *

We're home, and my mother-in-law is cooking pigs-in-a-blanket downstairs in the old gas oven. My father-in-law comes in with a loaf of bread under each arm. He's wind-burnt.

"Oh my, them pigs smell good," he smiles, drawing his face into wrinkles. "Your mother-in-law here. . . she don't work," he catches his breath, hands her the loaves, then cups his hands over his mouth and blows into them long and steady. "She's a lover, not a worker."

She pulls the foil away from one of the loaves, and gets a knife.

"After I worked over ta Mrs. Crowley's," he says, "I went on over to the Rectory and unplugged their pilot—they gimme some o' that priest bread, like every time I get over ta there. It'll go good with them pigs."

She cuts us all a piece of priest bread and we eat it. The bread is poppy-seeded, dry, but light and sugary. She sets her piece down half-eaten, goes into her Suzie's bag and comes out with one precious angel.

"We went by the Hallmark in his Ugly Duckling and got some pretties," she tells my father-in-law.

He takes the precious angel in his huge hand and rolls it between his thumb and forefinger.

"Oh my..." his voice is distant. "You know, I was over ta that *House of Genesis*, the one for them battered wives—remember? I had to fix a leak and tried to call the Gas Company so they would pull the meter so's I could get to the leak. Don't you know, them women would not

let me call? One of 'em says: 'We *had* to have *you* out here, but we don't want no one else.'"

"Come on, guess what it is!" my mother-in-law pleads, still intent on the angel pinched between his fingers. "Isn't it nice?"

Now there's a long silence, then he says: "It's a *pretty*, right...?" and his words go off again, like he's not all there. "You know that Mrs. Crowley?" he says, "She's that woman who acts so hard and mean from her wheelchair? You should've seen these big old tears come down her face when I got her heat back for her."

"Here, let me show you," my mother-in-law says, pulling another precious angel from the sack. She goes over to one of her brushed brass candle lamps, pulls off the chimney, and jams the tiny angel, bottom-first, onto the flame.

The hot wax oozes and curls around the bottom of the angel's tiny white smock.

"It's a candle snuffer!" she exalts.

He glances at me strangely, with a tired face that may know more than a heating and cooling man needs to know. He hands me the precious angel and goes downstairs, probably to wash-up, and to check the pigs.

* * *

Sharon calls in again. My mother-in-law snags the phone. She cups her hand over the receiver. "Are you here?" she asks me. Then she is listening a moment into the earpiece.

"Who wants to know?" I say.

"Sharon," she laughs, moving her fingers over the receiver. Then she removes her hand altogether. "Yes, he's here," she says.

* * *

We eat late, and the pigs make me sleepy. I don't think about how they make me sleepy. They just do. My father-in-law and I are in the living room. We have been cutting in and out of sleep all evening. Sometimes I'm gone, and I suspect he is awake, hoping I'll raise an eyelid; then I'm up and he's gone, catching Z's.

I'm really drowsy, and I'm thinking: if we last the year, I'm thinking of taking Sharon to Bermuda. We can drive to Key West. That'll save money... maybe then we can get a cheap charter boat to the Islands. Anyway, they're just sleepy thoughts. If I can remember them, I'll run them by Sharon when she's in a good mood.

* * *

My father-in-law is gone again, so I'm at the table having a piece of blackberry pie. Sharon comes in so late I can't remember her name. *"Oh, it's you,"* I mumble.

I'm wondering where Sharon has been; unfaithful, no; it's too close to Christmas; maybe she's been shopping, relishing it like her ma; only she wouldn't be doing it at *Suzie's* because it's not like her to be shopping in the same place she works—that would take the romance out of it.

She comes over to the table, dragging her coat off her shoulders. She says she's tired; she just wants to go to bed. Then she sits by me and leans in close. She whispers, *"I want you to go home. I don't want you here. I don't want you here anymore."*

I try to tell her Johnny Carson's coming on, the very next thing. *"Honey,"* I say, *"can't I stay just a little longer? Maybe your old Pa will tell us about his glory days with the Dodgers."*

My mother-in-law comes in from the bedroom, goes over to the codaphone and puts it on. She curls up on the floor at the foot of the television. My father-in-law has his white-socked feet crossed over the top of the foot stool several feet from her. He is in the Lazy Boy and I move into the rocker beside him. He shows me an exercise machine in the Sears catalog, then pulls out the new Penney's summer book, and shows me the dock-wear: light denims, breezy pantaloons, bright cotton shirts and canvas deck shoes. He doesn't say a word. He just smiles. I smile. Then we are dozing again, together, and I am dreaming something I know I'll never remember.

Fiction

SIGHTINGS
Stephen Wolter
The Heartlands Today: Community, Volume 4

It has become apparent to me that people will do or say anything to achieve their fifteen minutes of fame. I didn't use to think this way. When I was growing up, I would take as gospel almost any story told to me by an honest face. Now, I'm not so gullible. Witnesses from the grassy knoll, celebrities who have lived other lives in other times, bodyguards of presidents and kings—they all have a story to tell. These days it's usually for a price, or if nothing else, an invitation to appear on a television talk show. Who is telling the truth, and who is only out to make a buck?

Mrs. Edna Roberts, who lives just down the street from me, claims to have seen a UFO two nights ago. Her sighting has become the talk of the town, and in Arlington, Nebraska, the talk spreads fast. We have a population of only 1,100 citizens and I doubt there is anyone left who has not heard about Edna's flying object by now. The skeptics—and I must include myself within this group—while doubting the existence of an actual alien aircraft, must also wonder what Edna's motivation could be in telling such a tale. She is hardly the type of person who would be classified as a publicity hound. Edna is a seventy-one year old widow, a devout Lutheran, and lifelong Nebraskan. She has shown me pictures of her grandchildren and told me about life with her husband who died four years ago. She delivers Christmas cookies to my door every December. I do not believe her to be either dishonest, or a person who craves an audience. I certainly do not think she is crazy. And yet, we are now presented with this story of a flying saucer, or at least some sort of bright light in the sky.

"You probably think I have bats in my belfry, don't you, Jenny?" she says to me on this sunny Saturday morning, as I take my walk. "Or that I don't know what I'm talking about." Edna stands in her front yard, watering her petunias with a sprinkling can.

"Oh," I say, "not at all." I try to laugh. "No, not at all."

But when she looks at me, she knows. I am standing three feet away from her. She can see for herself. Right through me.

* * *

I am not a native of Nebraska, not even close. I grew up in Bennington, Vermont. Standing in the middle of my hometown it is possible to look in all directions and see nothing but green-covered hills and small mountains, rising upwards like the sides of a large bowl. The horizon is never more than two or three miles away in any direction, a reality that seems to make many of the locals feel safe and cozy. I felt closed in. Claustrophobic. There was another part of America I knew existed, because my school textbooks told me so, but it was as though my parents had never heard of places like the Grand Canyon or California. On vacations, they never took my brother and me out of New England; it was always a week on Cape Cod, ten days at Bar Harbor, that sort of thing. I had been to Pittsburgh once, for the funeral of an aunt.

On the day that I graduated from the state university in Burlington, I already had my letter of acceptance to graduate school in hand. The University of Denver. Library Science. This was the school farthest west on the map that offered me a fellowship. My parents couldn't believe it.

"You've never been to Denver," my father said.

"I know, Dad. I've never been past Pennsylvania. That's the point."

My mother was more direct. "Are you doing this to get away from us?"

"Jesus, Mom," I said, and I waited for the tears to well up in her eyes.

Eventually they offered to pay my way if I agreed to attend graduate school in Albany. I know they didn't really understand, but I went to Denver anyway, and Denver is where I met, fell in love, and married Rick. All in the span of less than a year.

Rick was at U.D. the same time I was, only he was working on a Master's in history. "A *real* degree," he joked one time, not long after I had received my diploma in library science. I *think* he was joking. I didn't laugh.

We only left Denver to move to Nebraska because Rick wanted to get his doctorate in agricultural history. The fact that I had recently been fired from my first library job didn't seem to be much of an issue, even to me. Back then, we had a plan, and the plan appeared to make sense.

"Agricultural history?" my father had said, when Rick and I announced that we were headed to the Cornhusker State. "Is that a subject?"

* * *

Edna is a member of the altar guild at Gethsemane Lutheran church, which sits off a county road four miles to the north of town. On Thursday night, after laying out clean altar cloths for Sunday morning services, and making sure that the wine and wafers were well stocked, Edna locked the church door behind her and stepped out into the warm, July night. Normally, Edna tells me, she would have worked with a partner, but Carrie Stanke had come

down with a summer cold, so Edna performed her duties alone that evening. Fifty yards down the road, she could see a single light shining through a window of the parsonage.

"It was right before I opened my car door," Edna says. "Over the cornfield, west of the cemetery. You know where I mean, don't you dear?"

I nod. I do know where she means, only because I have driven past Gethsemane before. I am not a member of the church, but I don't bother to remind Edna of this.

"Well, that's where I saw the light. Right over the cornfield." Edna shakes her head. "I still can't believe it. It was...it was...so *low*," she says. She looks down at her petunias for a moment. "It was so low and so right," she whispers.

"Well," I say softly. I try to keep my voice even and non-judgmental.

"Oh," Edna says, "I wish somebody else would have seen it. I wish Pastor would have seen it." She looks up at me now and I can see the worry in her eyes. It is hard to believe this is only an act "I just wish I could explain it to someone."

"You're doing fine,' I say. "I mean, you're explaining it to me very well." I reach over and smooth the palm of my hand several times along Edna's arm. "You saw something you don't understand, that's all. Who can say what it was?"

Her eyebrows lift up as her eyes grow larger. "Oh, Jenny," she says, "that's not the problem. It's not that I don't understand what I saw. I understand it quite perfectly." She shakes her head again.

I study Edna for a few moments. "You do?" I ask.

"Oh, yes." She leans closer to me, as if to seal our partnership in conspiracy.

"It was not of this earth," she says.

* * *

Rick and I got divorced six years after we moved to Nebraska, which is roughly the amount of time it took for him to earn his Ph.D. The history of that time has become a blur, and that is how I want it. I have worked hard in the four years since our separation to erase from my mind the details of our unraveling. I tell myself, the future is what counts. This is a convenient maxim; one, I suppose, that divorced people like to repeat to themselves. Even so, there are times when I imagine the satisfaction that could be derived if I ever got the chance to punch my ex-husband right in the mouth. One clean shot; a little healthy retribution.

In the meantime, I am still here, in Nebraska, continuing down a path that I could never imagine when I was seventeen. In the ten-plus years that I have been a member of this profession, I have yet to meet a colleague who dreamed of being a librarian while growing up. Still, I like to think that I have a good job, working as the reference librarian in a liberal arts college in Blair, another small town, fifteen minutes down the road from Arlington. Outside of eastern Nebraska, no one has heard of this school, but I am past caring about prestige. In Arlington, even on my salary, I was able to buy a house that is seventy years old. It has four bedrooms and a stairway that makes a right angle turn halfway up the steps. You could place an easy chair on that landing; it's big enough. People, I would guess, probably view me as a stereotype, the old-maid librarian who lives alone, her house full of books—I own less than twenty, actually, including the phone book—but would they blush if I told them I once made love to a man on that same stairway landing? He was the first person to touch me after my six-year slide with Rick. This was not a random miracle, of course, our being together, making love to each other, not a miracle at all. It was just a natural occasion between two people, the kind I had forgotten about years before, and it was good to be reminded that this sort of contact—that heady mixture of lust and affection unlike an irreplaceable natural resource—was not something that gets used up once and then is gone forever.

I only mention this story to indicate I am not a person who has retreated to rural America with the intent of escaping her past and putting the future on hold. I like to believe I am reasonably happy. Some days are very good. Some are filled with doubt. The recovery from what I once considered to be a misspent decade is an ongoing process, but I take comfort in the fact that it is happening, and that I am aware it is happening. My parents, however, still believe I am a ship lost at sea. We talk on the phone every weekend.

"They have libraries in New England, you know," my father says. "With all your experience, you could surely find a position at one of those, couldn't you?" Then he laughs, as though to indicate he is not trying to sway my way of thinking. "When you get tired of the wild west, I mean."

My mother, who hates where I live, doesn't say much when Dad brings up the topic. To her, this *really* is the wild west. Cowboys, Indians, and buffalo stampedes. I think she expects, on any given day, to receive word that her only daughter has been abducted by savages, a white captive.

* * *

The second sighting occurs on Monday night, although I do not learn about it until the following evening. I should have guessed something was up, as over the course of Tuesday afternoon I receive three calls at the reference desk concerning UFOs. A fourth caller wants the phone number for NASA. Now we are going to involve the federal government, I see.

Fiction

I search the stacks for books the library does not own, but find some helpful information in a few standard reference sources. Addresses and phone numbers are given out to the patrons. I also refer them to other, larger libraries in Omaha and Lincoln, and especially to one in Los Angeles, which I happen upon while thumbing through the *ALA Directory*—a library which claims to have an extensive special collection of UFO-related materials. The latter suggestion earns me a snort in my telephone ear piece.

Los Angeles? Why can't I get the answer right now?

I count to five, take a deep breath. *Because this is not the Ivy League or the Big Ten. This is a library that serves 800 students at a liberal arts college located in the middle of nowhere, that's why.*

"I'm sorry, sir," is what I say. "I just don't have the resources to give you a complete answer to your question."

Click. A dial tone buzzes in my ear.

When I pull into my driveway that evening, there is a white van parked in front of Edna's house. Stenciled on the van's side is the logo of a television news station from Omaha. **NewsWatch 4!**, it reads. The words are so big they nearly shout. I cringe at the site of neighbors milling around in front of their houses. Suddenly everyone on this street is interested in how their lawns are doing.

I walk back to the curb to retrieve my mail and when I turn around there are a man and a woman walking in my direction. The man has a video camera hoisted on his shoulder. The woman is young—younger than me, anyway—and her shoulder-length hair bounces as she walks and is illuminated by sunlight that streams towards us from the west. The sunlight makes me squint.

"Hello," the woman says. Her smile could be painted on. "Hello," I say.

"Would you mind if we asked you a few questions? I hope you don't mind."

She raises her eyebrows as though she is on the air, reading the news to half a million people. The man has already begun to focus his camera on me and I almost laugh at this presumption.

I glance over at Edna's house. "Is this about flying saucers?" I ask.

"Well," the woman says, "not really. Unless you've seen one. Have you?"

"Only in the movies," I say.

She laughs at this, but there is a false note in her mirth. She doesn't really think this is funny. "Of course," she says. "Actually, we wanted to ask you a few questions about your neighbor. Edna. Do you have the time? We would really appreciate it."

This woman might be twenty-five years old, at the most, but I have been aware of her presence, flipping from channel to channel during the late-night news hour, for some time now. It is quite possible she has been with NewsWatch 4! for years. I recognize the upturned corner of her mouth, the tilt of her head. The sound of her voice annoys me—just as it does when I watch her on TV—and I wonder for a moment what qualifications are required anymore to read the news on local television. Age, obviously, is not one of them.

"I don't think so," I tell her.

"Just a few questions," she says. "Really, it won't take much time. I promise." Her smile is so wide I expect to see the skin above her jaw crack from the stress.

I shake my head, avert my eyes. "No," I say, already walking away from her. This rejection creates a small thrill that rushes through my body, spreading into my limbs, even. It makes me feel good that I have not bothered to apologize.

As I walk up the driveway, Terri Kurtz waves to me from the opposite side of a well-groomed hedge that borders my lawn. Terri is a teenager, the rebellious daughter of neighbors who live on the other side of my house. Her father is the one who cares for the hedge.

"Can you believe all of this?" she says. She has twisted a strand of pink bubble gum around the tip of her index finger.

"What's going on?" I ask her. I am hoping Edna was not the one who called the news people.

"Do you know Bret Paxton?" Terri says.

I do; I know the name, at least, but suddenly I am not able to place it with any one face or individual.

"He saw one of the UFOs last night," Terri says. "Right on his parents' farm. Or right above it, I guess."

One of the UFOs. Aliens are landing on earth, and naturally, as is always the case, they bypass such places as Seattle, Chicago and Washington, DC, focusing instead on a locale the size of Arlington, Nebraska. I have a dismal vision of the near future, and it begins with tonight's ten o'clock news on channel four. In a day or two, we'll be going national, and then one of the video tabloids will roll into town, tempting us with that elusive gold ring of celebrity. The whole town, we'll be told, will be on television. Who will be able to resist an offer like *that*? After all, it's television!

What we'll end up seeing, of course, is ourselves: women in faded house dresses and men wearing dirty baseball caps stained with sweat. We will stumble with our grammar as we stare wide-eyed at the flawless complexions of reporters who hold microphones three inches from our mouths. Somehow, it will play back on videotape in a way we did not quite imagine. How often do we bristle when an outsider portrays us as a bunch of hicks? It's about to happen again, but this time we are practically sending out the invitations.

"It's kind of exciting," Terri says. "It's like Arlington is finally on the map or something."

Or something.

I say goodbye to Terri and walk into my house, which feels like the inside of a bath. I switch on the air

conditioner and pour myself a glass of iced tea. It is only when I take my first swallow of the cold, restoring drink, that I remember who Bret Paxton is. I saw his name, earlier in the summer, in our small weekly newspaper. He was this year's senior class valedictorian at Arlington High, the winner of a four-year scholarship to the university in Lincoln. I even remember seeing his picture; a handsome boy. And obviously, a very bright kid. Why would someone like that make up a story about alien spaceships?

What continues to elude me in all of this, is motive.

* * *

My mother asked me, "Why do you live here?"

That was last summer, when my parents came for a week to visit. After two days, I knew my mother was eager for Vermont. "It's so humid," she said. "How can you stand the humidity?"

"I work in an air-conditioned building all day, Mom," I told her. "When I come home, I sleep in an air-conditioned house."

"Good thing," she said. "It would be impossible to even *breathe* if you didn't have that."

I drove her around the country side. The fields of corn were every bit as green as the mountains in Vermont, although this fact seemed to go unrecognized. I think the openness frightened her, the way the farmland stretched off towards the sky for miles. And when I stopped the car, and we stepped out into bright sunshine and thick summer air, my mother held a handkerchief to her brow.

"Good Lord," she said. "The humidity."

* * *

A favorite saying around here is "It's too hot to eat," and even though I'm not hungry, I drive over to the grocery to pick up a few items. But before I do, before I even step out of my house, I peer through a gap in my curtains to make sure the news van has left the neighborhood.

At the market I fill a handbasket with fresh fruit and vegetables, then search for a bottle of lo-cal dressing. As I walk along one of the aisles I pass the section where the videotapes are stocked. This town is too tiny to support a video store; it's either choose from this somewhat limited collection at Arnold's Grocery, or drive into Fremont seven miles west of here.

"I hope you aren't looking for science fiction," I hear someone say. I turn to my right and see a man I know, Walt Petersen. "How are you doing, Jenny?" he says.

"I'm well," I say. "Thanks." Actually, I'm very warm and tired, and would like nothing more than to take a shower, lie down on my couch with a book, and munch on a salad. But I try to sound pleasant. Walt is someone I met when I attended the Presbyterian Church for a short time, a couple of years ago. We occasionally run into each other around town, which is a common enough occurrence. Nearly every face around here becomes familiar after awhile, but for the first few months that I kept bumping into Walt, it always felt like a scripted opportunity for him to ask me out. A foolish conceit on my part, as I had listened to too much gossip about Walt's wife leaving him for another man, then taking their two young children with her when she remarried and moved to Oregon. For some reason, I expected Walt to be the type of person who wants to tell the whole sorry story over dinner, but it is plainly evident to me now that all Walt wants to be is a friendly neighbor. Looking at him, it makes me glad my divorce was final before I moved here. Just because some matters are private, doesn't mean they'll stay that way in small-town Nebraska.

Walt points at the videotapes. "Not a single sci-fi left," he says. "Why do you suppose that is?" He chuckles softly as I scan the wall of videotapes. *Close Encounters of the Third Kind*, *Fire in the Sky*, *Communion*; anything about aliens arriving on earth is missing. "Is this what's known as mass hysteria?" he asks. The tone of his voice makes it clear how he feels about all the UFO talk in town. That, and the wry smile on his face.

I smile back. "I guess maybe it is."

He taps me on the arm as me moves away. "Let me know if you see one," he says, pointing upward with his finger.

I wave goodbye and tell him that I will. For a few moments I just stand there, staring at the wall of video boxes. They carry illustrations of people being zapped with rays of light descending from the sky, of round glowing disks hovering above isolated American towns, and strange, elf-like creatures that gather in circles around frightened human beings.

I let out a breath. Far behind me, I can hear Walt's laughter as the clerk rings up his groceries.

Later that night, I lie in bed, staring through the darkness at the ceiling. I make a list in my mind, an attempt at answering my mother's question of a year ago. I live here because:

A) My husband walked out on me and moved in with another history major, leaving me stuck in Nebraska;
B) I need to work and this is where my job is;
C) The air is clean here and there's no crime.

For the moment, this is all I can come up with, and all of a sudden, it's not very satisfying. I am thirty-seven years old and I would like something more definite than clean air and a steady job. Sometimes, lying

Fiction

alone on this bed and unable to sleep, I feel the stir of self-loathing inside my body as I ponder questions like this. Famine, natural disasters, civil wars, stray bullets and a hundred other calamities make a misery out of so many daily lives, that I feel guilty even considering something as seemingly trivial as personal self-fulfillment. What is a vague sense of dissatisfaction compared to earthquakes in California? I roll over on my side. This must be one of the days of doubt.

The answer, Mom, is: D) I don't know.

I don't know why I live here. But, so what? Does every question have to have an answer? Does every moment of our lives have to have meaning? And if so, when something is lacking, should we then dream up mysterious colors in the night sky to compensate for what we don't have?

After a while, I begin to notice bursts of light that appear beyond my window. Every ten or fifteen seconds there is another, and then another. Soon, the illuminating effect becomes strong enough for me to see the pattern of threads that woven together make up my curtains.

Well. Maybe tonight it's *my* turn to see a spaceship.

I get up and go to the window, and when I pull back the curtains the western sky fills up with great flashes of sheet lightning. Even though the air conditioner is running, I open the window and feel a warm rush of sticky air as it sucked into my bedroom. The window has no screen and I lean forward so my entire head is outside in the summer night. I watch as the storm approaches, each flash of lightning seemingly closer that the one before. The wind rises and all along the street the heavy branches of elm trees begin to bend. Even though I am surrounded by the homes of my neighbors, I imagine looking out at the fields of corn that press up against every side of this town, and I pretend for a moment that I can hear the gentle friction of cornstalks, as they sway back and forth in the storm's breath.

I lie down on the bed and face the open window, waiting for the first drops of rain to fall. From underneath the window, I hear the fan of the central air unit kick in, but now I feel too tired to walk downstairs and shut it off. Thunder swells and echoes, or possibly I am only dreaming of this sound, I can no longer tell for sure.

The last thought I have before sleep finally overtakes me is this: I do not believe in flying saucers.

* * *

When I was a little girl, my father would often take my brother, David, and me for walks around the Revolutionary War monument that stood at one end of Bennington. It was a tall, stone obelisk, the tallest structure in the state of Vermont, and depending on how you looked at it, either an impressive tribute to the countrymen of our young republic or an eyesore. It stood at the juncture of two streets that were lined with homes, many of which were two centuries old or more.

One summer evening, the air cool and dry, unlike the summer nights I now experience in Nebraska, our father walked with us around the base of the monument, our sneakered feet sinking into the soft grass. He held on to both of us by the hand, and when we stopped moving, I craned my head back as far it would go. David, who was two years younger than me, followed my example.

I remember the feeling of dizziness caused by looking upward at the monument's impossible height. At the pinnacle, a red light blinked on and off, its meter as sure and unvarying as the heartbeat in my chest.

"What's that light for, Daddy?" David asked.

Our father looked up toward the top of the monument and paused, as though he was giving consideration to David's question. "It's a warning light," he said. "It's to let airplanes know the monument is standing here, so they can fly around it."

David was silent for a few seconds, but then he said, "Maybe it's to let men in spaceships from other planets know we live here. Maybe that's what it's for." Our father laughed gently at this notion, but didn't say anything else.

At the time, I thought David's explanation of why the light existed was startling. What if this was true? What if this flashing beacon, right here in Bennington, was intended to guide men from Mars to our planet? This was a thrilling and scary thought, and for some time after that, I entertained the idea that David might be right.

These days, my brother is an astronomer. He spends months at a time in places like Scandinavia and Alaska, studying the night sky and tracking celestial events. The heavens are his fascination. He has invited me, several times, to join him on one of his research trips.

"You need to abandon terra firma, now and then," he tells me. "Look up."

* * *

Two nights after the storm I get into my car and drive north of town. Call it curiosity. On Wednesday morning, after the rain, one of the local farmers found a large, circular patch of ground in a field of corn that had been burned away. Could it have been caused by a spaceship from another world as it landed on this one? The county extension agent took a look and his conclusion was somewhat more pedestrian: lightning. More than a few people are skeptical of this explanation. As might be expected, the rumors are flying. The town divided itself into a number of camps: those who believe in UFOs, those who suspect a hoax, and those who believe the events of the past

week can be explained by natural causes. As for me, the only thing I am sure of is that a current of excitement has passed through most of my neighbors, filling them with a sense of anticipation I have not seen before. Each night brings the possibility of surprise. The air crackles with the promise of wonder.

Prepared as I am with this knowledge, I am still astonished as I approach Gethsemane Lutheran. There must be thirty or forty cars in the parking lot. For a brief moment I think there are mid-week vespers in progress, but then I see that all the windows of the church are dark. The people gathering here tonight are sky-watchers, not worshipers.

I park the car and step out into the warm twilight. In the west, a bright pink ribbon runs along the horizon. It is an amazing sight, not just the changing sky above us, but this crowd of people who have congregated on the grounds of a country church. Beneath the wrought iron gate of the nearby cemetery, under a metal arch that bears the words "Acre of the Lord," a middle-aged man sets up a camera on a tripod. Across the cemetery lawn, a group of young people, possibly high school students, huddle around a small telescope. I walk lazily through the parking lot, feeling as though I'm in a dream, and step on to the grass behind the church. It is only then that I notice Walt, hands in his pockets, standing by himself, gazing not upward, but at the people around him. When he sees me approaching, he nods his head and smiles.

"Well, it's quite a night," he says.

"Some turnout," I say.

"Roger Franks, over there, says it was even bigger last night," Walt says, then shakes his head and laughs.

"What?" I ask him.

"I don't know," Walt says. "I grew up on this stuff. Watch the skies, invaders from Mars, all that sort of thing. I really *do* remember reading science fiction comics under the bedclothes at night with a flashlight. I actually did that."

He stares at the ground a few feet in front of him, suddenly oblivious to the carnival atmosphere around us. It is as though this brief childhood memory has triggered some hidden condition inside of Walt, released a buried emotion that was long forgotten. I can tell he is thinking about another time and place, one as far away from this moment, as that summer night when David and I stared at a red warning light 200 feet above the Vermont soil.

Then, just as if someone had snapped their fingers, Walt looks at me, his train of thought back in the present. "Do you believe in any of this stuff?" he asks. He pulls a hand from his jeans pocket and makes a motion towards the darkening sky. All week long at the reference desk I have been answering questions about this mystery we call unidentified flying objects. Such a term! As if these lights in the sky would be any more real—or any less illusionary—if we *could* identify them. Whatever I believe, it makes little difference. They will still be out there, up there, or maybe nowhere at all, except in our own trusting imaginations.

"No," I say, "I guess I don't."

"Neither do I," Walt says. He grins at me then, a playful sort of look, one that I can barely discern through the growing darkness. "But here I am anyway."

Yes. Like me. I'm here, too.

The air feels heavy enough to push aside with the palm of my hand. All around us, crickets and other insects invade the night with their sounds; their rubbing legs, their fluttering wings. As the last touch of color vanishes from the day, Walt and I look up at the sky, searching, perhaps even hoping, and all the while, waiting for history to be born.

© Becky Dickerson, *Heartlands*, Volume 3, 2005

◆◆ Photography ◆◆

© Charlee Brodsky, *Heartlands*, Volume 2, 2004

© Matt Kowal, *Heartlands*, Volume 2, 2004

GEORGIE O'KEEFFE'S SUMMER VISIT HOME
Terri Brown-Davidson
The Heartlands Today: Midwest Sirens and Muses, Volume 8

She'd seen her lying on the blanket stitched with an infinitude of stars, red over black over red glittering like the insignia of a Stalin regime and Georgie crawling on top, all fat limbs and bug eyes and puckered, disapproving mouth. She'd seen her gaunt, black-draped figure framed by the tall glittering windows of the Shelton, an austere white room laid open to the City and, below, all the shimmering blue-gold near-translucent lights of New York. She'd seen her and her husband sitting across from each other, elbows propped vulgarly on the table as they imbibed huge platefuls, portions of the cheapest red-sauced spaghetti—a ridiculous pair in matching black capes, him old, her bony, not a scrap of coherent, let alone intelligent, conversation between them.

Why, then, did she hate her?

It was unnatural. Monstrous. Of course. One couldn't hate one's sister. And yet, for Muriel, there was every hour of every day to swim through, clench her muscles against, as if she were battling the Atlantic's undertow and settling supine into the cusp of her own drowning. It wasn't that it wasn't fair. Georgie could draw and sketch as well as anyone, though her new ones—the New York skyscrapers, for example—leaned like the Tower of Pisa, making Muriel bark with laughter until Georgie, irrefutably offended, escorted her to the door of their opulent suite of rooms. And that oddity Georgie'd shown her—the fat black orchid, petals glistening drenched with moisture, like a hundred lascivious tongues—made Muriel so abruptly disturbed she'd nearly bolted from the room, Georgie's snorting catcalls staining the air black around her.

She knew her sister was *good*. Or what everyone else described as "good." So that wasn't it, exactly. Muriel thought about it until her head felt fibrous as a daisy ready to snap off its stalk. That morning, recovering from last night's feast—prime rib and baby carrots swimming in wine sauce, new whipped potatoes sweating lemon-bright-butter—Georgie slept in late, until eleven o'clock, noon, a real slugabed while Muriel started scrubbing the old copper pot.

Outside—through her window—a glorious Sun Prairie sky. A clear blue gift of a day, Momma might've said. Muriel squealed the hot water faucet on, soaked one of Poppa's old frayed undershirts, tenderly ran her hand inside the rag around the meat-drippings rim of the pot. Outside, that clear azure sky glittered and winked purely cloudless, putting on a show. Reaching for the scrub bush, Muriel was startled to hear a tiny, cat-slow yawn behind her.

"Morning," Georgie said. "That was quite a meal."

And you look a sight, Muriel thought. Georgie was just standing there, slumped and sad-shouldered as an ancient woman though she wasn't old yet, scarcely old, hell, she didn't even really know what old was. Muriel sneaked a peek. Her feet were bare beneath the raggedy hem of one of Momma's oldest nightgowns, a ridiculous affair with tiny, red-lipped poodles printed across the white fabric. And her feet were dirty. In Muriel's house. But, most disgusting, Muriel could see that Georgie was naked beneath her nightgown, her starved body, spiky breasts, exquisitely revealed in undercurrent of blue washed summer light from the window.

"I'll just take some coffee this morning, if you please," Georgie said, settling into the breakfast nook that glanced out over a sunburned expanse of vast green yard, arid and treeless and bright. She hoisted her feet up onto the chair, curled them beneath her, her scabby toes protruding from beneath her bottom; she slouched forward onto the table, head draped across her arms, drinking in the view so avidly with those brilliant darkening eyes of hers that Muriel wanted to slap her.

Instead, she poured the coffee. Trickled it out black and steaming as a tar pit into Momma's oldest, cracked-glaze mug, the blue one with white stars and a dangerously wobbly handle that might send scalding coffee right across the pointy perfect breasts of her unsuspecting older sister. Thinking better of her plan, Muriel sloshed Georgie's coffee from that mug into the next, a safer, crimson-painted affair shaped into the head of a bull. She nearly cried as she poured, thinking how Georgie was sitting there like a queen, expecting her to serve her.

How Georgie took so much for granted.

Muriel placed the coffee before her. Georgie didn't thank her. Her eyes, framed with crow's feet that took incipient subtle flight across those amazing cheekbones, stayed resolutely turned toward the window, the Out There. *What does she see?* Muriel wondered. She'd glimpsed it on the blanket, though then Georgie was only a writhing mass of nondescript humanity, wiggling baby flesh with eyes. And then the chant, perpetual interior monologue dedicated to Our Lady of Perpetual Helplessness: Please what does she *see* I want to see it too give me one second one hour of her life I wanted that passion I wanted that love please Mommy please.

As if Georgie—ugly little baby Georgie—had *ever* been their momma's favorite.

"What do you see?" Muriel whispered, draping one hand across her shoulder, abandoning her small fit of pique in the wonder of that moment. Georgie startled at the contact, took flight from her body abruptly, as a sparrow wings up precipitously, tiny heart bursting, at the

◆▪Fiction▪◆

black shadow roiling across it: shadow of the moon, of the sun, of the hawk. Muriel ignored her, so accustomed to her sister's feinting, gasping, withdrawals she could almost view them with wry amusement. "Out there—in the yard. You must be looking at something. But I can't imagine what on earth it might be."

Georgie looked at her, slowly, studied her as if Muriel were the famous dead rabbit and copper pot still life from William Merrit Chase's class. "I guess—that I'm as interested in your perspective as you are in mine."

"You are?"

"Why, yes. You've never revealed a hint of yourself, Muriel. Never revealed—even an inch—who you are. Where you are. What you see. And I'd really like to know."

Cautiously, Muriel smiled. "All right," she said, and leaned forward until the entire expanse of backyard cracked open cleanly as a walnut before her. "I see—I see—grass burned off by the summer sun. Scorched slightly yellow. Oh, I suppose, with little brown tips, stained by the fire. And a flatness like a mother's stomach. After she gives birth. Like my stomach, after Anna and Charles." She paused, scrutinizing Georgie's face. Unable to read it, she continued. "And the fence—surrounding the yard—made with lumber that's thicker than the sticks we used to build those forts in winter. D'you remember, Georgie? We were so proud of those things. Both of us always had that creative streak."

Georgie was studying her blunt, clean-cuticled nails.

More desperately, Muriel went on, "And the clouds framing the sky against the horizon—right over there. Like—like big cotton balls. Fluffy white sheep. Traveling in a flock! And—I can imagine myself, you know. As the shepherd. Herding and herding my—Georgie, where are you going?"

"Stieglitz," Georgie said, rising. "He needs his morning coffee. A jump-start for the day. You'll excuse me, won't you, Muriel?"

"Why—yes. Of course. Please—please tell Arthur that I've made his coffee fresh. With the finest Arabica beans. Just—just the way he likes them. He always—"

"Yes," Georgie murmured, turning toward the stairs. "He loves Columbian coffee."

Muriel watched her ascend. Words were in her mind, shoved back deep into the recesses where she couldn't ever access them. She waited until Georgie was out of sight then called, "Georgia, what do you see?"

But she knew the answer. Vibrant, primary colors—scarlet desert. Creamy flowers. Ghostly black shapes. Blue Texas sky shadowed with streamers of rose. Strong, geometric shapes: flower. Phallus. Fingers. Bone.

Upstairs, Georgie and Stieglitz were laughing. She listened to them, shutting down: the warm, companionable coughs, the bedplay on rumpled sheets. Muriel leaned close to the coffee pot, inhaled the pungently beautiful, smoky brew. She had her own memories. She was lying on a blanket. Squirming, as any baby would. And Momma was hoisting her. Momma was breathing warm breaths into her neck as Muriel stretched out her hands for the fabric blocks, listening to Momma murmur, "Muriel, oh Muriel, my special, creative child." ◆▪◆

© Becky Dickerson, *Heartlands*, Volume 1, 2003

BIRDS
Ron Nesler
The Heartlands Today: Midwest Characters and Voices, Volume 9

Bill wandered into the retirement center maintenance building a few minutes before seven. Eugene sat at his desk, staring out the bay door at their latest project, a half completed animal pen. In his left hand was a cigarette nearly burned down to the filter. The stub of ashes sagged towards the dusty concrete floor. Bill decided not to disturb him. Instead, he grabbed a five gallon bucket from a stack near the drift press, flipped it over and assumed his usual position against the stacks of cola cases.

"Them birds are comin' today," Eugene said, breaking Bill's line of thought.

"I thought we had a few more days."

"Nope, Brooks told me he wanted that pen finished by noon." Eugene flicked his cigarette out onto the access road.

"I suppose we'll have to miss another lunch break. How many is that this month?"

Eugene didn't answer. He took another cigarette from his breast pocket and lit it. Bill watched and wondered how many that made since dawn. Bill had never seen anyone that small (he was only five two) smoke as much as Eugene. The man probably bled smoke.

"What time are they coming?" Bill asked.

"After twelve, I reckon. If not, we'll have to put them in the goat pen."

"That should be interesting."

"You ever seen an ostrich up close before?"

The ostriches were for the petting zoo which consisted of eight goats and one mule. The current administrator, Mr. Brooks, had placed them in a half acre of woods behind the facility.

The residents were supposed to be able to come and pet the animals if they wished. They hardly ever did. Most of the residents were in wheelchairs and unable to wheel themselves out to the pen. Those that did got stuck in ruts left by delivery trucks. Still, Brooks kept it around. He was sure it was good for public relations.

It was typical of how things had gone since Brooks had purchased the retirement home earlier in the year. Previously, Brooks operated a small oddities museum out in Arizona. It was the kind that advertised stuffed two-headed calves and genuine Indian bones. His claim to fame was having the only frozen cave man in North America. There was even a picture of it in Brooks' office. The picture, horribly out of focus, hung above his desk. It showed a block of ice with a dark blur in its center.

Eugene swiveled around in his chair and looked at the clock. It was five after seven. "We'd better get after it. Noon'll be here before we know it." He got up from his chair, grabbed his green fishing hat and walked out the bay door.

The pen lay before them just as it had the previous day. It was constructed out of 'borrowed' sections of oil field pipe. Presently, they had the base completed and were preparing to put up sections in the corners. Bill had just picked up a section of pipe when a shiny red Dodge pulled into the access road. Behind it, a silver horse trailer glistened in the sun.

"Shit," Bill muttered. Flicking away his cigarette, Eugene seemed to mutter the same thing.

"HELLO BOYS!" yelled the driver.

"Hey Mr. Brooks," Eugene said. He was lighting up another cigarette.

Brooks stepped out of his truck and came around the front, hobbling because of a prosthetic left leg. Brooks was a tall, fat man who dressed like a Texas oilman, even though he lived in Illinois. He always wore a brown suit jacket, matching pants, boots and a silly-looking cowboy hat with a feather stuck in the hat band.

"You're not done?" he said, almost tripping over cut sections of pipe. "I told you boys I wanted that pen done by noon!"

Eugene looked at his watch. "It's just after seven now."

"Well I've got to dump these birds off so I can take the trailer back to my brother. Put 'em in the goat pen till you get done."

Yeah right! Bill thought to himself. He looked at the trailer. Something was scratching around inside.

"Them birds'll kill them goats!" Eugene said.

"Aw bullshit! It's just birds we're going to put in there," Brooks answered

Six-foot birds that could kick your fat head off if they wanted, Bill thought. He shook his head. "I don't think that's a good idea, sir."

Brooks glanced at Bill, took off his hat and rubbed a hand through his thinning gray hair. "Look, I don't give a damn what you all think. I want them birds in that pen and I want it done right this damn minute!"

It took a few minutes for Brooks to maneuver the truck and trailer so that they were in line with the gate to the goat pen. The gate was at the far end, facing town. Standing beside it, Bill could see his grandmother's home nearly a block away. It was surrounded by a tall white picket fence. The fence was a new addition. A few months before, the goats had escaped from the petting zoo and migrated onto her front lawn. That was the end of her prize-winning garden. That wasn't the only escape they'd had. A month later one of the residents, an elderly man, had stolen the mule. He rode it bareback down the middle of Main Street. He passed right in front of the local newspa-

Fiction

per. They slapped a picture of the incident on the front page. Brooks nearly had a stroke. He swore the editor, a guy named Jim, was out to make him the laughingstock of the town.

Bill glanced at the fence, it was barely waist high. He was no expert on ostriches, but he could easily picture one leaping over it like Carl Lewis. *What's going to happen if they get loose?* he thought. It gave him a chill just thinking about it.

One of the goats, a brown female, came up to the open gate. It looked up at Bill, expecting to be fed. He shooed it off. Before heading back to the herd, it gave the approaching trailer a questioning glance. The mule, standing behind a fallen tree nearby, also seemed to be studying the trailer.

The gate opened to the inside. Bill was standing between it and the fence. Eugene was walking behind the trailer, motioning Brooks back. Through the slits along the top of the trailer, Bill could see movement. A bald head was bobbing up and down with the trailer as it jostled over dips in the ground. As it passed, he heard a loud thud followed by more scratching sounds.

"Did you ever see the first part of *Jurassic Park?*" Bill asked Eugene as he threw up both hands as a sign to stop.

"Huh?" Eugene answered.

The truck stopped and Brooks hobbled out. "All right. I want you boys to open the trailer up and let them things out. If they don't come, just beat on the side of the trailer. That'll scare 'em out."

Bill stood his ground behind the gate. Eugene didn't move either.

"Well, what the hell are you waiting for? I've got to go!" Brooks thundered.

Tossing his cigarette away, Eugene walked towards the trailer. Bill, not wanting to look like a pussy, jumped over the gate and followed. Eugene got there first and pulled up the long steel rod that was holding the trailer door in place. He did it slowly, as if he were afraid that it might explode in his hand. Bill came around the opposite corner and tried to catch a glimpse inside the trailer but the door slits were too high up.

"Ready?" Eugene asked. Bill nodded.

Eugene grabbed the latch and, ever so slowly, pulled the door open. It was cracked maybe five inches when a long, narrow beak poked out. It sniffed the air, paused, and then slowly the rest of the head emerged. It was bald except for two tufts of white hair just above the biggest, blackest eyes Bill had ever seen. They were focused right on him. They blinked. Eugene let go of the door.

"I think it's taken a shine to ya," Eugene said. The head cocked to one side and came further out into the open. Now they could see its neck. It snaked out and around until it was practically in kissing distance of Bill's face. He could see his reflection staring back at him from its eyes. The ostrich opened its mouth and hissed.

"Fuck," Bill said, slowly pulling back. The ostrich cocked its head to the other side and then suddenly darted forward. It's beak clamped down on Bill's nose. "AARRGH!" He swatted his hand and connected with the side of the bird's face. It let go and withdrew back into the trailer.

"Damn! Are you all right?" Eugene asked. Bill had his hand over his nose. He felt more surprise than pain. Brooks laughed.

"Having trouble, boys?" he asked. Brooks left his truck and came along side the trailer. "I told you, if you have any trouble, just beat on the side." He reared back and slammed his open hand on the side of the trailer. The trailer door swung open and smacked Eugene in the head. He flew back against the fence. Two brown blurs shot out and headed to the rear of the pen. The goats all shrieked in unison and bolted towards the front. Only the mule stood his ground.

"God damn it to hell! Shit fire!" Eugene screamed as he pulled himself up.

"HHAHAHHAHA! You boys weren't expecting that, was ya?" Brooks said.

"Those damned things like to kill me!" Eugene said. He had his hand just above his right eye. A trickle of blood ran through his fingers.

"Aw! You'll be fine," Brooks said, leaning an arm against the trailer. "Have one of the nurses take a look-see." He looked out into the pen. "Looky there. Have you ever seen such a fine sight? They'll make great publicity."

"What?" Bill asked. He was still rubbing his nose. There didn't seem to be any blood.

"I called the paper to come and take some pictures with the birds and the residents. They'll be here this afternoon."

"No kidding." Bill said.

"Them birds'll end up making this place famous. We're the only facility in southern Illinois with a petting zoo. Now we'll be the only ones with ostriches."

Bill looked and saw the birds quickly pacing back and forth near the back edge of the pen. They were nearly identical except that one was a little taller than the other. To Bill, the birds seemed almost all legs and neck, only their mid sections had any color. Their feathers were a muddy brown that reminded Bill of river water. The rest of their bodies were covered in grayish pink skin. They stopped pacing when one of the billy goats made its way towards them. It got within spitting distance before they rushed him. They stuck their tiny wings out and flapped as they ran. The goat quickly turned tail.

"Maybe you ought to wait till they simmer down," Eugene said. The bleeding seemed to have eased a little. There was going to be a knot.

"They'll be fine. My brother said these birds ought to be tame enough to have walk in the Labor Day parade next month," Brooks said with a smile. He was turning to

get back in his truck. "You boys get fixed up. I don't want you bleedin' all over the preschool class that's comin' later."

"Preschool?" Bill asked.

"Yep. I invited Ms. Appleby at the school board meetin' last night. I thought it might make a good photo."

Brooks hopped in the truck and began to pull out. Bill and Eugene followed, closing the gate behind them. Looking back at the pen they watched as the ostriches chased the herd of goats. The birds were throwing their legs forward, exposing the spurs on the backs of their legs. Bill expected to be cleaning up dead goat before the shift was over.

At exactly one-thirty a small yellow school bus pulled onto the access road. Bill and Eugene, who had refused to go home despite his injury, were welding the last bit of corner pipe. The bus pulled to a stop in front of the maintenance shed. The folding door opened and a dozen pint-sized preschoolers poured out. They walked in a fast moving, single-file line followed by a short middle-aged woman.

"Class, line up along the side of the bus. No pushing now," she said.

A mass of children barreled out of the bus and stood in confusion along its side. Two of them, a young boy and girl made a dash for the goat pen. Mrs. Appleby chased after them, seizing them by their arms and dragging them to the bus. She stood them at the end of the line and put her hands on her hips. "You children behave this instant!" she yelled.

"Where are the animals?" demanded a little girl.

"Shush!" cried a boy nearest to the teacher. "Ms. Appleby said behave!" In response, the class erupted into a cheer of "Teacher's pet! Teacher's pet!"

Eugene put down the welder and adjusted his hat. It sat cockeyed with the bill pointing left. There were two strips of gauze wrapped around his head keeping it from fitting right. "You reckon we ought to tell Brooks the young'uns are here?" he asked.

In answer, the back door to the kitchen swung open. Mr. Brooks hobbled out and took Ms. Appleby's hand. He bowed and took off his hat as if he were a country gentleman. "Ma'am, you're as lovely as ever." Ms. Appleby withdrew her hand and smiled. He quickly turned his attention to the kids. "Are you ready to see some ostriches?"

"Yeah," said a child at the end of the line.

About this time, a small green pickup pulled onto the access road. It pulled in behind the school bus. *Thompsonvlle Gazette* was written on the passenger door. A small, skinny man with long brown hair and a beard jumped out. He had a camera hanging from his neck.

"Well, if it ain't my old friend Roscoe Brooks!" the man said as he approached.

"Jim," Brooks answered.

"Where are these birds I've been hearing about?" Jim surveyed the area with his right hand above his eyes.

"In the pen. You just get that camera ready. I want these pictures on the front page of the next edition. You hear?" Brooks said.

"I'll get them in there. But it's going to be hard to beat the mule picture. Did I tell you I got an award for it?"

"No." A flushed Brooks turned back to Ms. Appleby and her students. "You all wait here. I need to get the residents." Brooks went back inside the facility.

Bill turned his attention to the pen. The ostriches had stopped accosting the goats, who were huddled in a far corner, and were walking around the center of the pen, occasionally dipping their heads and pecking the ground. He had noticed, though, that they were steering clear of the mule. There seemed to be a feud brewing between the three animals. Whenever the bird got too close the mule would put his ears back and bare his teeth. In return, the ostriches would scratch at the ground and hiss.

The rear door to the kitchen opened. An old lady in wheelchair being pushed by a CNA (Certified Nurses Aid) came out. Brooks followed. "I could only muster up one. It's nap time," he said apologetically.

Bill watched the trio as they slowly made their way across the lawn. The old lady was Brooks' mother. She was 97 years old and seemed to be resisting. "Let me go damn it! I'm tired and I want to go to sleep! Roscoe! Do you hear me?" she cried.

Brooks waved her off and began giving orders to the CNA. "You two get in front of the fence. Ms. Appleby, why don't you get your students to gather around them? Bill, Eugene, get out of the way."

Ms. Appleby mobilized her students and gathered them around Mrs. Brooks. Appleby stood on one side of the group. Brooks stood on the other. Fiddling with his camera, Jim knelt on the ground. "Hey Roscoe, after we're through, why don't you get that old man and the mule back together. We could do a follow up."

"He's dead," Brooks answered.

"This old lady stinks," said a boy on the ground. Mrs. Brooks glared down at him. She raised her hand as if to slap him.

"Richard!" Ms. Appleby exclaimed.

"She does! She smells like my brother's diaper!" Richard protested as he pinched his nose. Appleby reached down and pulled the boy next to her.

Bill nudged Eugene. They were standing in the bay door of the maintenance building. "How do they think they're going to get the birds to pose?" he asked.

Eugene shrugged. "Damned if I know."

Jim gave the signal that he was ready to proceed. Brooks turned around. He started beating on the fence. "Come here birds," he cried. "Here, *chik chik chik chik chik*." Some of the kids began to giggle.

"You got to be fucking kidding me," Bill said, almost laughing.

Fiction

The two ostriches stopped pecking at the ground and looked up. Brooks saw he had their attention and stepped up his antics. "*CHIK CHIK CHIK CHIK CHIK!*" The birds slowly moved towards the fence. Brooks backed around. "My brother taught me that one."

By now the ostriches had made it to the fence. They were studying the group curiously. The tall one cocked its head and blinked. The smaller seemed to find interest in Mrs. Brooks.

It sniffed at her hair. The CNA shooed it back. The kids smiled and pointed, a couple of them gasped in astonishment. Bill thought he even heard one "Wow."

"Can we touch them?" asked one of the children.

"Later, children. Let's get this picture taken." Ms. Appleby said. She motioned to the children to turn around. Jim was still kneeling.

"Everyone ready?" he asked.

At that moment, the smaller bird bent its head down and snatched the bright pink lap cover from Mrs. Brooks' lap. She immediately grabbed for it. "Let go of that, it's mine!" she screamed. Backing off, the CNA tripped over one of the kids. What ensued was a vicious tug of war. The ostrich pulled up with its neck, the old lady pulled down. The CNA regained her composure and tried to assist. The taller ostrich also joined the struggle. It leaned forward and pecked the CNA in her forehead, knocking her back down.

"Help, Roscoe! Help me!" the old lady screamed.

"Give that here!" Brooks shouted as he made a lunge for the cover. The ostrich gave one last pull and seized its prize. Both birds ran for the rear of the pen. All the while, Jim was snapping pictures.

"This is classic," Bill said. Eugene was doubled over, laughing.

"It stole my cover! I want my cover!" the old lady said. She was shaking her withered fists in the air. "Roscoe, git in there and git it!"

"Bill, Eugene! Get over here and help me get this cover," Brooks boomed. He took his hat off and threw it on the ground. He pushed down on the fence and swung his prosthetic leg over. He stopped and looked back at his maintenance men.

"Bullshit," Eugene said. "I've tangled with them birds enough." He pointed at his bandaged head.

"I'll second that." Bill added.

Brooks waved them off. "You're a bunch of chicken shits!" He swung his other leg over and headed back into the pen. He stopped in the center, standing behind the mule. Its head was buried in a bush. The birds were standing along the back fence row playing tug of war with the cover.

"Here *chik chik chik chik chik chik chik*!" he cried. They stopped and turned in his direction. "That's right, come over here."

The tall one let go and came forward. It put its head down and walked towards Brooks, slowly picking up speed. Brooks threw his hands up. "No, not you. The small one." The bird in question shook the cover at him, as if it were teasing him.

Bill, still standing with Eugene by the maintenance building, looked in horror. "Oh shit," he mumbled.

The ostrich burst into a full sprint. Brooks stood, dumbfounded. The mule, realizing something was going on, lifted its head. Hissing, the bird spread its wings and picked up speed. It was less than twenty feet away and closing.

"Get back you god damn bird!" Brooks screamed. "Help me! Somebody!" Bill and Eugene broke into a run and headed for the fence. Bill reached it first and vaulted over. He watched as the mule whinnied, put its ears back, and bared its teeth. Brooks, thinking he was saved, slapped it on its backside. "Go get 'em, mulie!"

"Eee aaah!" The mule roared. It moved forward and bucked its hind legs up. Bill stopped running. The hooves made contact with Brooks' prosthetic leg, detaching it at the knee. It flew back and struck the fence. He fell to the ground, grabbing for his missing leg. The children were letting out shrieks and running for the bus.

"Oh, my!" Ms. Appleby gasped.

"What the hell was that?" Mrs. Brooks asked.

"This is going to make the major leagues!" Jim said, snapping pictures. Bill hopped the fence and seized the prosthetic leg lying by the fence.

Brooks was struggling to sit up. Eugene rushed out to his side. "Are you all right sir?" he asked.

"Eugene, where's my leg?" he asked.

"I think Bill's got it." Eugene turned. "Hey Bill, bring that leg over here!" he shouted.

Bill jogged over and held it out. "Missing something?" he asked. Brooks took the leg and laid it by his side. Rolling up his pant leg, he exposed a stump just below his knee. Covering it was a large white sock. Gingerly, he took the prosthetic leg and slipped it on. It made a sound like a foot going into a tight shoe. "Would you boys mind helping me up?" he asked. Bill noticed a strange tone to his voice. It seemed to have lost its commanding presence.

Brooks held up his hands and the duo pulled him up. Behind them, Jim sauntered over. He was holding a miniature tape recorder. "Any statements?" he asked, smiling devilishly.

"Jim, please. Just let me go inside for awhile," Brooks answered. He waved the reporter off and headed towards the fence.

"What about you guys? Anything good to say?" Jim asked.

"Maybe later," Bill said. He watched Brooks hobble over the fence, take his mother and head for the building. He seemed to have lost the swagger in his step. Before entering the building, Brooks turned and surveyed the scene. He shook his head and entered, letting the door slam behind him.

◆◆ PHOTOGRAPHY ◆◆

A Young Photographer:
Adam Osterling

© Adam Osterling, *Heartlands*, Volume 3, 2005

© Adam Osterling, *Heartlands*, Volume 3, 2005

© Adam Osterling, *Heartlands*, Volume 3, 2005

THE DUNE HOUSE
KEVIN BREEN
THE HEARTLANDS TODAY: THE REAL WORK, VOLUME 11

My wife and two sons were huddled together on the couch, galvanized in hatred against me. I could picture them—a tight warm ball of smooth hairless skin, pretty green eyes, and shiny blond hair—watching the old Donna Reed Show in our brand new living room. Even Polly, our sleek-coated yellow Lab, lay at their feet, head up, ears alert, vigilant.

On the skin of my youngest son I had drawn blood. A minute ago, as I lay in bed, he came to show me what I had done. Jill snapped the light on—the click sounding new, fresh—so I had no choice but to look. Willie, his face twisted from crying, tears dripping down his cheeks, lifted the bottom of his T-shirt up to his chin. And there it was. A thread-thin, inflamed red line that ran from just below his tiny left nipple to almost his neck, across the whiteness of his chest. The mark looked like something a cat could have done.

"I have no time for this," I growled. "I work tomorrow. I've got to get some sleep."

Jill flicked the switch off. "You're mean," she said in the dark, before slamming the door. "Mean, mean, mean."

Lying in the dark, I remembered with slow-motion clarity my fingernail tearing into the flesh of my son. I had grabbed for him in his bedroom because he had been fighting with his brother. He had accidentally jerked into me—you see it was no one's fault. My hand jabbed into his bare chest. I felt my index finger—the nail too long, dig into Willie as into a soft bar of soap in an elongated, slow line.

Everything stopped. I had that awful feeling one has when making a serious mistake, like the time I backed the car over Johnny's new bike. I wanted to apologize, to nurse the wound, but then Willie flopped on his bed and screamed, holding his chest as though I had just pounded a wooden stake through it. Jill came running into the room.

"What happened?" she asked.

"It's nothing," I said.

"He stabbed me with his fingernail," Willie blurted out, pointing at me.

"Way to go, Dad," Johnny said, from the corner of the room.

"It's not my fault," I said. "If you two hadn't been fighting this wouldn't have happened."

"Fine," he said, "abuse my brother and I won't say a thing."

I glared at Jill. "Great," I said. "I wonder where he got that from. Go to your room, Johnny."

He stomped a foot and began walking, too slowly to suit me, so I grabbed the back of his neck and gave him a little shove. He went flying into the wall, as though I were Hercules, and then collapsed on the floor. Jill, sitting on Willie's bed, holding him and rubbing his belly just below the mark, glared back at me.

"Don't you hurt my sons," she said. "Don't you hurt my boys."

"Gimme a break," I snapped. "You weren't even here."

She grabbed Johnny by the arm and pulled him toward her. All three of them looked at me, accusing me. "We know what you can be like," she said.

And then I lost it. I exploded, yelling as loud as I could. I felt wronged, slandered. In my indignation, I called my wife and kids names. If I yelled loud enough, I thought, they would see how wrong they had been, how they had misunderstood me. Sure, I had lost my temper before—with good reason—but I had never hurt anyone. It was the first time I had really let loose in our new house, and the yelling seemed strange, as though some seal had been violated, some oath or vow broken.

When I was done, I went to bed feeling justified. I had shown them.

I lay in the darkness and felt the anger slowly drain out of my body. As that powerful emotion left me, the places it had occupied began to fill with another emotion, a smaller, quieter one. A more disturbing one. I could feel, as surely as I have felt the current of the undertow on the big lake, my family's love pulling away from me.

I could sense the foundation of love I had been so happy to lay down—of reading to the boys in the evenings, of playing catch in the park, of fishing for bluegills on small lakes, of bringing Polly home as a "puppy," of long walks in the evening with Jill, of planning our dream house in the forested dunes only a couple hundred feet from Lake Michigan—eroding away. Now, I feared, in a few years, when my sons reached that age when their love for me would shrink—as it had in me for my father when I was a teenager—there would be nothing, no small memory of love inside of them. When the last heat of anger had expired, I realized I had given my sons an excuse to hate me. And I had given Jill an excuse, too.

Through the door I listened to Jill getting the boys ready for bed—I heard them use the bathroom, wash their faces, brush their teeth. I heard their small voices, sounding far away. Jill read to them, and I strained to hear the peculiar lyrics, the odd rhythms, of Mother Goose. She tucked the boys into their beds with only the smallest noises—her slippered feet on carpet, the folding of covers, a kiss on each cheek. It was like they were fearful of waking some monster who lived in their home.

Even after the house was quiet, I couldn't sleep. I had the sensation that I was on a boat on Lake Michi-

gan, on a cloudy night, that I was drifting away from my family, and that when the morning came I would be too far away to ever find them again.

I got out of bed, opened the door, and walked down the hallway to Willie's room. His door was open. I turned the hallway light on. It shone onto Willie who lay on his back in bed, in his Winnie-the-Pooh pajamas. Polly was sleeping on a blanket in one corner. When I came in the room, she uttered a low growl, but I told her to be quiet.

Willie was still awake. His eyes, green like Jill's and Johnny's, were still red and puffy around the edges. I sat down on the edge of his bed. He couldn't help smiling at me, showing me his tiny white teeth, with three front ones missing. I smelled the clean scent of toothpaste from his mouth. I smiled back.

"How do you like your new school, Willie?" I asked.

"Good," he said.

"What did you do in school today?"

He was biting on the end of his Humpty Dumpty covers. "I got a gold star for drawing."

"Way to go." I put my hand on his head and lightly rubbed his hair. "Willie, I'm sorry I hurt you. I didn't mean to. I was tired and mad and grumpy. I didn't mean to hurt you."

He pulled the covers over his head and said something. I tried to pull the covers down, and finally got them to his chin. "What did you say, Willie?"

"You scare me," he said, in a little voice. "Like the Big Bad Wolf. When you scream."

"I won't yell anymore."

"Promise?"

I nodded. "Can I have a hug?"

He lifted up from the bed onto his knees and put his arms around my neck and squeezed. His head fit perfectly into the space between my jaw and shoulder. At six, Willie couldn't really conceive of hating me. For a couple of more years he would love me no matter what. Just as I had continued to love my father, even after I shouldn't have.

As we hugged, I looked around at his new room. In one corner was his dresser, with several cat-eye marbles on the top. Built into the next corner was his brightly-shellacked desk and bookcase, filled with dog books, nursery rhymes, Hop on Pop, and the Berenstein Bears. The desk top was cluttered with pieces of driftwood, smooth stones, and blue-jay and cardinal feathers we had found in the past week.

When I was Willie's age, I collected feathers, too. I kept them in a clear glass jar. Each night, after my mother tucked me in, I looked at them before I turned off the light. Some nights, I remembered, while I looked at my feathers—blue and gold and black and crimson—while I stroked them and pulled apart the smallest portions and watched them go back together I heard my father yelling. His voice was loud and angry. He seemed like a giant. I turned off the light and got under the covers, listening for his footsteps, hoping he wouldn't come this way.

"Dad?" Willie looked up at me. "Will Lady-bug's children burn?"

"What are you talking about, Willie?"

"You know," he said. "The rhyme. Lady-bug, flyaway home."

"Oh," I said, remembering. "The nursery rhyme. Lady-bird, Lady-bird, flyaway home, your house is on fire, your children will burn. That one?"

Willie nodded. "Will they burn?"

"No," I answered. "It's just a story. It didn't happen. Besides, this is a new house, and new houses don't burn down. Now go to sleep."

Willie said goodnight and he curled up in his bed. I pulled the covers up to his neck. When I was at his door his eyes were wide open. I could tell he was still thinking about fires and children trapped in burning houses.

"Good night, Willie," I whispered. "Think of finding more feathers in the dunes."

I walked down the hallway to Johnny's door, which was shut tight. I opened the door and walked in. The hall light shone in at a sharp angle. Three of the corners received no light. They seemed spooky, even to me, filled with troubling things. They made me think of our coming years together, which I almost feared. The fourth corner caught the light from the hall and I could see Johnny's desk. The shelves on the wall were filled with books: *Kidnapped, Where the Wild Things Are, The Tell-Tale Heart, Hansel and Gretel.* In a part of the bookcase that wasn't lit, I knew Johnny kept his newest comic books, featuring Batman, Darkhawk, and Spiderman.

I walked over to Johnny's bed, in the darkest corner, and sat on the edge. His face was pointed to me. I wanted to tousle his hair, comfort him somehow, but I just said, "John?"

"Yes," he answered, his voice steady, flat.

"How are you?"

"Fine."

I couldn't think of anything to say. I felt him looking at me. I couldn't see his eyes, but I felt them accusing me for the times I had yelled too loudly, the times I had punished him unfairly.

"You really went flying into the wall," I said. "That was quite a show."

"You shoved me," he said. "Really hard."

"I must be stronger than I think. Or maybe you're weaker than I thought."

"I'm only nine."

"That's right," I said. I apologized. I said I wouldn't do it again. I promised him I'd work to get better, if he'd stop fighting with his brother.

Johnny reached beneath his pillow for his flashlight and he turned it on. He shone it in my face, but I told

Fiction

him not to point it at me. He flashed it around the room, casting some light on the dark corners, and for a moment they didn't look so scary. Then he turned it off and the room looked even darker.

When I was about Johnny's age, I remembered, my father's face became crusted over with blisters and scabs. For several weeks, he didn't go to work and lurked around the house like an ogre in a bathrobe and slippers. Sometimes, late at night, I heard him groaning or cursing. I avoided him even more than usual. One evening his grotesque head poked into my room.

"I'm going crazy," he said. "How about some checkers, Jack? Out in the kitchen."

He left but I stayed in my room. He yelled for me again, but I still didn't come. Finally, the door opened again. I had my back to the door, pretending to read.

"Aren't you going to play?" It was my mother's voice. "He's still your father. It's only the Shingles. What's wrong?"

She saw my fright when I looked at her. I told her I didn't want to catch what he had.

"It's okay," she said. "You can't catch anything from him. You've already had your chicken pox. You'll be all right."

We played five games of checkers that evening. He smelled oily, bitter, like bad medicine. I stared at him whenever he was concentrating on a move. His eyes darted beneath his lumpy face like a man trapped in a wild creature's body, like someone who wanted to jump out of his skin. We played checkers for the next five evenings. Each night, his skin cleared a little more and his eyes roved less wildly, as he again grew more comfortable in his skin. Finally, he went back to his job on the second shift and the checker games ended.

I said goodnight to Johnny and hugged him, but he didn't hug me back, except to touch my shoulder with one finger. I walked over to his door and stood there. The warped world of nursery rhymes and the dark stories of children's literature rose in my mind, mingled with memories of my father. I thought of all those images of children alone in dark woods, being chased and sometimes eaten by witches or monsters, falling through the ice and drowning, being beaten for stealing pigs, or whipped for soiling new clothes.

I vowed, as I shut Johnny's door, not to be a scary character in his life, as my father had been in mine.

As I turned off the hall light, I heard the murmur of the TV at the other end of our house. I walked through the dining room, past the oak table and chairs. I tried to open the door to the living room but it was locked. Through the beveled glass, I saw Jill lying on the floor, a pillow under her stomach. The flickering blue light from the TV made her face look ghostly. I had the strange feeling that she wasn't even there, that all I was seeing was a hologram, or a memory. For a moment, our beautiful new house seemed empty, except for me.

I tapped on the glass. She got up, unlocked the door, and went back to her spot. She never watched any new shows and was now watching *Father Knows Best*.

I grabbed a pillow from the couch and lay next to her on the tan carpet. "Hi," I said.

She didn't even look at me.

I felt my anger return, that sense of unfairness. "What I did wasn't so bad," I said. "It was an accident."

"What about the yelling? That's just as bad."

"You provoked me. Give me a little credit, would you? I'm not so terrible."

"I won't live with a madman. I won't live like your mother did all those years."

My father, I'm still ashamed to admit, was a classic low-level abuser. His verbal and physical attacks were usually subtle enough that you sometimes wondered if you were being abused. Whenever he did go over the line—with a vicious slap, or an especially hateful remark—he was shrewd enough to apologize, though he always mentioned exceptional circumstances. I stopped loving him when he hit me with his fist—I had it coming, he said in front of my friends when I was thirteen. My mother left him two years later, after he accidentally broke her arm in public.

"I'm not my father," I said. "I'll never hit you. I'll never hurt the kids."

"No, you won't," Jill said. "Sometimes you scare me. I don't want you to damage the kids in any way."

I looked hard at Jill. After all these years, I thought, she should know me better.

"I don't want to either," I said, swallowing my anger. "Sometimes I get mad, but I'm not my father."

"You know how that stuff," she said, "alcoholism, sexual abuse, is passed on from family to family. He still spooks me."

Jill met my father only once, just before our marriage. She wasn't impressed. What struck her most, she told me after the encounter, was his total lack of remorse, or responsibility, even after the leveling of his family. The last words I said to him were to ban him from our wedding.

"If you ever hurt one of my boys," Jill said, looking right at me, "Or me, we're leaving. We'll go somewhere, to my parents, anywhere."

"You would leave me?"

Tears came to her eyes. "If I have to."

For many years, news of marriages dissolving had reached us through conversations, letters, phone calls—but Jill had never once said she would leave me. She always believed in the sanctity of marriage, even more than I had. For the eleven years of our marriage, I had acted and thought as though I were immune to the disease of divorce. Now I saw this wasn't so.

"Would you leave me if I had an affair?" I asked.

"Possibly."

"What if we just started growing apart?"

"You never know."

"Maybe you don't really love me."

As I stared at Jill's face in the glow of the TV light, I began to understand what had made me so mad: I had worked so hard, for so long and still nothing was for certain.

Eight years ago, when Johnny was one, we bought this lot in the sand dunes to eventually build on. For eight years, we lived in a small house in a run-down neighborhood, saving all the money we could, not taking vacations. I worked two jobs—as a guard at the county jail and driving a newspaper truck—and Jill worked a few evenings at the grocery store. Once a week we would drive over to our lot among the cottonwoods, maples, and beeches and picture our house here one day. We didn't have access to Lake Michigan, but when we stood on the highest point we could feel the cool breezes off the water. In early spring and late fall, when the leaves were off the trees, we could glimpse the big lake, blue and beautiful in the distance.

When the time came to build we didn't scrimp on materials. We used extra wood for the frame, cherry for the kitchen cabinets. We bought expensive windows, an efficient furnace, quality carpeting, durable paint, the best wallpaper. We wanted everything to be perfect in the Dune House. The builders poured an extra four tons of cement for the foundation because, they said building on a sand dune was tricky business, and the sands were liable to shift over the years in unpredictable ways.

And now I saw, after all of those years, I could lose everything in a matter of weeks or days or even hours, with the right combination of events. One fire, one bad storm, destroyed years of careful construction. One insult, one slap, nullified a hundred hugs and tender words. And not only that, I saw myself as the destroyer, as taking an axe to my own home. I swallowed my anger again. I apologized again. I said that I would try to be better. This time, the apology took.

Jill wiped her eyes. She stood and turned the overhead lights on. I saw the nice room, the tweed couch, the peach walls. Jill's skin took on flesh tones and she looked real again. We hugged, and I didn't want to let go. I wanted to make love to her, but she told me I should get to bed so I wouldn't be too tired at work. I felt a little better, but she hadn't gone out of her way to reassure me. As I left, Jill asked me to turn out the lights.

I walked back to our room through the dark house. The house seemed different somehow, like it was tilted. I thought of my father, still out there, at large in the world, still, no doubt, sowing discord. And I supposed a part of him was in this house even now, in me. I thought of the reasons given by various people for his actions: a hot temper, disappointment with himself, a growing bitterness, bad blood.

For some reason the words of the nursery rhyme, "Peter, Peter, pumpkin eater, had a wife and couldn't keep her," bounced in my head. When I passed by Willie's room, Polly growled at me again.

In bed I thought of all the things in the coming years that could go wrong, that could work on my anger. Bad grades, school suspensions, drugs and fast cars, accidents, flirtations with strong, rich men, illnesses, economic downturns, mysterious changes, unthinkable events. I dreamed the wind howled all night, that it worked on the sands below our new home. Four or five times I swore the house listed on its side, and I jerked in bed as though I had fallen off a stack of crates. Each time, I reached over to touch Jill next to me, but she hadn't come to bed yet, even though it was very late.

•• PHOTOGRAPHY ••

PHOTOGRAPHY OF ALGIMANTAS KEZYS
THE HEARTLANDS TODAY: THE URBAN MIDWEST, VOLUME 7, 1997

"ELEVATED TRACKS ON WELLS STREET, CHICAGO, IL" ©

"RIVER CITY, CHICAGO, IL" ©

66 BEST OF HEARTLANDS 1991-2005

✧✦ **Photography** ✦✧

"Gateway Arch, St. Louis, MO" ©

"St. Louis Place, St. Louis, MO" ©

"North Shore Congregation Israel Synagogue, Glencoe, IL" ©

PLANNING FOR THE PAST
DAVID SHEVIN
THE HEARTLANDS TODAY, VOLUME 1

It's no secret the M & R's supposed to be a rough bar
and I'm a peaceful man. I've been coming here for years
and never had a part in any of the violent stuff. Tell you
why I sat here. You're my generation—no offense, I'm forty
and you seem like someone who would know my history,
not like most of them kids (and he shrugs toward the dart throwers)
who don't care about space travel or anything; what do you think
of that telescope, anyway? I love to fly, wanted to fly in Nam
but they wouldn't have me. Three times they called me up,
and three times they turned me away. The physical would come
down at the forthouse in Columbus. The doc would say, "Squat down,"
we'd be a row of us naked, and one of my knees would rise,
rise higher than the other like a derrick pulling oil.
The doc would say "Go home" and they'd call me again. I'd want
to go because I believe in democracy, because people get
what they vote for here. Now I don't vote, but I believe
in this country. The guy who won has advisors up the ass—
he has thousands of advisors, so if he doesn't know what's
going on, who does? I don't like fighting, but if he says
the moon is a prune or the Vaseline is gasoline, I believe it
because we elected him and he knows. You know what I like?

I like finches. I been keepin' em four months now. You like
birds? I got six of em, three pair. They're tiny and fly
free in the apartment. I love to fly. They call me
the Birdman of Cary, that's where I do my finishing work.
Thought the pet shop at Six's ripped me when they sold
me the Cordon Bleus, because I was reading about a mark
the female's supposed to have at the neck. They told
me they had papers, this was a male and female pair and now
I've got these little blue eggs they nest on. If the chicks
don't have a mark and they're girls I might have a new strain
and I'm gonna sell em. They're beautiful. The Bleus don't call
except to trade places nesting. The other, Zebras from Australia,
quack all the time like ducks, like this: "Quack! Quack!"
And the third pair, they're Society finches. They sing way back
in their throats like the opera. I hurt my knee once at football
and if the pain comes I listen to finches and I'm somewhere
else. The Societies got eggs, too. Pretty soon I'm gonna
be an uncle. I put these three cages together, but they're
always open. Did you know that finches will show affection?
And birds aren't supposed to domesticate. They're so tiny.
They sit on my shoulders like epaulets. They talk in my ears.

Architecture
Herbert Woodward Martin
The Heartlands Today: A Life's Work, Volume 12

For Raymond Fitz

In the brilliant neighborhood of the imagination
Someone always wants to commission a feeling,
To have you set your responses on the dotted line,
Have you faithfully sign the contract with some
Obscure mark no one understands, until, years later,
Some bookish scholar unearths the silence around it,
Imagines a voice speaking in the dust of that signature,
And watches light slowly form around the former words.
It is best to avoid such contractual agreements,
Permit the body to select its own natural function;
Discover its personal way through the architecture
Of the body, through the predicament of blood, nerves
And bones. The skull will always be first protector
Of the house of speech. The heart a distinct second
Of the body's strict room; the hands and arms, married
To the torso, are third; the fourth is the digestive
Region, far below the eyes which reach beyond the windows
Into the garden of thought where the curvaceous figures
Of Atlas and Venus stand. They are our physical gods.
They set the feet adventurously wandering and
The tongue meditating about the structure of pure fruit.
It is, finally, the tedious scholar, all dust and thought,
Who teaches us how to tune the human ear.

◆• PHOTOGRAPHY •◆

WINTER PEACE
EILEEN WOLFORD
HEARTLANDS:
OUR NATURAL WORLD,
VOLUME 1

RIVLET ©

SHADOWS ©

◆ **Photography** ◆

Quiet ©

Tree Patterns ©

Best of **Heartlands** 1991-2005 71

OPEN HOUSE AT THE CLEVELAND VALVE PLANT: 1996
DAVID ADAMS
THE HEARTLANDS TODAY: THE REAL WORK, VOLUME 11

Fifty years he worked in that bitter factory.
He learned to love what I found so ugly.
 ~James Wright

Walk the side streets where the honey locusts,
parched to yellowed parasols,
shade the tree lawns and the broken walks.

Here and there a sprinkler fizzes still,
arching from grass to driveway
in hope or stubbornness. Who can tell?

You might not believe that it could be so warm
in Ohio on this Sunday in October,
as furtive breezes snap the paper arrows
stapled to a sandwich board
past which the cars, like scarabs,
creep through the rusted gates
and squeeze the gravel of the lots.

In the languor of this day of rest
the old plant calls its children like a hymn.
And so the families assemble
from suburbs in the eastern hills,
from the weathered rows of GI homes
platted near the lake,
from Glenville, Euclid Beach, and Collinwood.
This sarcophagus of brick and glass and steel
coughs and trembles in the sun,
still by some miracle alive
amid the asphalt cracked and sealed
over the snakeskin blue and yellow clays,
behind the screens of dried-out shrubbery.

Outside, a foreman and two stewards blink,
as if unaccustomed to this light,
and lean across a table
handing bags of favor—a keychain
like a valve, some candy,
a U.A.W. thermometer.

So walk along the cedar planks
of the old factory floor
where the grease and creosote of decades
hold the shavings of a galaxy
whose history flickers in those lights

where anyone would notice him,
the pensioner whose crooked fingers
trace the stubble on his sunken cheek.
So obvious you'd think he was an actor;
and yet, the worn bandanna blooming from his trousers,
the black oil in his pores,
the whispered words you cannot hear
and could never learn…
Is this old man like a scripture
or a dream? Who can tell?

You might not believe…
but never mind. Reach instead
across the exhibition ribbons
where new presses spill the valves
like nuggets into carts.
You could touch one,
let its ice bleed to your fingers
like a life, a made thing, after all.

CLOSED MILL
MAGGIE ANDERSON
THE HEARTLANDS TODAY: A CULTURAL QUILT, VOLUME 2

I'm not going to tell you everything,
like where I live and who I live with.
There are those for whom this would be
important, and once perhaps it was to me,
but I've walked through too many lives
this year, different from my own,
for a thing like that to matter much.
All you need to know is
that one rainy April afternoon,
exhausted from teaching six classes
of junior high school students,
I sat in my car at the top of a steep hill
in McKeesport, Pennsylvania, and stared
for a long time at the closed mill.

"Death to Privilege," said Andrew Carnegie,
and then he opened up some libraries,
so that he might "repay his deep debt,"
so that light might shine on Pittsburgh's poor
and on the workers in the McKeesport Mill.
The huge scrap metal piles below me
pull light through the fog on the river
and take it in to rust in the rain.
Many of the children I taught today
were hungry. The strong men who are
their fathers hang out in the bar
across the street from the locked gates
of the mill, just as if they were still
laborers with lunch pails, released
weary and dirty at the shift change.

Suppose you were one of them?
Suppose, after twenty or thirty years,
you had no place to go all day
and no earned sleep to sink down into?
Most likely you would be there too,
drinking one beer after another,
talking politics with the bartender,
and at the end of the day
you'd go home, just as if you had
a paycheck, your body singing
with the pull and heave of imagined
machinery and heat. You'd talk mean
to your wife who would talk mean back,
your kids growing impatient and arbitrary,
way out of line. Who's to say you would not
become your father's image, the way any of us
assumes accidental gestures,
a tilt of the head, hard labor,
or the back of his hand?

From here the twisted lines of wire
make intricate cross-hatchings against
The sky, gray above the dark razed mill's red
pipe and yellow coals, silver coils of metal
heaped up and abandoned. Wall by wall,
they are tearing this structure down.
Probably we are not going to say
too much about it, having as we do
this beautiful reserve, like roses.

I'll say that those kids were hungry.
I would not dare to say the mill won't
open up again, as the men believe.
You will believe whatever you want to.
Once, philanthropy swept across our dying cities
like industrial smoke, and we took everything
it left and were grateful, for art
and books, for work when we could get it.

Any minute now, the big doors buried under
the scrap piles and the slap along this river
might just bang open and let us back inside
the steamy furnace that swallows us
and spits us out like food, or heat
that keeps us warm and quiet
inside our little cars in the rain.

"Closed Mill" is from *A Space Filled With Moving*, by Maggie Anderson, 1992©.
Reprinted by permission of the University of Pittsburgh Press.

THE TRAINS
LAWRENCE FERLINGHETTI
THE HEARTLANDS TODAY: MIDWEST SIRENS & MUSES, VOLUME 8

The long freight trains
 Let out their lonely shrieks
 in the Lake Erie dawn
 in fruit of first light
Their boxcars strung out
 horizon to horizon
 the engines disappeared westward
 and their ends still not visible
 over the cornfields
 the corn itself peaked high
 in the open bins
 cradles rocking
 across the landscape
 toward Huron
 Sandusky
 Port Clinton
 Toledo
Admiral Perry offshore
 sends up his signals
 off Put-In Bay
 The wind shifts
 and his flagship drifts
becalmed in the middle distance
 he's raked by British broadsides
 He rows to another ship
 carrying his flag with him
 He closes on the British brigs
 and blasts them with his cannonades
And carries the day
 The battle is won
 for Free Trade
 and all the Northwest Territory
 as Chief Tecumseh shakes his lance

And the freight trains roll
 over the Northwest Territory
 over the American empire
 past Lake Erie
 past Huron
 from Buffalo
 (Gateway to the West—the New Athens!)
 from Cleveland
 to Detroit ("des troits"—the narrows)
 to Chicago
 (hog-faced brawler!)
And the freights roll on
 in the early dawn
 still endless
 over the horizon
Ah but
 there is an end in sight
Here it comes now
 as we idle at a crossing
 the RR bell ringing
Here comes the end of it
 the end of all our imaginings
And no caboose in sight
 no brakeman hanging out
 from the last platform
 railroad cap cocked up
 his coffee still steaming
 on the caboose table
 the cabooses all gone now
 shunted into boneyards
Yet still the train cries out
 crying far away like the sea
sending its lonely signal
 to the good townfolk
 becalmed in backwaters of
 shopping malls and filling stations
 tv networks and computer terminals
Admiral Perry
 still offshore
 unsure of what bright future
 he was fighting for

◆ PHOTOGRAPHY ◆

SEASONS IN THE MIDWEST
BECKY DICKERSON
HEARTLANDS, VOLUME 3, 2005

◆─ **PHOTOGRAPHY** ─◆

BEST OF **HEARTLANDS** 1991-2005 77

THE SUICIDE SISTERS' DANCE HALL
HEART VISITS THE ROMANCE FACTORY
SUSAN FIRER
THE HEARTLANDS TODAY: COMMUNITY, VOLUME 4

On weekends people dress in snow-
mobile suits and ride snow-
mobiles to Polynesian restaurants
where miniature paper umbrellas are
the elegance that keeps
them warm on their 40-below-
drunk-wind chill, bar-stopping
snow-mobile rides home.
(Fact: Everyone is overweight.)

The men love each other
more than the women they will spend
their lives with. The men do things
together: kill
deer and drive around
with their bullet-polka-dotted
dead bodies tied to their
car roofs. The deer's tongues
fall from their mouths, slap
against the cars' windows.

Together the guys fish and nail
the fish heads to their garages.
They love cards: poker & sheepshead,
and motors, and guns. At night
they throw bar dice, throw bones. Sometimes,
just for the fun of it, the bartender
has a little, crotchless, black, Frederick's
number behind the bar for the winner,
for the fun of it. The winner will

take it home, wake his sleeping wife
and thrown the thing at her. He will be
passed out before she discovers
what it is, that she is too fat
for it, that he is already passed out,
that her crying is louder than his sleep apnea.

Their beautiful translucent children
shave their heads or grow jungle
beautiful wild hair, or shave half
of their heads & grow the rest.
They pierce their noses, pierce their
ears, pierce their tongues, pierce
their nipples, pierce their sexes.
They scald themselves, drink to toxicity,
drive their cars into trees.
They shoot themselves in the divine
search for a tender connection. While
all around us all the world
with its effortless beauty keeps
giving up potatoes & moonlight & birds.

FARMER BROWN
ASCENDS THE GALLOWS
EDWINA PENDARVIS
THE HEARTLANDS TODAY: MIDWEST CHARACTERS & VOICES, VOLUME 9
(December 2, 1859, Charlestown, Virginia)

One booted foot on the steps, he looks up
at the dangling noose and the blue sky.
Drums roll as he climbs; a breeze
touches his leathery cheek.
Beside him on the steps
and in the crowd of soldiers,
wait solemn men in top hats.
Cannon surround the scaffold.
He stands at last on the platform
and looks again at the noose
then through it
to green hills in the distance:

"Beautiful," he says, "This is beautiful country.
I never noticed till now."

He'd kept his eyes on heaven
and the hell of this world and the next.
He loved the beauty of action.

The crops he raised
blossomed fire.

THE SIDE YARD
CHARLENE FIX
THE HEARTLANDS TODAY: MIDWEST CHARACTERS & VOICES, VOLUME 9

When a strange dog wandered into the side yard,
the child who knew nothing of the good or evil of dogs
hid between the storm and screen doors, pressing herself flat.
But the screen still wouldn't close, nor the storm door open to the house,
and the dog, loping from behind the garage
and across the wide driveway, his tail propelling his rear,
nosed his way into the crevice between the doors
to sniff and lick the child who in terror stretched tall
and closed her eyes.

The side yard faced a wall of the neighbor's house.
But from a second story window on the other side,
an old woman without teeth
was unfurling to the ground her wet white hair,
through the back door the oldest son was leaving for the factory,
his lunch box silver in the morning light;
on the front lawn the youngest son, martyred to mild idiocy
by a bat to his skull while trying to stop a sandlot fight,
was moaning for his lost life,
and in her room the housecoated daughter,
who at night unpinned her gray and thinning braids to love a married man,
lined up her porcelain saints and prayed.

In the side yard, behind the taller than the flimsy pink roses
that opened so wide they fell apart,
trumpet-shaped flowers bloomed, silent as God,
bearing seeds like black coins sized for the fingers of dolls.
These lured the child from her press between the doors
and brought salvation from fear of the world bearing down like a dog's nose,
fear of leaving the yard,
and being ravished by her neighbors' hearts.

◆ PHOTOGRAPHY ◆

THE PHOTOGRAPHY OF HERBERT ASCHERMAN, JR.
THE HEARTLANDS TODAY: THE MYTHIC MIDWEST, VOLUME 6, 1996

MUDMEN ©

CHRISTINE ©

◆◆ **Photography** ◆◆

Mother & Daughter ©

Portrait of the Small Scott Family ©

Grampy's Clothes ©

Best of Heartlands 1991-2005 81

◆◆ POETRY ◆◆

TWO WOODEN BOWLS
MILLA KETTE
THE HEARTLANDS TODAY: A LIFE'S WORK, VOLUME 12

On the top of the chest of drawers they sit
the small atop the bigger wooden bowl, oblong both,
as feathers, light material, hand carved, reminiscent of another world.

The wheels cross the distance between the asphalt and the shoulder
dust floats on the air breeding with the rays of a sunny afternoon.
A little wooden shack, miserable, piles of wooden bowls around,
slices of fresh curled wood fill the floor
huddling around unfinished bowls, as chicks around their mother.
Behind the shack, the mountains spread their perfume
a river crosses down at the valley. Then we see the man.
Dark thick hair, shy, awkward gesture from artistic hands
a perfect model for Velasquez's light-darkness drama.
The lines in his face, his aquiline nose, black eyes lowered,
thick eyebrows defend him from the look of strangers.
His lightly curved back anatomically prepared to accept the chore,
the chisel born in these callused industrious hands of his.
Heavy bones beneath his stretched tanned body form a sculpture,
the dusty, faded shirt reveals its texture in lines and swirls across his body.
He could have been a Ramses, his strong profile defying the horizon,
he was the man who simply carved light pieces of wood. Simple.
No majestic ramseic sandals stepping on the dry soil, no precious-gem adornment,
just the curved back leaning over his work, no more than what he was.
Simple.

The sound of car doors slamming, words, dirty children's silhouettes,
a pile of fresh carved bowls holds the air around them
exhibiting their light rough skin, tempting, pale, primitive, pure.
The man's hands are dirty, dark. He is not literate.
He doesn't know he's an artist or where America is,
he just sits and carves wooden bowls;
art flows from his hands as water from the spring down to the valley.
The artist is a man who doesn't know what an artist means.
The man, the artist, needs to feed his children.

Two wooden bowls sit on my lap as the car moves away.
I feel as if I carry this man's children and I speak softly,
only they can hear my whispering "there, there"…
Only they can hear the man's, the artist's thoughts they carry.
They will go to a far land, they will cross rivers and mountains,
there, where the sun shines from a different angle,
there, where the words have different meanings and tastes.
Two wooden bowls sit inside each other as if they speak
and they both find comfort in their oblong, concave contact;
they will look for acceptance from the chest of drawers,
there, where they can not understand the language.

MIDWEST
M. L. LEIBLER
THE HEARTLANDS TODAY:
THE MYTHIC MIDWEST, VOLUME 6
For Tyrone Williams

There's a dance
We do in the fields
Of the Midwest.
It's a cross
Between milking a cow
And fishing a smooth pond
That's the size
Of a small cosmetic mirror
Used for touching up
Before the *big* event.

There's this thing
We do in the Midwest
Called a dance. Up and down
The highways and the country roads,
Everyone calls it
By different names,
But mostly we all know
It stated at birth
In our bones—
A movement as unique
As corn in the field,
As the sweet in the tar
That holds the roads
Together connecting one
Farm to one neighborhood
And so on
And so on.
The wind whistling thru
The lawns of our hearts.

TARBOX CEMETERY ROAD
DEBORAH E. STOKES
THE HEARTLANDS TODAY:
THE URBAN MIDWEST, VOLUME 7

It's always blistering
On Tarbox Cemetery Road
I stand in disbelief,
A sentinel to defeat.

And think this granite stone
will be more prominent
Than the supple head and bed
On which he used to lie sleeping,
Dreaming, loving.

Making me stand here wishing
For the just one more time
Time—
Before the that's it forever.

It's always planting time
On Tarbox.
The earth giving
Receiving light or not.

I stand
A breathing memorial,
A living ornament,
A dazed testimony

Then kneel,
Not knowing what to do
Wondering
Whether a primordial sin
(whatever that is)
Has anything to do with

Why

I'm here
On a hill
Beside a road
Called Tarbox.

Photography

Photos From Drive-In Tales
Karen St. John-Vincent
Heartlands, Volume 3, 2005

Cowboy ©

RYAN RAY ©

NONFICTION

WORKING CLASS SISTERS: MAKING AN AUTHENTIC ART
LARRY SMITH
THE HEARTLANDS TODAY: THE URBAN MIDWEST, VOLUME 7

The contemplation of things as they are, without substitution or imposture without error or confusion, is in itself a nobler thing than a whole harvest of invention.

-Francis Bacon

This quote which Dorothea Lange placed over her studio door provides both an invitation and a challenge to make art more direct and invisible each day. In my fifties I discover kinship in the work of two older sisters—photographer Dorothea Lange (1895-1965) and writer Tillie Olsen (b.1912). Both achieved their greatest work in recording the working-class life of the Great Depression era. That I discover these artists so late is a testament to my ignorance, but also to the bias of cultural historians against Populist art. My bond is felt as well as thought, as one sees through a Lange photo or reads through an Olsen story toward a fuller life sense. As brilliant social historians each used her art to capture an essential human story—the heart in conflict with itself. In their intimate and genuine stance toward subject and art they achieve a rare empathetic sincerity, in which the artist—the content—the treatment are bonded into the authentic. They remain our best teachers.

Dorothea Lange did it in the clear witness of her photography, by going amongst us with her eyes and heart open, and the shutter waiting for the shared moment to arise. She speaks her method:

You put your camera around your neck in the morning along with putting on your shoes, and there it is, an appendage of the body that shares your life with you. The camera is an instrument that teaches people how to see without a camera . . .You *force* yourself to watch and wait. You accept all the discomfort and disharmony—Being out of your depth is a very uncomfortable thing...You force yourself onto strange streets, among strangers. (*Dorothea Lange: Photographs of a Lifetime*, 7)

Lange knew instinctively that technique and aesthetics alone would not capture it, that the artist's stance required more if it were to register truths:

It's very hard to photograph a proud man against a background like that [lost farm], because it doesn't show what he's proud about. I had to get my camera to register the things about those people that were more important than how poor they were—their pride, their strength, their spirit. (*Dorothea Lange: Photographs of a Lifetime* 62)

In countless photos, she makes us intimate with the lives of wind blown migrant workers, the silence of Depression breadlines, the bodies of men and women leaning through the wait for relief checks, the damaged children looking back at us, the wounded eyes of folks too beat to hide their grief. It is wholly human work she did, limping slightly toward her subject with her simple black box allowing them to touch her equipment, not embarrassing them with questions, giving them dignity even as she took their most intimate images. She clarifies this: "I knew I was looking at something. You know there are moments such as these when time stands still and all you do is hold your breath and hope it will wait for you. . . . You know that you are not taking anything away from anyone: their privacy, their dignity, their wholeness" (*DL* 14-15).

Lange's key to subject and art lie in her stance, "For me documentary photography is less a matter of *subject* and more a matter of *approach*. The important thing is not *what's* photographed but *how*" (46). Fellow photographers recognized the rightness of Lange's insights. Willard Van Dyke compared her approach to her medium... "Her attitude bears a significant analogy to the sensitive plate of the camera itself. For her, making a shot is an adventure that begins with no planned itinerary. . . . Her method is to eradicate from her mind before she starts, all ideas which she might hold regarding the situation—her mind like an unexposed film" (DL 15-16). In her most famed photograph of "Migrant Mother" (above) George P. Elliot found the essence of directness: "The picture like a few others...leads a life of its own. That is, it is widely accepted as a work of art with its own message rather than its maker's; for more people know the picture than know who made it. There is a sense in which a photographer's apotheosis is to become as anonymous as his camera. For an artist like Dorothea Lange

who does not primarily aim to make photographs that are ends in themselves, the making of a great, perfect, anonymous photographs is a trick of grace, about which she can do little beyond making herself available for that gift of grace"(20). And yet we recognize that the gift was partly within Dorothea Lange, in her humble sincerity before her subject, her sense of the human moment, and her ability to become the unobserved observer. Avoiding the clinical objectivity of journalism as a bias in itself, she captured instead the authentic.

Lange kept copious notes on her photos for the Farm Security Administration, assisted in part by her sociologist husband, Paul Taylor, a forerunner in ethnography. Her famed photo of "Man Beside Wheelbarrow, San Francisco, 1934" suggests the sense in which this broadened her treatment:

I'd begun to get a much firmer grip on the things I really wanted to do in my work. This photograph of the man with his head on his arms for instance— five years earlier, I would have thought it enough to take a picture of a man, no more. But now, I wanted to take a picture of a man as he stood in his world— in this case, a man with his head down, with his back against the wall, with his livelihood, like the wheelbarrow, overturned. (*DL* 50)

What she achieves in us, the viewers of her work, is a profound silence, a sense of shared humanity which she brings to and finds in her subjects. Yet it is the kind of profound quiet that sends you from an exhibit or a book of her art with a great urge to tell others. She sums it up in this direct advice:

I enjoy looking quietly and intently at living human beings going about their work and duties and occupations and activities as though they were spread before us for our pleasure and interest. A huge opera. A huge arena. And also to be only dimly self-awake, a figure who is part of it all, though only watching and watching. This is an exercise in vision and no finger exercise, either. For a photographer it may be closer to the final performance. (158)

Lange's work moves me to realize more fully the act of the art, the way in which the artist and her art become interdependent with her subject, and the intimacy and honor of that bond.

As a writer I have to ask if using the medium of language can achieve this great silence before a subject. And the writer who convinces me that we can come as close to the heart of being human is Tillie Olsen. Her own working-class life in Nebraska (like Lange's early poverty in New Jersey) guides her. Like a skilled carpenter Olsen uses simple woods to make work of deep grained beauty. Her brilliant writing in the 1930's as Tillie Lerner was eclipsed for decades as she worked to meet the needs of earning a living, of keeping a family going through hard times. We have the haunting portraits of *Tell Me a Riddle* and *Silences,* and her great unfinished novella *Yonnondio: From the Thirties* (begun in 1932, left unfinished in 1936, rediscovered and published in 1974). These works all achieve that empathic authenticity, despite the literary world which denies worth to them and their subject of poverty. Olsen has adopted the word "Silences" in another way, as her anthem, using it to depict the dominant cultural patterns of ignoring women and working class art. She lists among her familiar silencing forces:

Anxieties, shamings. "Hidden injuries of class." Prevailing attitudes toward our people as "lower class," "losers," (they just didn't have it); contempt for their lives and the work they do ("the manure theory of social organization" is what W.E.B. DuBois called it). (*Silences* 263)

And that is what Olsen continues to call it, as her writing brings us back to our roots in what she terms "the whole of *human life*." She has given voice to the struggles of all writers against political and economical forces in order to create. Not publishing a book until she was fifty, Olsen clearly connects with all those who have felt the weight of cultural denial, who have battled the "festering and congestion" of trying to write in bits and pieces, with those who have tasted the bitterness of incompletion, "(I so nearly was one) who never come to writing at all":

The habits of a lifetime when everything else had to come before writing are not easily broken. . . . habits of years—response to others, distractibility, responsibility for daily matters—stay with you, mark you, become you. The cost of 'discontinuity' ...such is a weight of things unsaid, an accumulation of material so great, that everything starts up something else in me; what should take weeks takes me sometimes months to write: what should take months, takes years. (*Silences* 38-39)

In Olsen's refusal to accept this silencing of voices and cultures and self, she calls out the violation:

The silences I speak of here are unnatural: the unnatural thwarting of what struggles to come into being, but cannot. In the old, the obvious parallels: when the seed strikes stone; the soil will not sustain; the spring is false; the time is drought or blight or infestation; the frost comes premature. (*Silences,* 6)

Olsen has broken these oppressive silences by addressing then, just as she has achieved that deeper resonance in her own work by a profound listening to life. Her *Yonnondio,* in its brief 152 pages, writes doorways into the world of growing up poor in America. The Hillbrook family is forced to move from mining towns of Wyoming, to a barren farm rental in South Dakota, to the shanty towns and slaughterhouses of a midwestern city. Much as Lange moves into intimacy with her openness to details, Olsen brings us into the interior of this family's world with brief images and thoughts, with fragmented longings and fears:

A new life in the spring. But now fatback and cornmeal to eat. Newspapers stuffed in shoes so that new ones need not be bought, and the washing done without soap. Somehow to skimp off of everything that had long ago been skimped off on, somehow to find more necessities the body can do easier without. The old quilt will make coats for Mazie and Ben, Will can wear Mazie's old one. This poverty arithmetic for Ann, and for Jim—hunger for the gayness whiskey gives the world, battling fear that before spring the mine will engulf him.

A new life...in the spring....

The children were changed. Even their "ain't there nothing else to eat, mom?" was apathetic. The peace at home, their father so awkwardly gentle, sitting home nights now, frightened them. Always they were expecting something else....

On the women's faces lived the look of listening. And the autumn days, shaken with rain and restless wind, brought always the sound of fear, undefinable, into the air.

One November day the sky was packed so thick with clouds, heavy, gray, Marie Kvaternick said it had the look of an eyelid shut in death. Leaves dashed against the house, giving a dry nervous undertone to everything, and the maniac wind shrieked and shrieked. (*Yonnondio* 16-17)

The interior of their lives is laid bare for us in these details, both sensory and emotional. Following the mine explosion a new voice close to the author's comes forward to render the silent tones of such living:

A cameo of this, then. Blood clot of the dying sunset and the hush. No sobs, no word spoken. Sorrow is tongueless. Apprehension tore it out long ago. No sound, only the whimpering of children, blending so beautifully with the far cry of blown birds. And in the smothered light, carved hard, distinct, against the tipple, they all wait. The wind, pitying, flings coal dust into their eyes, so almost they could imagine releasing tears are stinging. (21)

These prose descriptions, so sensitive and direct, so delicate and undeniable, seem apt renderings of Lange photographs (which themselves have been suggested as illustrations of Steinbeck's migrant workers in *The Grapes of Wrath*). All of it is marvelous art that rises out of direct human contact, a caring and open stance toward subject. The life of the artist is kept in check before the largeness of these others.

In *Yonnondio* Olsen has us view life from within her characters, from the mother Anna and the father Jim, and most remarkably and movingly from within eight-year-old Mazie's mind and heart. We witness her abuse and losses, her tragic learning to dissociate from life in order to endure it. In the midst of the city's squalor she escapes to a dream of farms:

Only Mazie did not see. Still she lived on the farm in June, in early June, when the voluptuous fragrance lay over the earth. Wooden she moved about, lifting and washing and eating, and always a scarcely perceptible smile about her mouth. Mazie, a voice came shrill, you see the tub of diapers? Git to the tub of diapers....Noise ceaselessly rained blows upon her, the stink smothered down into her lungs. Enveloped in the full soft dream of the farm, she was secure. Hollow and unreal the dirty buildings and swarming people revolved around her, flat like a picture that her hand could smash through and see the rolling fields and roads of home just beyond.

But terrible moments of waking would come when the world that was about her would crash into her dream with terrible discordant music. Fear held her limbs there in the streets where the flats rose a tumble of ruins, and a voice would cry: Run, run, the next shake the house'll fall, run, run. (58-59)

Such inner terror is an apt description for Lange's haunting "Damaged Child" photo of the chalk faced girl with black hair and wounded eyes. A deep and respectful silence surround this exposed suffering, as we are human together. It is not that there is no beauty in the book—Olsen finds it everywhere in the simples acts—but that it must be sacrificed to survive. Our final poignant image of Mazie shows her comforting her little brother, "Her hand on the arm around him was open and tender, but the other lay fisted and terrible like her father's that night in the kitchen. Till the day..." (152). It is the same kind of tender, human detail that Lange captures in the Migrant Mother's searching face as she brings her hand to her face, and it renders us speechless and profoundly moved.

I do not know exactly what to call this approach to art. The term "Populist" has a history misapplied so often and suffers a history of abuse. "Sincerist" has been applied well to the writings of James Wright, Denise Levertov, Philip Levine, Mary Oliver, and others. There is also an open "existential" and "humanist" quality to it that refuses to judge another's life. I know that neither woman ever sought to found a movement, yet in our inability to recognize the essential qualities of their authentic work I sense a loss we cannot afford—"the whole of *human life*." The rightness of their work restores us all.

WORKS CITED:

Dorothea Lange. *Dorothea Lange: Photographs of a Lifetime*, with an Essay by Robert Coles. New York: Aperture: 1982.

Tillie Olsen. *Silences*. New York: Delta Books. 1978.

Tillie Olsen. *Yonnondio: From the Thirties*. New York: Delta Books. 1974.

◆◆ REVIEW ◆◆

15 YEARS OF BOOKS REVIEWED IN *THE HEARTLANDS TODAY* AND *HEARTLANDS*

Over the last 15 years, we have tried to feature some of the "Best of the Midwest" writing. Our staff and outside reviewers have kept their eyes and ears open for what matters in our region, but also what reflects the heartlands of America. Here are some of those reviews. – Larry Smith, Review Editor

Secrets of the Universe: The Journey Home, Essays by Scott Russell Sanders (Beacon Press 1991).

The whole book imparts this playful acceptance of life by putting things into scale: "Behind the hoopla, the comet's return was a reminder that we are tiny, transient creatures in a very large and orderly house." In his Midwestern honesty and directness Scott Russell Sanders speaks to the soul of each person's secret universe.

-Larry Smith

Among the Dog Eaters, Poems by Adrian C. Louis (West End Press 1992)

Louis aches and cries throughout these pages. He demands that we see the connectedness of struggles, both private and public. His celebration is always in the measured risks, cautions and demands. And it's real. So many volumes of truth vibrate in these short pages. Our moment is like the canary's moment, come up from the mine unsuffocated. At-riskness lies on tomorrow's bright dawn.

–David Shevin

Claiming Breath, Creative Nonfiction, by Diane Glancy. (Univ. of Nebraska 1992).

On many fronts of modern politics, the dilemmas of humankind continue to manifest themselves.... Within this context, it is well to listen to a language that touches more than the tradition, defining spaces between options; in Glancy's case: it's the Christian gods, the Indian gods, and then the human heart.

–Nancy Dunham

New and Selected Poems by Mary Oliver (Beacon Press 1992).

This three decade collection establishes Oliver as one of America's finest poets of Nature and self.... Her poems move like music or evening light across the water yet richly aware of the processes and the steady movement of life.... Mary Oliver's writing flowers on the page. One comes away from the body and spirit of this fine collection of poems *nourished*.

–Larry Smith

The Granite Pail: The Selected Poems of Lorine Niedecker (North Point Press 1985).

Lorine Niedecker is achieving literary stature only now some twenty years after her premature death in 1970 as an Emily Dickinson of the sixties who chose to remain in a single isolated place, Black Hawk Island on Fort Atkinson, Wisconsin, for most of her life. Her ability to write poetry as songs, to condense words and phrases into the pure music from which they originally began, teaches her reader much about the best of poetry.

–Debra Benko

Selected Poems by Rita Dove (Vintage 1993) and ***Through the Ivory Gate: A Novel*** by Rita Dove (Pantheon 1992).

"Writing poetry is the most intimate of arts....Poetry is one person talking, whispering to another. Connection is one of the most incredible experiences that a human being can have. Connect with your innermost feelings, render them through language in a poem, then give that to someone else," writes Dove. It is appropriate then to see these skills extended into the novel form. For an intimate, though fictionalized, sense of Dove's own life, one need only read her *Through the Ivory Gate*....Dove has emerged as a major voice as a poet and novelist, but also as a woman, African American, and compassionate writer of the human condition.

–Larry Smith

REVIEW

After the Reunion: Poems by David Baker (University of Arkansas 1994).

As certain of his future joy as he is of his future sorrow, Baker's persona has faith that his marriage, family, and community as well as his poetry will sustain him. Baker presents issues of love, death, family, and community with beauty and honesty, not sentiment. *After the Reunion's* cadences and imagery will sustain its community of readers.

–Debra Benko

Moo, Novel by Jane Smiley (Knopf 1995).

Smiley is adept at creating a bevy of characters—so many that I had to construct a written list—but ultimately a comic cast....Smiley's long novel remains fun to read, perhaps because it reflects our own society so well, but mostly because it draws you in, one character at a time. She remains a Midwestern author of character and substance.

–Barbara Schnellinger

Writing from the Center, Nonfiction by Scott Russell Sanders (Indiana Univ. Press 1995).

"Although grounded in the personal, all my essays push toward the impersonal; I reflect on my own experience in hopes of illuminating the experience of others," confides the author, and yet, it is the personal sense of Sanders—fair minded fellow traveler—which is the chief blessing of his works.... Reading Sanders is like walking with him down a Midwestern street, out of town, along a path through a wilderness that brings you back home safe and sane.

–Larry Smith

Fresh Oil, Loose Gravel: Collected Poems by Maj Ragain (Burning Press 1996).

There is a Beat feel here in the best sense of being "beatific" and close to the ground of saying what counts—direct and sweet, but full of pain and love as well. It's an original blend of the voices and visions all pushed along by the work of brother-poets Gary Snyder, Lew Welch, Jack Kerouac.

–Larry Smith

Dreaming of James Wright: An Appreciation"

Many James Wright poems are important to me, but I would like to single out two that have remained indispensable for the seemingly separate but interrelated aspects they represent of Wrights world and vision: "Autumn Begins in Martins Ferry, Ohio" and "A Blessing." The first captures, in a mere twelve lines the explosive working-class frustration, anger, and shame rippling beneath the surface of a small-town kept in nervous check by the devotion to the feats of sport...The second, set along a highway in Minnesota, at dusk, tenderly celebrates a mystical communion with nature. Two "Indian ponies" approach the speaker and his friend who step over a barbed-wire fence and move toward these gentle creatures.

–Norbert Krapf

Crossing into Sunlight: Selected Poems by Paul Zimmer (Univ. of Georgia Press 1996).

Crossing into Sunlight does other work besides showing us the evolution of the Zimmer persona. Throughout the poems, we see a developing iconography: birds, apples, the color yellow, and the list of recurring minor characters. Wanda embodies the yin to Zimmer's yang, a personally idealized woman for whom both poet and persona yearn in "Wanda Being Beautiful": "To be beautiful is to somehow keep/ A dozen firs burning at night." This book is an education.

–Gabriel J. Welsch

On Writing: A Memoir of the Craft by Stephen King (NY: Pocket Books 2001).

"Writing isn't about making money, getting famous, getting dates, getting laid or making friends. In the end, it's about enriching the lives of those who will read your work, and enriching your own life, as well. It's about getting up, getting well, and getting over.... Writing is magic, as much the water of life as any other creative art. The water is free. So drink." [Stephen King]. from a review by James

–Clifton Spires

Windfall: New and Selected Poems by Maggie Anderson (Pittsburgh, PA: University of Pittsburgh Press 2000).

We can all be thankful for the "windfall" of fruit which Maggie Anderson has gathered in for us from her three previous books. These are poems of loss and closeness that touch the wounds for us all to know truth and make song of it... a key source of Anderson's reputation as a poet of Appalachia.

–Larry Smith

Women & Other Animals: Stories by Bonnie Jo Campbell (University of Massachusetts 1999)

In this fresh, first fiction collection by Bonnie Jo Campbell we have "imaginary gardens with real toads in them," or is it real gardens with imaginary toads in them? Writing at times like a Midwestern Franz Kafka, at times Faulknerian in her use of grotesques, at times in the magic realism of Gabriel Garzia Marquez, often in blunt realism of Raymond Carver, Campbell fills her garden with a wonderful blend of vegetables and flowers, a ménage of the Midwest.

–Larry Smith

Ava's Man: Memoirs by Rick Bragg. (NY: Random House 2001; Vintage 2002)

Rick Bragg comes by his storytelling natu-

REVIEW

rally having learned them from his family—"They taught me, in a thousand front porch nights, as a million jugs passed from hand to hand, how to tell a story." His subject is family and social history as he reveals the reality behind the cultural stereotypes of the working poor, particularly in his native South.... In book after book Rick Bragg gives us the gift of his world.

–Larry Smith

Local Wonders: Seasons in the Bohemian Alps by Ted Kooser. (University of Nebraska Press. 2002)

Ted Kooser, our Poet Laureate, has given us a quietly beautiful book of ordinary life in the Midwest. *Local Wonders* is set in Seward, Nebraska, amidst the Bohemian alps with flashbacks to his youth in Ames, Iowa. Kooser's rich images and colloquial metaphors, place it for us: "Nebraska isn't flat but slightly tilted, like a long church-basement table with the legs on one end not perfectly snapped in place, not quite enough of a slant for the tuna-and-potato-chip casserole to slide off into the Missouri River." It is a book that helps you see, hear, and appreciate the life that surrounds you. And it does so with a light humor that borders on a caress.

–Larry Smith

Kettle Bottom: Poems by Diane Gilliam Fisher (Perguia Press; Florence, Massachusetts 2005)

Kettle Bottom is a looking-glass into the heart of what was then referred to as "Bloody Mingo County,"a look into one coal-mining camp pushed to the edge of human endurance. Painted with dynamic characters and enhanced with ingenious humor and irony, metaphor and folk tradition, it rivals the intensity of a full dramatic novel. As the voices come to life and tell their story, the intention behind the story—that these are the struggles shared in common and not isolated to one time and place—clutches at the reader's humanity....By the end of the book the intention is clear: a deep appreciation of human value above all else. No wonder *Kettle Bottom* was chosen as the Ohioana Best Book of Poetry for 2004."

–Michael McMahon

Gift of Incense by Abubaker and Judith Ashakih. (The Red Sea Press, Trenton, NJ and Asmara Eritrea, 2005).

In *Gift of Incense*, Judith and Abubaker welcome the reader into their lives, family, and home as they evolve as a couple and family as their country dissolves around them. You share the suspense as they sit and wait to hear when they can leave Ethiopia for the United States, and hold your breath along with them as their airplane finally departs. The use of the two voices of Judith and Abubaker to tell *Gift of Incense* is an interesting choice.... Through the combination of both personalities, the reader is transported into the lives of Judith and Abubaker.

–Susanna Sharp-Schwacke

Moving Out, Finding Home: Essays on Identity, Place, Community, and Class by Bob Fox. (Wind Publications, Nicholasville, KY 2005)

Moving Out, Finding Home is a book that keeps your heart company, as Fox traces his life through its places and movements: his parents' migration as Jews from the Ukraine to New York City, his own youth in Brooklyn, a brief escape to San Francisco then return to the East Coast, college days, marriage and migration to Levittown, then to the Appalachian country of Southeast Ohio where he ran a farm, and a final move to Columbus, Ohio, where he worked for the Ohio Arts Council. As the book's subtitle indicates, the life and writing are layered with levels of interest and intention, but above all else, it is a story of one man's relentless investigation of the self, which he freely and authentically shares with us.

–Larry Smith

CREDITS

AUTHORS FOUND IN THE BEST OF HEARTLANDS

MJ Abell (Columbus, OH) has received an Ohio Arts Council poetry fellowship. Pudding House Publications released her chapbook *Below the Waterline*, and her poems appear in several anthologies. She's taught workshops for all ages at The Thurber House and created the performance "Women Loving, Wild & Wise," celebrating the feminine spirit through poetry and props.

David Adams, born and raised in Cleveland, OH, received an M.F.A. from Bowling Green State University. He's settled on a lake in rural Maine and teaches technical writing at the University of Maine. His most recent book of poetry, *Evidence of Love*, was published by Finishing Line Press in 2004.

Maggie Anderson is the author of four books of poems, most recently *Windfall: New and Selected Poems* (2000). She is the editor of the new and selected poems of Louise McNeill and co-editor of *Learning by Heart: Contemporary American Poetry about School* and *A Gathering of Poets*. She's professor of English and a faculty member in the Northeast Ohio MFA program at Kent State University.

Herbert Ascherman, Jr. is a fine art photographer from Cleveland, Ohio.

Carolyn Banks (Bastrop, TX) was born and raised in Pittsburgh, PA. She's published these books of fiction: *A Horse to Die For* (Amber Quill Press, 2006), *Death on the Diagonal* (Amber Quill Press, 2006), *Groomed for Death* (Amber Quill Press, 2004), *Death by Dressage* (Amber Quill Press, 2004).

Joan Baranow's poems have appeared in *The Paris Review, Spoon River Poetry Review, The Antioch Review*. Her book of poetry, *Living Apart*, was published by Plain View Press. She and her husband, poet David Watts, are currently producing a documentary on poetry and healing. A native of Ohio, she is an Assistant Professor of English at Dominican University of California.

Kevin Breen's work has appeared in *Potpourri, The MacGuffin* and *The Side Show Anthology*. He received a Michigan Creative Writing Grant in 2000.

Charlee Brodsky (Pittsburgh, PA) is a photographer on the faculty at Carnegie Mellon University. Her latest book is *Knowing Stephanie* (Univ. of Pittsburgh 2004.)

Terri Brown-Davidson has published poetry and fiction. She taught at University of Nebraska where she lives with her husband. Interviews and her work can be found by internet search.

Bonnie Jo Campbell is the author of the novel *Q Road*, and the AWP award-winning collection *Women & Other Animals*. She writes and trains donkeys in Kalamazoo, Michigan. You can see her website: www.bonniejocampbell.com.

Becky Dickerson (Huron, OH) is an art graduate of BGSU, and teaches photography at Lorain County Community College. She is also Photography Editor for *The Heartlands*.

Robert DeMott teaches at Ohio University. Bottom Dog Press published *News of Loss* (1995) and *The Weather in Athens* (2001). A collection of prose poems, *Brief and Glorious Transit*, is in progress.

Lawrence Ferlinghetti is San Francisco's poet-at-large and founder of City Lights Books, America's first all-paperback bookstore and publisher in 1955. He is in his eighties and still a prolific writer of American culture. His recent titles include: *These Are My Rivers: New & Selected Poems, 1955-1993* and *Americus, Book 1*.

Susan Firer's fourth book, *The Laugh We Make When We Fall*, Backwaters Press (Omaha, NE) won the 2001 Backwaters Prize. Her third book, *The Lives of the Saints and Everything*, won the Cleveland State University Prize and the 1993 Posner Award. Firer's poem "The Beautiful Pain of Too Much" has been performed as the text for "The Weight of Skin," a piece choreographed by Janet Lilly.

Charlene Fix, Associate Professor of English at Columbus College of Art Design and member of *The House of Toast Poets*, has received several poetry fellowships and has published poems in various literary magazines. Her chapbook, *Mischief*, is available from Pudding House Publications, and her a collection of poems, *Flowering Bruno*, with illustrations by Susan Josephson, is forthcoming spring '06 from XOXOX PRESS.

Connie Smith Girard (Huron, OH) has been a photographer for over twenty years. She owns March Fourth Publishing Company, specializing in books about the Lake Erie region.

Jeff Gundy's fourth book of poems, *Deerflies* (2004) won the Editions Prize and the Nancy Dasher Award from the College English Association of Ohio. His earlier books of poems are *Inquiries* (1992) and *Rhapsody with Dark Matter* (2000), both published by Bottom Dog, and *Flatlands* (CSU Poetry Center, 1995). His prose books include *A Community of Memory: My Days with George and Clara* (Illinois, 1996), *Scattering Point: The World in a Mennonite Eye* (SUNY, 2003), and *Walker in the Fog: On Mennonite Writing* (Cascadia, 2005). He teaches writing and literature at Bluffton University.

Richard Hague (Cincinnati, OH) grew up in the industrial Ohio River Valley around Steubenville. His story "Fivethree Filson and the Looking Business" received the 2004 James Still Award in Fiction. He was recently nominated for a Pushcart Prize by *Margie: A Journal of American Poetry*. Recent books include *Alive in Hard Country* (Bottom Dog Press) and *Lives of the Poem: Community & Connection in a Writing Life* (Wind Publications.)

William Jolliff grew up on a farm near Magnetic Springs, Ohio, and now chairs the Department of Writing and Literature at George Fox University. His poetry has appeared in many journals. He recently edited and introduced *The Poetry of John Greenleaf Whittier: A Readers' Edition;* and his ballad "The

Laughlin Boy," recorded by Tracy Grammer, was 2005's 4th most played song on American folk radio.

Diane Kendig's poetry has recently appeared in *Colere, Calapooya, Mid-America, U.S. 1* and *Slant*. Her recent essays on class in academia appear in the *Minnesota Review* and the anthology *Those Winter Sundays: Female Academics and their Working-Class Parents*. She's received two Ohio Arts Council Fellowships in Poetry and a Fulbright lectureship in translation, and she lives in Lynn, MA.

Milla Kette was born in California, was raised in Brazil and returned to the US ten years ago. She lives in Huron, OH. She's the current president of an action group, Grassroots American Values (www.plan2succeed.org/grassroots.)

Algimantas Kezys is a fine art photographer from Chicago, Illinois.

M.L. Liebler, Detroit's poetry guru, teaches at Wayne State University, and has published several books of poetry, including *Written in Rain: New and Selected Poems, 1985-2000*.

Herbert Woodward Martin has authored seven volumes of poetry, the most recent of which was *Escape To The Promised Land* (Bottom Dog Press.) He has written two opera libretti and recently a cantata titled *Crispus Attucks: An American Patriot* with the American composer Adolphus Hailstork. He has long been associated with public performances of the poetry of Paul Laurence Dunbar.

Wendell Mayo, a native of Corpus Christi, Texas, teaches at Bowling Green State University. He is author of three books of fiction: *Centaur of the North* (Arte Público Press), *B. Horror and Other Stories* (Livingston Press); and a novel-in-stories, *In Lithuanian Wood* (White Pine Press). Over eighty of his short stories have appeared in magazines and anthologies.

Ron Nesler graduated from Southern Illinois University to pursue a career in writing.

Susan Neville is the author of four collections of nonfiction: *Fabrication, Essays on Making Things and Making Meaning; Iconography: A Writer's Meditation; Indiana Winter*; and *Twilight in Arcadia*, as well as the story collections *In the House of Blue Lights* and *Invention of Flight*. She lives in Indianapolis and teaches at Butler University.

John Noland, winner of the 2005 Kulupi Press sense of place chapbook contest, was born and raised in Kansas, but now lives on the Oregon coast. He has published poetry and essays in many literary magazines.

Adam and Sam Osterling are young students living in Berlin Heights, Ohio.

Edwina Pendarvis often writes in the interest of community, about people from different times and places than the time and place she occupies. Her poetry collections include *Joy Ride* (Bottom Dog Press's *Human Landscapes*) and *Like the Mountains of China* (Blair Mountain Press.)

Roger Pfingston is a poet and fine art photographer from Bloomington, Indiana.

Maj Ragain lives, learns and teaches in Kent, Ohio. Bottom Dog Press has published two collections of his poetry: *Burley One Dark Sucker Fired* (1998) and *Twist the Axe: A Horseplayer's Story* (2001). A new collection of poems, *A Hungry Ghost Surrenders His Tackle Box*, is out from Pavement Saw Press.

Helen Ruggieri lives in Olean, NY. *The Character for Woman*, a short volume of haibun about Japan, is available from foothillspublishing.com.

Lin Ryan-Thompson lives in Huron, Ohio, and teaches at BGSU Firelands. She is poetry co-editor of *Heartlands*.

David Shevin teaches at Central State University, received a National Endowment for the Arts in Poetry, and is the author a many books of poetry, including: Needles and Needs and Three Miles from Luckey (Bottom Dog Press). He is poetry co-editor of *Heartlands*.

Brian Smith (Huron, OH) works in the law firm of Masters & Associates in Cleveland, Ohio. Photography is a creative hobby for him.

Larry Smith is director of the Firelands Writing Center as well as Bottom Dog Press. He is professor emeritus of Firelands College, BGSU, where he taught for 35 years. A native of the industrial Ohio River Valley, he is the author of 7 books of poetry, 2 books of fiction, 3 video documentaries on Ohio authors. His new book *A River Remains: Poems* will be released this summer from WordTech Books.

Molly Stewart was a native of Castalia and Sandusky, OH area. She was an artist, poet, and conservationist.

Karen St. John-Vincent (Westlake, OH) is a graduate of the Cleveland Institute of Art and currently working in the medium of photography while experimenting with creating artist's books that incorporate photography, painting and writing. She's recently exhibited her work in Chicago and New York City and hopes to do so again in northeastern Ohio. The work featured here is from the series "Drive In Tales", a solo show, presented at Artmetro in Cleveland in 2004.

Degorah E. Stokes teaches at Central State University and is the author of "Epicurus' Dominion" in *Dunbar: Suns and Dominions* (Bottom Dog Press.)

Pat Temple (East Aurora, IL) is a fifth-grade teacher in the bilingual education program at Brady School. She spent her first 16 years living in a farm in rural Michigan.

John Vanek's poetry has been published by literary journals, university presses and such diverse publications as *Bowling Digest, JAMA,* and *Biker Ally – The Motorcycle Magazine Geared For Woman*. His poem, "The People's Republic," is part of the George Bush Presidential Library's permanent collection. He teaches creative writing classes at the high school level and occasionally judges poetry contests.

Eileen Wolford of Mansfield, OH, exhibits her work throughout the Midwest region. She strives to make photographs of great subtlety and detail within the disciplines of traditional photographic processes.

Stephen Wolter writes fiction from his home in Indiana.

BGSU Firelands

CEDAR POINT CENTER AT BGSU FIRELANDS

- 30,000 square feet of meeting space and classrooms, including the 450 seat divisible meeting room.
- Completely wireless with high speed, data, video, and voice communications technology.
- Distance learning and multi-media classrooms plus public computer stations with high-speed connections to BGSU and the Internet.
- Adjacent to the James H. McBride Arboretum with Instructional Terrace and paved walking trails.

For More Information, Call 419-433-5560
or Visit www.firelands.bgsu.edu

FAMILY MATTERS
POEMS OF OUR FAMILIES
Eds. Ann Smith and Larry Smith
150 Poems & 100 Poets
Treating: Birth-Children-Couples-Aging-Parenting-Family Life & Portraits-Death
Including: Antler, Bogan, cummings, Daniels, Frost, Garcia, Harjo, Kinnell, Patchen, Ray, Soto, Williams, Wright, etc.
230 Pgs., Harmony Series Anthology
ISBN 0-933087-95-0, $16.00 (postpaid)

THE SEARCH FOR THE REASON WHY
NEW & SELECTED POEMS
Poems & Art By Tom Kryss
"Tom Kryss is an outsider's outsider and as sweet a poet as I've ever encountered... What he writes always gives you something and never takes anything away."
—John Bennett
Harmony Series, $15.00 (postpaid)
ISBN 0-933087-96-9, 192 Pgs.
Special Edition with Hand Painted Print $35.00

STREET
Poems by Jim Daniels
Photography by Charlee Brodsky
"Jim Daniels' poems in conversation with Charlee Brodsky's photographs make for a remarkable collective work...The poems mirror the pictures' cool balance. Sardonic, smart, wily, tough, they are stories for each image..."
—Alan Trachtenberg

Working Lives Series
ISBN 0-933087-94-2, 96 Pgs., Paper $14.00; Hardcover $20.00 (postpaid);
Special Edition, Numbered and Signed with a Photo Print $50.00

BOTTOM DOG PRESS, INC.
PO Box 425/ Huron, OH 44839 Lsmithdog@aol.com
Homepage: http://members.aol.com/Lsmithdog/bottomdog

CALL FOR SUBMISSIONS:

HEARTLANDS: A MAGAZINE OF MIDWEST LIFE & ART
VOLUME FIVE

Our intended audience begins with the Firelands Area and extends to Northwest Ohio, Ohio at large, the Midwest, and the nation. We are looking for ideas, photo stories, interviews, clusters of poems-fiction-essays around our theme of *Midwest Life and Art*.

- **Nonfiction:** Query the editor with articles on the theme of Midwest Art and Writing, 500 - 4000 words. [Nancy Dunham ndcat@adelphia.net]
- **Poetry:** Send 3-5 poems on the theme [Editors: David Shevin & Lin Ryan-Thompson]
- **Fiction:** Send 1-2 stories on the theme. 4,500 words maximum. [Editor: Connie Willett Everett]
- **Art:** Query the editor: We are looking for photography primarily on this issue, but some nature drawings may be accepted. [Editor: Becky Dickerson]
- **Our Readers Write:** Email submissions on question to be established. Query the editor, Susanna Sharp-Schwacke, sgail1@sbcglobal.net.
- **Payment:** $10-$20 plus 2 copies
- **Managing Editor:** Larry Smith [Lsmithdog@aol.com]

Deadline for the issue is May 15, 2007
Please submit poems, essays, fiction & art between January 1, 2007 and May 15, 2007.

Please send manuscripts with a Self-Addressed Stamped Envelope to:
HEARTLANDS
Firelands Writing Center
BGSU Firelands/ One University Dr.
Huron, Ohio 44839

The Firelands Writing Center supports the art of writing and art in the Great Lakes Region.
It is supported in part by grants from the Ohio Arts Council
And is distributed through Small Press Distribution:
http://www.theheartlandstoday.net/

For a copy of any of our issues, please submit requests to:
Firelands Writing Center
BGSU Firelands/ One University Dr.
Huron, Ohio 44839

© Eileen Wolford, *Heartlands*, Volume 1, 2003